How To
Paint Flames

Bruce Caldwell

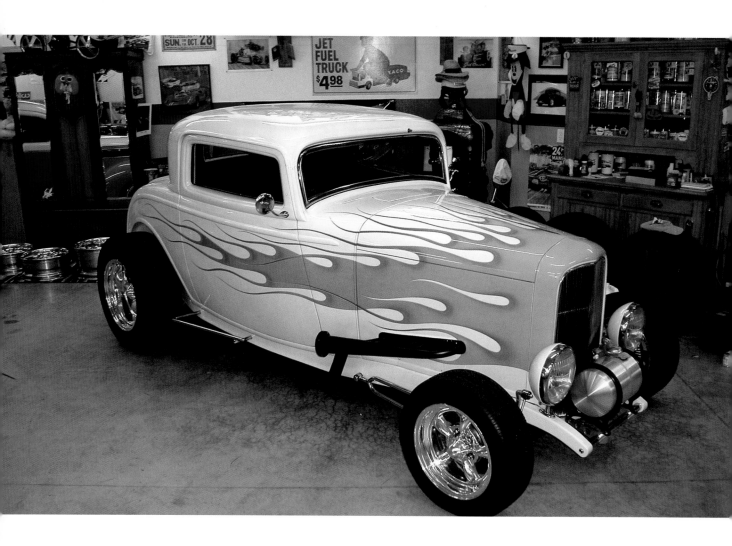

How To
Paint Flames

Bruce Caldwell

MOTORBOOKS
INTERNATIONAL

First published in 2004 by Motorbooks International, an imprint of MBI Publishing Company, Galtier Plaza, Suite 200, 380 Jackson Street, St. Paul, MN 55101-3885 USA

Motorbooks International titles are also available at discounts in bulk quantity for industrial or sales-promotional use. For details write to Special Sales Manager at Motorbooks International Wholesalers & Distributors, Galtier Plaza, Suite 200, 380 Jackson Street, St. Paul, MN 55101-3885 USA.

ISBN 0-7603-1824-7

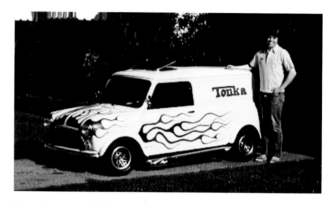

The author as a youth. The ample brown hair and trim physique date this photo as sometime during the Pleistocene epoch. Eddie Paul painted the '68 Austin Mini van.

About the author

Bruce Caldwell has been an automotive journalist and photographer since 1975 when he became associate editor of Car Craft. He was a feature editor at Hot Rod and editor of Chevy High Performance, Mustangs & Fords, Muscle Car Review, Chevy Action, and Street Rod Quarterly. His work appears regularly in major truck, street rod, and performance car magazines. He has authored several automotive how-to books. He lives with his wife in Woodinville, Washington.

Editorial: Peter Bodensteiner
Design: Mandy Iverson

Printed in China

CONTENTS

ACKNOWLEDGMENTS

This book wouldn't have been possible without the generous help of these fine people and companies.

Roy Dunn
Donn Trethewey
Mike Lavallee
Travis Moore
Jason Rushforth
John Sloane
Darren Johnson
Shelly Cullen
Frank Manning
Craig Lang
Gary Becktold
Terry Portch
Shawn Fitzpatrick
Jim Carr
Chris Odom
Denise Caldwell
Craig Caldwell
Barry Kluczyk
Dunn Autographics, www.dunnautographics.com
Killerpaint, www.killerpaint.com
House of Kolor, www.houseofkolor.com
Anest Iwata USA, Inc., www.anestiwata.com
The Eastwood Company, www.eastwood.com
One Shot, www.1shot.com
Rushforth Performance Design,
 www.jasonrushforth.com
Extreme Metal & Paint, Inc.,
 www.extrememetalpaint.com

INTRODUCTION

Flame painting is as much an art as a science. That's why there's no perfect way to design or paint flames. Opinions on how flames should look and how to paint them are as varied as the flames themselves.

The important thing about flame painting is to find techniques that work for you. Like all custom painting, results are what matter. How the finished flames look is far more important than how they got there. If you can produce great looking flames with a Q-Tip and nail polish, people will applaud you.

Flame painting involves a fair amount of experimentation, but you have to start somewhere. Often, you don't know what works until you've discovered what doesn't work. The goal of this book is to make the learning process easier by showing lots of techniques that have worked for experienced flame painters.

Custom painters are by nature very creative and innovative. A style or technique they notice someone else doing will often spark a new idea. Hopefully ideas presented in this book will serve as a launching pad for your creativity. Don't worry about copying existing styles. So what if you're the millionth person to paint traditional flames on a '32 Ford? Would you rather have great looking copycat flames or terrible, but totally original flames? By using established paint schemes as a guide, you're far more likely to succeed. That success will bolster your confidence. Being confident makes it easier to experiment, because you know you can always go back to the tried and true methods if the new stuff doesn't work.

MY FLAMING PAST AND WHAT I'VE LEARNED

I've been interested in flame paint jobs since I was a young child. During the production of this book I found drawings of some cars I drew when I was probably six or seven years old. The cars were flamed. I made frequent use of the flame decals that came with the old AMT 3-in-1 1/25th-scale plastic model kits. I hand-painted custom flames, but that was before I knew about stencils. It was also before my motor skills were fully developed.

I flamed wagons and crude gravity racers (pseudo Soap Box Derby cars). The first motorized vehicle I flamed was the cowl of a '30 Ford Model A that had been converted to a tractor. I used Testor's white model enamel on the faded

red cowl. The tractor subsequently caught on fire, which could have been a predecessor of today's realistic flames, but we extinguished them.

I've owned several flamed cars and trucks. A couple of them have been *Hot Rod* magazine cover cars and appeared in other national publications. I've painted a couple flame jobs and helped more talented friends on others. I've made some serious mistakes, such as botching the clear coat of a *Hot Rod* cover truck, but it didn't show in the photos. I nearly ruined a one-year-old Cougar XR-7 when I painted it with a spray gun that wasn't suitable for spraying graffiti. But I've always learned from my mistakes, and most importantly, I've always had fun.

I've been fortunate to observe and photograph some extremely talented custom painters. I've done lots of magazine articles and a couple of books on various aspects of custom painting. I'm always fascinated by the different techniques. I've learned a lot from these artists.

Key things I've learned include:

Design—A flame job is only as good as its design.

Flow—The best flame designers and painters have a natural flow to their movements and work. This applies to both design and paint application. Flames are almost organic, and as such should be smooth and fluid.

Color—This is an important aspect of design, and flame colors should work well together, so they flow from one to another. Understanding contrast plays a big role in determining pinstriping colors.

Tape—It usually takes many attempts to get a satisfactory layout. That means lots of wasted tape, but tape is such a minor part of the total cost. Don't sacrifice design to save a few bucks on tape. Quality tape is well worth the extra cost.

Mistakes—Mistakes happen. Pros don't get rattled because they know how to fix problems. Many people can apply beautifully smooth paint as long as everything goes right. Pros know how to get a great paint job in spite of mistakes. That ability separates the pros from the amateurs.

Clear—A good clear coat is key to a beautiful flame job. Clear gives depth and brilliance as well as protection.

Buffing—Color sanding and buffing are an art unto themselves. It's during this stage that the paint job comes alive. The work is tedious but pivotal to the success of the flames.

Striping—Not all flames require pinstriping, but for those that do, color selection and line thickness are very important. Color choice determines how well the flames "pop" off the base color. Pinstriping affects the way the tips look, and it can cover minor mistakes.

HAVE FUN, SAVE MONEY

If it isn't fun, why bother doing it? Flame paint jobs aren't one of life's necessities. Flames are a way of personalizing a vehicle. They make the vehicle stand out from the hordes of bland transportation modules.

Saving money can be fun, too. The goal of this book is to help you achieve a great flame job, regardless of how much of the job you do yourself. By doing some or all of the work yourself, you should expect substantial savings. Top-notch professional custom painters charge thousands of dollars for show-quality flame jobs. These prices reflect the high costs of materials, their years of experience, and countless hours of grunt work.

You can't do anything about the cost of materials, but any time you cut down on the amount of professional labor, you'll save money. Ensuring that the flames are exactly what you wanted is as important as saving money. When you have control, you get the flame job you want, not someone else's interpretation of your ideas.

The ability to do some of the work and have a professional complete the job depends on the flexibility of the pro. Most pros don't like to apply top coats over someone else's prep work, because they can't guarantee their work if they don't know what's underneath it.

You can design your flames and make a paper pattern as shown in this book. You can take the pattern with its pounce wheel holes and body reference points to the painter. The resulting chalk pattern will be your design. The painter may let you help with the masking after he is satisfied with the surface preparation. As this book discusses, design is a critical part of a successful flame job.

The best thing you can do to become a successful flame painter is practice, practice, practice. So, get some blue Fine Line Tape and start flaming.

CHAPTER 1
DESIGN AND INSPIRATION

The finest paint in the world won't hide a poor design. You can use the most expensive color-shifting paint and apply it so smoothly that it makes glass look rough, but if the basic flame layout isn't right, you'll end up with an unsatisfactory paint job. Conversely, you can lay out a beautiful, smooth-flowing flame job and spray it with hardware store rattle can enamel and get lots of compliments. Ideally, the handsome design should be combined with quality paint products and flawless application techniques.

The point is that a good design is every bit as important as your painting skills. The key idea behind successful flames is that they flow. Hot rod flames are supposed to impart a feeling of motion and speed. They're supposed to accentuate the overall look of the vehicle, not detract.

Once you spend time studying flames you'll notice significant differences between the flame jobs that work, those that come close, and those in which something just isn't right. Learn from the mistakes of others, and don't be afraid

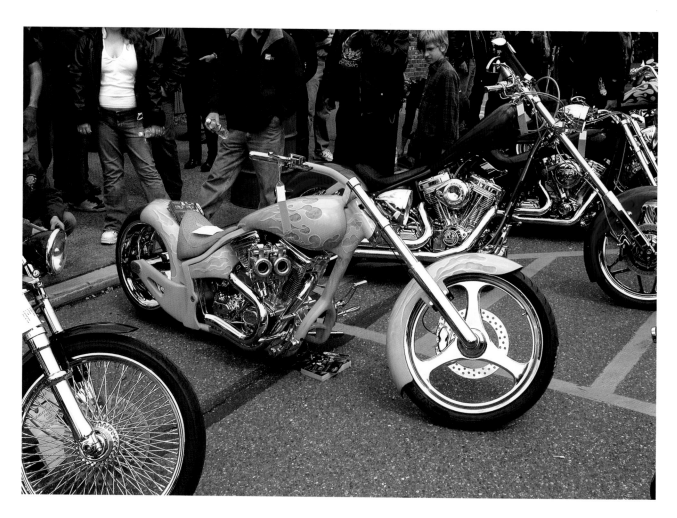

Ideas are everywhere, but you can't beat large shows for seeing lots of cool cars, trucks, and cycles in one place. Chopper paint jobs don't cover many square inches, but they can contain incredible detail.

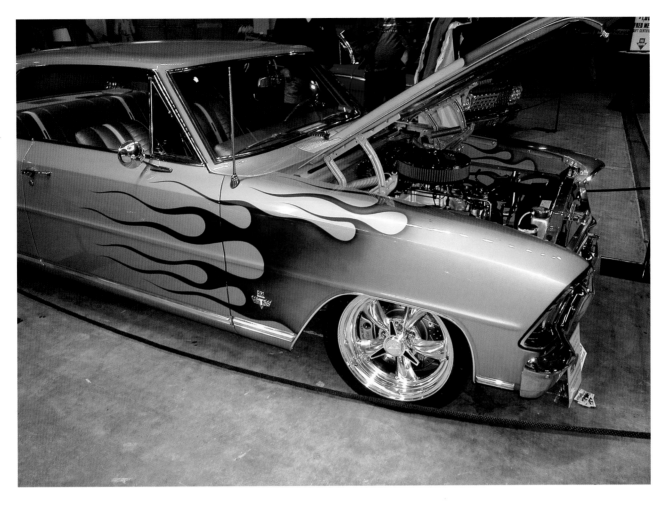

Don't be afraid to think "out of the box." This stunning '67 Nova features purple semighost flames over a stock-type metallic tan/gold base. This isn't a combination most people would initially pick, but the results are wild. Notice that the flames continued inside the engine compartment.

to outright copy or incorporate elements of successful flame jobs you've seen on other cars. It's tough to come up with a totally original design. You can add your own personalized touches, but there are only so many basic ways for flames to fit on a particular vehicle.

It's better to be accused of copying the flames on a well-known car than to have ugly, but highly original flames. Certain celebrated custom painters are known for their style of flames. Some people even refer to a particular style of flames as "so-and-so" flames. This goes all the way back to the 1950s when local painters first started getting national recognition in hot rod and custom car magazines. Von Dutch and Larry Watson were two famous painters/stripers who were known for their distinctive styles. Many people still refer to certain painting techniques as a Von Dutch or Watson thing.

There were even cases in which the flamed car became as much the moniker as the actual painter. That was the case with the bold flames on the nose of Bob McCoy's '40 Ford black sedan. The September 1957 *Hot Rod* magazine cover car was painted by Ray Cook of San Diego, but no one refers to Ray Cook flames. People still talk about Bob McCoy '40 Ford-style flames, though.

The same situation applied to the flames on Tom McMullen's iconic '32 Ford roadster. Tom painted the flames and Ed Roth pinstriped them, but even though the owner and painter were the same, the flames are known by the car, the McMullen roadster, not the painter. The wild chopped and flamed '34 Ford coupe from the movie *The California Kid* is another case in which the style of flames refers to the car, not the painter. Manuel Reyes was responsible for the massive flames, but people refer to them as California Kid flames, not Manuel Reyes flames.

Inspiration can come from a myriad of sources. Flames aren't found just on cars; they're everywhere. Flames can be

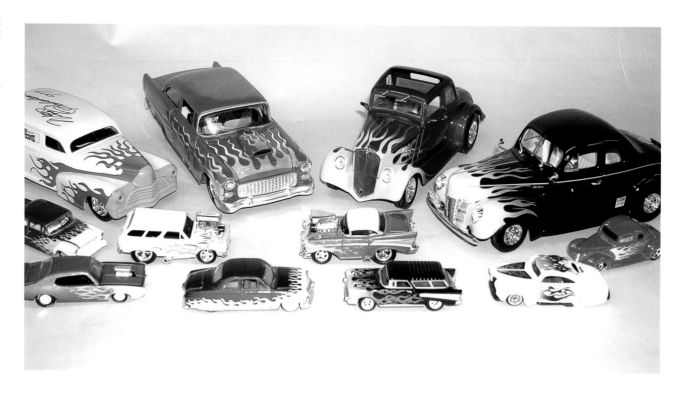

Very talented artists design die-cast models and toy cars. You can find all kinds of trick flame ideas on these affordable miniatures. If you're lucky, you might even find your exact vehicle.

This is a full view of the cover car flames on Craig Lang's '32 Ford Tudor sedan. Donn Trethewey painted the flames. This style of flames would look great on newer vehicles as well.

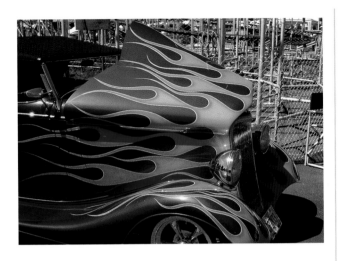

Color selection is a big part of designing flames. The contrast of the orange flames against the candy purple body of this '33 Ford roadster is incredible. The blue pinstriping serves as a "bridge" between the purple and orange. These flames have excellent flow.

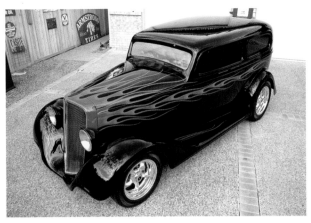

This is the "after" shot of Jim Carr's '35 Chevy. The relatively narrow nose-to-tail band of flames is very contemporary. Similar flames were applied to the front fenders, but they're not readily visible from all angles. This car is seen in various how-to photos throughout the book.

Adding flames to a car that's been around for a while can dramatically change the car. Jim Carr has owned this chopped '35 Chevy for decades. The superthin purple scallops were dated, so Jim asked Donn Trethewey for an extreme makeover.

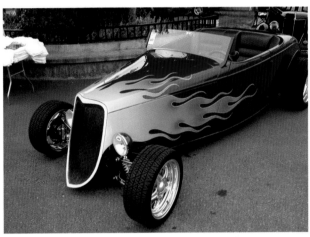

This style is often referred to as hooked-end flames due to the distinctive tips. Many high-profile magazine cars have used this style.

found on all kinds of commercial products, in advertising, as a part of logos, computer graphics, and video games—the sources are nearly endless. A few obvious automotive-related sources are die-cast, model, and toy cars and trucks, car event T-shirts, and car magazines.

Highly skilled artists often design flames on toy cars and in magazines. Someone or some big company already paid for their design skills, so you don't have to. If you're lucky, you can find examples of flames on vehicles like yours. You can save a lot of money by building a model of your car or truck and flaming it to see how your idea looks.

Speaking of automotive designers, it isn't unreasonable to engage the services of a professional designer. Most of the high-profile cars and trucks at big industry events, like the SEMA show in Las Vegas, were first designed and conceived by a professional designer. Getting a series of artist's concept drawings is virtually mandatory for companies that seek sponsorship for their project vehicles.

Some of the truly big-name designers are obviously expensive. You probably can't afford the fees that a major manufacturer pays, but many highly skilled designers are surprisingly affordable. When you're looking at spending thousands of dollars on a custom paint project, a couple hundred more for professional design help seems quite reasonable.

We spoke to Jason Rushforth of Jason Rushforth Performance Design (www.jasonrushforth.com) in Tacoma, Washington, to get some ideas about design. Jason's artwork appears frequently in national magazines, as do the finished cars and trucks. He does a lot of concepts for companies and individuals wanting to build vehicles for trade shows.

Jason emphasized that flames need to flow. If we sound redundant about flow, it's because it's so important. Jason says that ellipses and curves should be uniform and have a similar curvature and flow, even if they are of different sizes. The same theory applies to flame licks. They should have a similar flow and taper, despite their differing lengths.

Jason feels that flames are organic and should be designed accordingly. Straight lines should be avoided at all costs. Jason does a lot of tribal flames for sport trucks. He classifies tribal flames as flames with an aggressive attitude.

Any color flame is fine with Jason, but fades should be done with complementary colors. Traditional flames with yellow, orange, and red also look nice with blue or purple tips, but the main parts of the flames should be in the same family of warm colors. If you're not into traditional flame colors, there are lots of options. Some of Jason's favorites are silver to candy blue, like a propane flame, and lime green flames that resemble the color of antifreeze. He especially likes the lime green flames on black, white, or silver cars.

Jason feels that, for the most part, pinstriping should be done in contrasting colors. He likes the "pop" factor of lime green and process blue, especially on black vehicles. According to Jason, flame tips should be random and shouldn't be perfectly opposing. Tips should alternate directions unless you run into trim items or door handles. The length of the tips depends on how loud you want the vehicle to look.

Jason has more examples of his work and current pricing information on his website. At the time this book was written, basic design work started around $350 for four rough drafts with different looks, colors, and styles. Once a design is chosen, costs rise depending on how many final drafts are desired.

Planning is a key to a successful flame job. Spending as much time as necessary to research and plan will pay big dividends in the quality of the finished product.

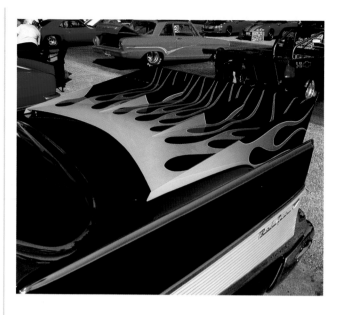

Flames can be used anywhere on a car. The Pro Mod style rear wing on this '57 Chevy proved to be an excellent place to add more flames in the same style as those adorning the nose of the car.

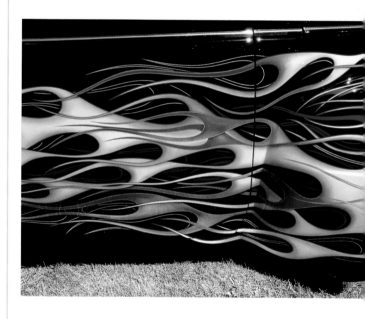

The more complex the design, the more time consuming the layout and masking portions of the job are. On flame jobs like this one, it helps to take digital photos or videos as you go along to help keep track of what goes where.

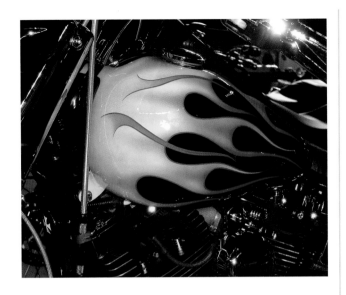

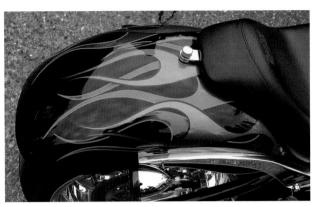

Flame lick starting points can be difficult to determine, especially on small objects like motorcycle tanks. Jon Byers used the same orange color that he used to fog the inner curves for these free-floating licks. The beginnings of the licks were blended into the base yellow. Purple pinstriping was used to separate the free-floating licks from the rest of the flame job.

Rear fenders on motorcycles traditionally have flames that start somewhere under the seat. You can't go wrong with this look. Stock bikes have more accessories attached to the fenders than choppers, but it's best to treat the fender as if it were totally blank than to try to design around fasteners, lights, and brackets.

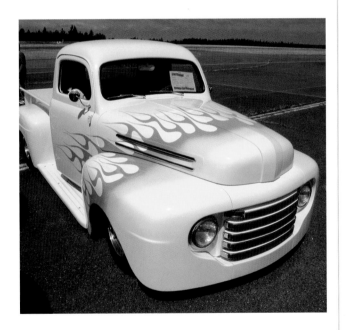

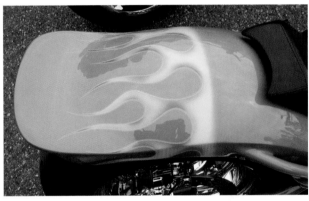

Some flame painters choose to start at the nose with the vehicle's main color, and begin the blend into the flames a foot or so back from the grille. This Ford F-1 used a pale orange to start the blend into the main orange of the flames.

RIGHT: Primered vehicles are a perfect "canvas" for flames. The contrast between the flames and the primer makes the flames jump. Primer and flames are a very traditional hot rod look. Barry Kluczyk

Mike Laird demonstrated flame Rule No. 1—there are no rules—by starting the flames on this chopper well behind the seat. He did the same thing to the tank. The starting point was fogged slightly to blend it into the purple base color.

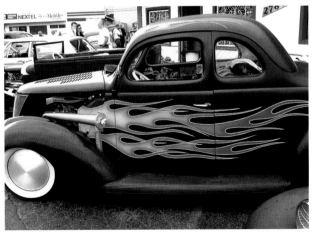

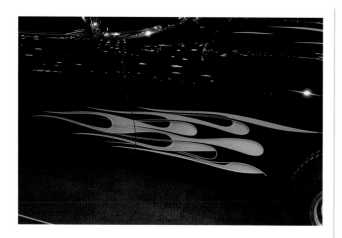

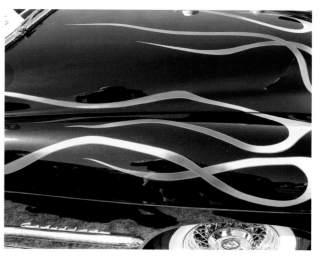

"Negative space" flames refers to an area of the car's primary color that is masked off as flames within the rest of the flames. The cove of this black '57 Corvette is a perfect example of negative space flames. The drop shadow airbrush work is excellent as it makes the black licks look as if they're floating over the orange flames.

Flame licks almost always have a rearward taper, although some designs feature fluctuating lick thickness. The thing to avoid is straight, parallel lines like the licks shown here. It's also critical to avoid any kinks in the inner curves or licks.

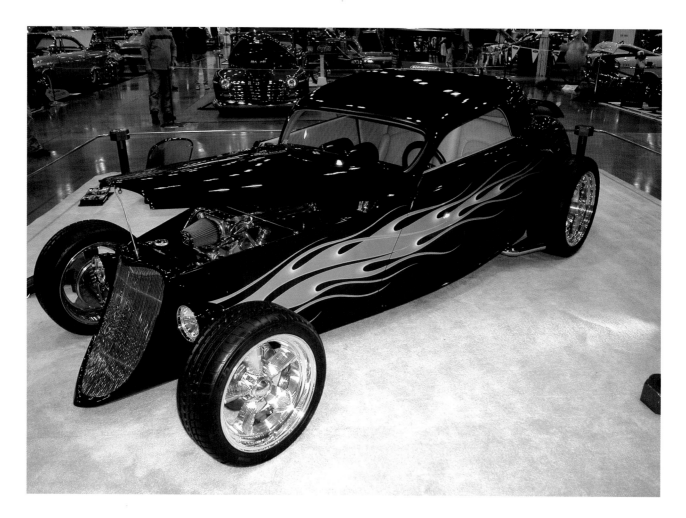

Flow and a sense of motion are very important flame design elements. This radical '33 Ford coupe built by Tim and Scott Divers and flamed by Donn Trethewey has a definite wedge shape, so the flames were designed to accentuate that shape. The flames emanate from the front suspension instead of the grille.

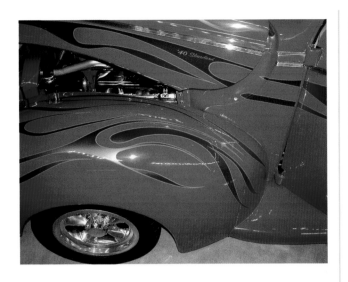

The licks on this '40 Ford are quite unconventional, but they still have excellent flow. The tapers are unusual, but they're not flat or parallel. The licks flow the natural shape of the fenders.

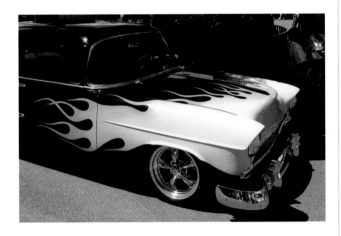

Instead of starting at the bottom of the fenders, the flames on this '55 Chevy flow from the parking lights. There are so many unique ways to design flames that making decisions for your car can be mind boggling.

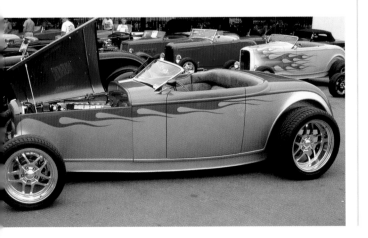

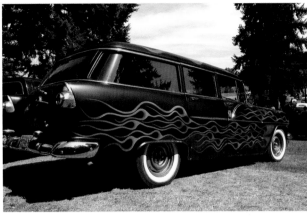

This style of flames is often called "Seaweed Flames" due to all the wavy motion. The fact that these seaweed flames are green is coincidental. Getting long flames from one end of a car to the other takes careful planning to make the design work well.

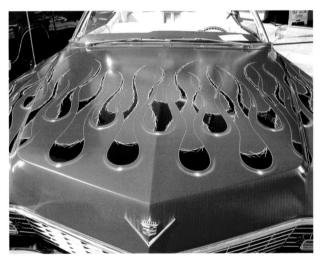

The main red color of this Cadillac convertible was turned into flames with three-part pinstriping and airbrush highlights. Black flames with ragged striping were placed underneath the red flames. The three-part pinstriping consists of a thicker orange stripe bordered by two very thin red stripes that are darker than the base red. These flames are quite large, but that works, because the Caddy hood is so big.

LEFT: Simple flames along the lower edge of a two-tone paint scheme can add a lot of interest without much effort. This technique can easily be applied to existing two-tone paint jobs.

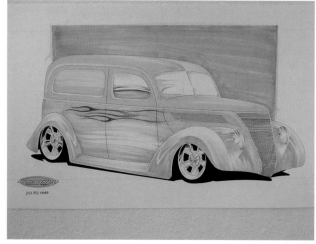

Given the cost of modern paint materials and the labor involved in a trick flame job, it makes sense to spend a little more money on a professional designer. Jason Rushforth is a talented automotive designer whose work appears regularly in national magazines and on top show cars. He can draw up your ideas or give you fresh choices.

This is a Jason Rushforth sketch for Jim Hart's '37 Ford sedan delivery. The truck was due for repainting, so Jason came up with some tasteful flames that add interest to a two-tone paint scheme.

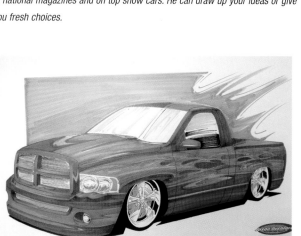

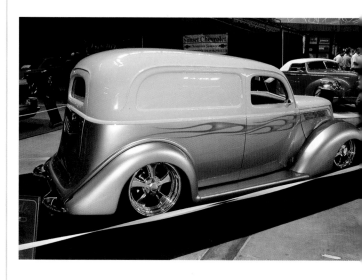

Jason Rushforth does a lot of design work for sport truck owners and companies that want an attention-getting truck for trade shows. Many project trucks can't get off the ground without a folio of design concepts. It's much easier to experiment on paper than with real paint.

Here is the actual '37 sedan delivery. The finished truck is very close to Jason's sketch. Like most successful flame jobs, the flow of these flames is excellent.

RIGHT: A designer can help you avoid overly busy paint schemes like the stars and flames on this '69 El Camino. The flames alone might have been fine, but the black hood stripes, stars, and black vinyl top provide too many conflicting design elements.

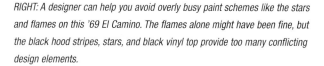

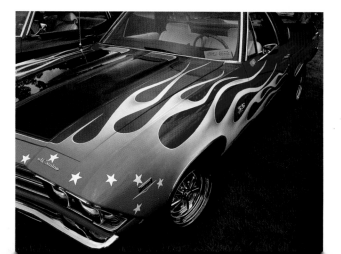

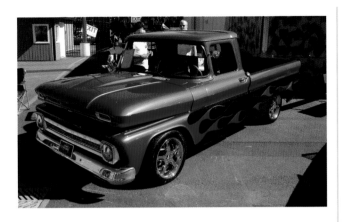

Using flames as part of a two-tone paint scheme is a great idea. The candy tangerine flames flow nicely out of the factory styling lines between the hood and front fender of this mid-1960s Chevy pickup.

Flow is the way to go. The traditional combination of yellow, orange, and red flames with bright blue pinstriping on a black hot rod is tough to beat. Street rods usually have a raked stance, so the upward flow of the flames accentuates this positive trait.

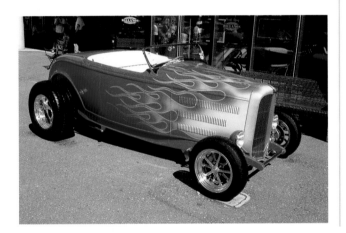

LEFT: Flames don't need to rise in order to have good flow. The traditional style flames on this '32 Ford highboy roadster are quite parallel to the ground, but they still have excellent flow and motion. The violet pinstriping is a key element in making these flames stand out.

BELOW: In general, flames tend to be on the long side, but this very old school Model A highboy shows that short flames can be effective, too. The shape of the Model A cowl and the open engine both contribute the success of these flames.

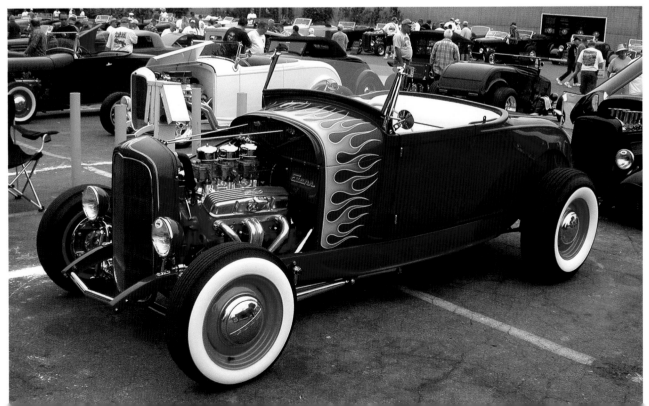

CHAPTER 2
MASKING BASICS

Masking off flames is where the theoretical meets the practical, and the tape meets the metal. It's time to tape the flames or tape your mouth—tape up or shut up. You can conceive your ideal flame job, but until you successfully transfer those ideas to the vehicle via masking tape (or any other masking medium) it's just a pleasant daydream.

Like every other aspect of flame painting, masking requires practice. The more flames you lay out, the more instinctive the process will be. The concept of free-flowing flames will be reiterated throughout this book. The masking process is where it all begins.

The most difficult part of laying out flames is the inner curves, but this is where great flames part ways with merely good ones. Long licks can have different amounts of oscillation, wiggle, or whatever else you want to call the motion. This movement is much more subjective than the inner flame curves. A curve that isn't smooth and uniform will stick out like a sore thumb.

You need to be comfortable with the way tape bends and stretches in corners. Plastic tape like 3M Blue Fine Line is much more flexible than standard masking tape. That's why most custom painters use some type of plastic tape for layout work. Even plastic or vinyl tape will kink if you start and stop part way through a curve. That's why it's so important to make inner curves in one continuous motion. You're better off to completely redo a curve than to stop in the middle of it.

In some ways, taping flames can be thought of as an athletic endeavor. There is great value to finding your groove. It's like downhill skiing, in which you ski so much better once you relax and let your body and skis flow as a single unit. Instead of tensing at each mogul, you just ride along with the skis. You go with the mountain instead of against it. You get into a flow or rhythm. When you reach the bottom of the hill you feel as if you're still moving because your body has gotten into the flow so well.

Successful flame layout can involve similar feelings of rhythm and flow. It can also help to listen to relaxing music.

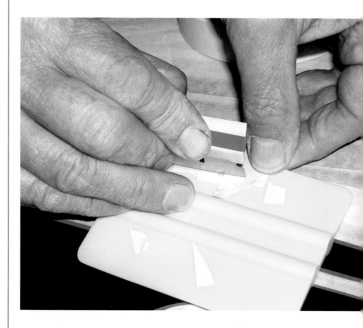

Masking tape comes in a wide variety of sizes and types. The plastic or vinyl tapes are very useful for designing flames. A plastic squeegee is useful for burnishing tape edges and working air bubbles out of transfer tape.

A plastic squeegee also makes a handy portable cutting surface for trimming small pieces of masking tape to fit into small, uncovered areas. Notice that masking tape was added to the top of a single edge razor blade to serve as a handle.

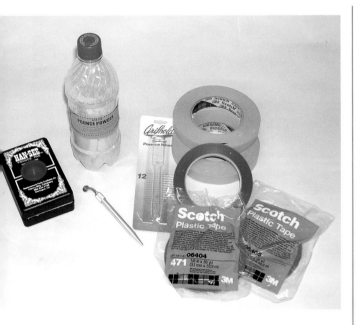

Pounce-related tools are necessary for making patterns. The Eastwood Company carries a good selection of these tools, such as a special chalk applicator, chalk, and pounce wheels. They also carry 3M masking tape and other layout and masking necessities.

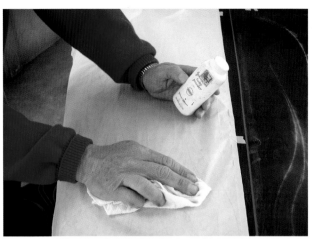

Colored carpenter's chalk powder is the most common marking medium for pounce wheel patterns, but baby powder can also be used. Baby powder works best on a black or dark colored vehicle. Baby powder is a staple with painters who also pinstripe, because the powder helps their hands glide along the body as they stripe.

This might sound like some goofy new age "Zen of Flame Painting," but the point is that relaxing and focusing on achieving a good flow will lead to the best layouts.

When you and the tape are flowing, it's a good idea to keep going. Don't stop and analyze each lick. Do a large area and then step back and see what you like and what could use some tweaking. Often you can make minor adjustments to spacing between licks or to the amount of taper in a given flame lick. Sometimes the design just doesn't cut it, and you need to start over.

One caution about starting over is that it's a good idea to keep a record of what the last layout looked like. It's not uncommon to do a couple layouts and then realize that you really liked the first one best. Once you've pulled up the tape it's tough to remember exactly what you did before.

Digital cameras are the slick solution to that problem. Basic digital cameras are so reasonably priced that it's easy to keep track of previous designs. You don't need an expensive large megapixel camera, because all you need is a basic reference image. You can compare layouts as you do them, or you can download the images to a computer and study full-screen versions.

During the initial layout process, press the tape just enough to allow adhesion. Don't burnish the tape until you're completely satisfied with the design. You can easily reposition

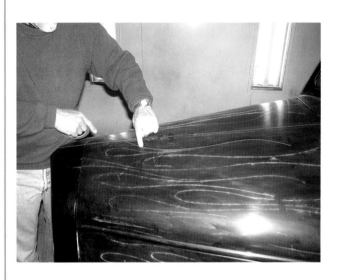

Try to find a rhythm when designing flames or even when following chalk guidelines. Notice how a section of tape is used as a leader. It's best if you can start at a tip and tape toward the inside curve. Try to make one continuous motion; too many stops and starts lead to jerky lines.

plastic tape if it hasn't been pressed hard against the surface. You can move tape that has been pressed down, but each time the tape is lifted it loses some of its sticking ability.

Tape that doesn't stick well is a serious concern when laying out flames. You want to avoid bleed-throughs. How many times you can lift and reposition a piece of tape is debatable. A time or two is usually fine, but lifting it several

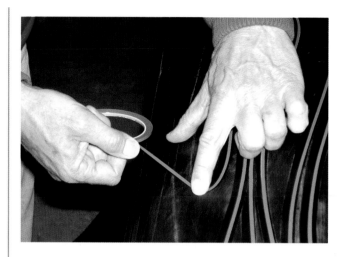

times can be questionable. Repositioning tape in corners multiple times is particularly risky, because the tape has already been stretched to make the curve.

Besides limiting the number of times a section of tape is moved, other ways to control unwanted lifting include always using top-quality automotive masking tape, using fresh tape, using it at room temperature, and working on a totally clean surface. Saving a few dollars on off-brand or old tape is a false economy.

The preferred way of holding tape during the layout process is shown in the accompanying photos. Most custom painters like to have a foot or two of lead between the tape roll and the vehicle surface. The outstretched arm helps achieve the "flow" while the finger on the vehicle positions the tape.

Once the initial design has been taped, stand back and study it. Besides checking the flow of the licks, pay attention to the amount of space between licks. There needs to be a good balance between the flamed areas and the rest of the vehicle's surface.

Flames that don't have much space between them can look like a solid color from a distance. Flames with too much space between them might be too small for the vehicle. An exception is when flames are just painted in a narrow band as an accent, more than a dominating element—in that case the proportions are not as important. The key thing to look for is balance and the way the flames work with the whole vehicle.

A design/taping mistake that novices often make is not allowing for the width of the tape. A flame job can look great in blue plastic tape but appear a little small once it has been painted. The problem is that your eyes see the flames as being the size of the tape's outer edge. Pinstriping can help this some but you don't want pinstriping as wide as tape.

Another design/taping consideration is viewing distance. When you're working on the flame job you won't be more than a couple feet away, but most viewers will be many feet away. You work on a small part of the vehicle at a time, but the finished viewpoint will be of the whole car.

When you're satisfied with the layout, it's time to make a pattern for the other side if you want symmetrical flames. That process is covered in Chapter 7, on how to do traditional flames. It isn't necessary to make a pattern. Many painters do both sides of the vehicle freehand. Their reasoning is that people only see one side at a time, and flames aren't symmetrical. Digital photos are a way to have a general reference of the first side without making a pattern.

After the layout is done it's time to fill in the gaps. The first thing to do is go over every inch of tape to be sure it

The amount of tape lead is usually shorter for curves. The tape is actually being stretched inside a curve so positioning the tape with one finger allows you to pull or stretch the tape with the hand holding the roll.

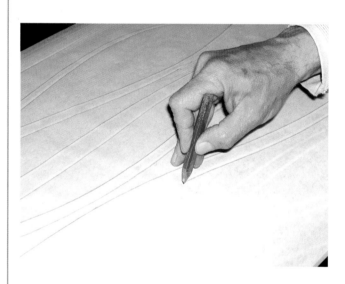

A variety of pencils can be used to trace the underlying tape when making a pattern. A wide-lead carpenter's pencil works well for following the tape ridge. Don't use ink marking pens, because they will saturate the paper and stain the surface.

is secure. Pay particular attention to inside curves done in 1/8-inch tape. Follow the 1/8-inch tape with overlapping 1/4-inch blue Fine Line Tape. Then tape the inner loops and areas between licks.

The goal in taping gaps is to avoid leaks and wrinkles. The problem with leaks is obvious, but wrinkled tape or masking paper will trap overspray or debris that can fall back into the wet paint. Masking paper is less expensive than tape and works well for large flat areas. If you use it inside loops, fold over any excess and tape the folds shut.

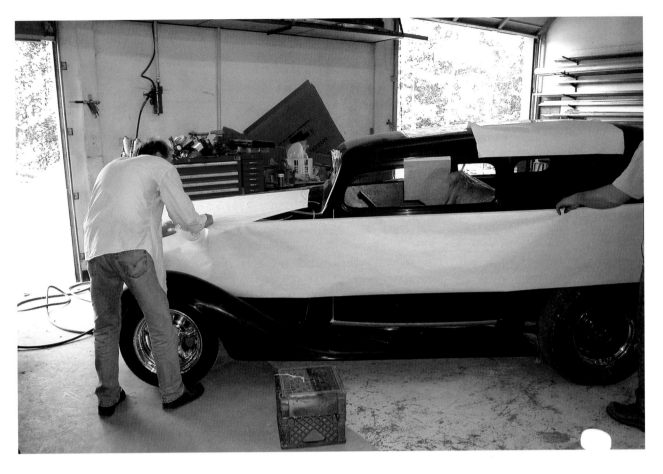

A continuous piece of masking paper or butcher paper is desirable when making a pattern for full-length flames. Make notations on the paper as to body reference points so the pattern can be placed in the exact location on the other side. When necessary, tape two pieces of paper together for areas like the hood.

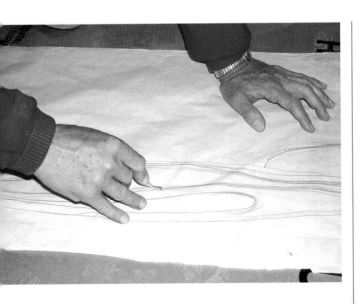

A large piece of cardboard works well as backing material when tracing the flame pattern with a pounce wheel. The paper needs to be on a porous surface so the pounce wheel can perforate it.

Try to make folds face down (so the opening of the fold faces the floor) even though you plan to tape them.

Some painters fill in the gaps with 3/4-inch masking tape, and others use 2-inch-wide tape. Whichever you use, overlap each piece of tape. If you "stack" the layers of tape as you work, from bottom to top, the whole section can be removed as a single piece.

Transfer tape, which is popular for masking intricate designs, can also be used to mask off large areas. The only problem with transfer tape is that it needs to be cut away from the areas that will be painted. An X-acto knife or stainless snap-blade utility knife are the preferred cutting tools. Some painters like the less expensive disposable single-edge razor blades. Whatever is used must be used with a light touch. You only want to score the tape enough that it will tear. If you cut through the underlying design layout tape into the metal, you will have noticeable cuts in the paint.

A key technique to cutting transfer tape is to let the sharpness of the blade do the cutting instead of using

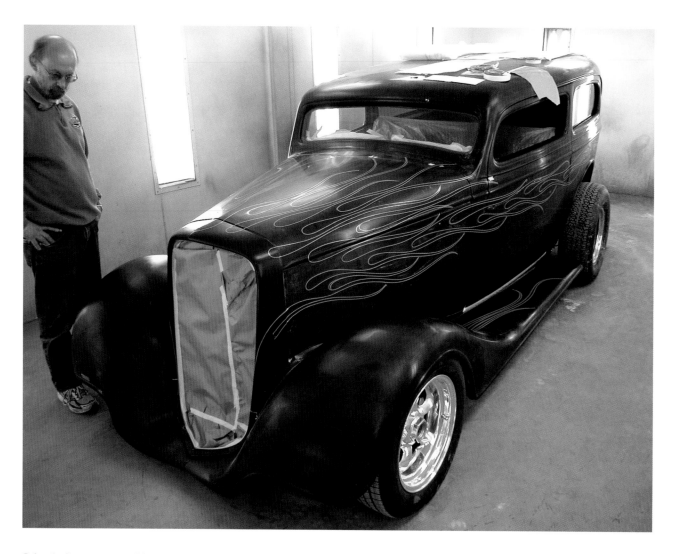

Before the flames are taped off for painting, study them for matters like flow, spacing between flames, and the direction of the tips. If you're painting flames for someone else, get that person to sign off before applying paint. Jim Carr is seen here making a critical inspection of Donn Trethewey's layout on his '35 Chevy.

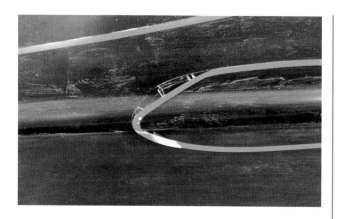

Every inch of tape needs to be checked for lifting. The thinner the tape, the more it is prone to lift. Eighth-inch Fine Line Tape is most apt to lift in tight corners, especially if the tape crosses a raised area like this hood styling crease.

pressure. That's why it is so important to use a fresh, sharp blade. Snap-blade utility knives make it simple to always have a sharp blade.

Another point about cutting out flames is to make one continuous cut through the inner curve. There are special knives with swivel heads, but few painters use them. Making smooth cuts is another one of those practice-makes-perfect things.

Besides masking off the flames, every other part of the vehicle needs to be protected. If there is the slightest opening, overspray will find its way in. There is plastic sheeting made for automotive painting, available where you buy paint. Masking paper will also work for protecting large areas.

Any gap that is bridged by flames requires extra taping. Doorjambs are the primary example of this type of taping.

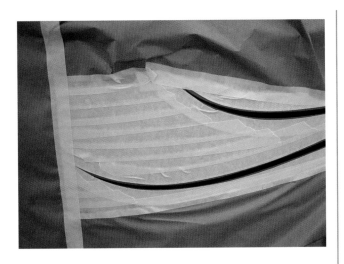

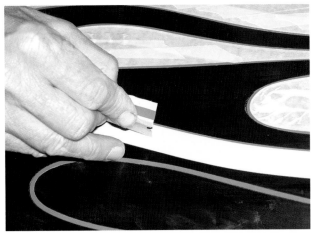

This area was covered with 3/4-inch masking tape, starting at the bottom and overlapping each piece. Notice the minimal number of debris-trapping wrinkles.

When the space between flames is tight, it's often easier to partially tape over an area and then cut away the excess tape with a sharp blade. This requires care not to cut too deep and to keep the cut centered on the outline tape.

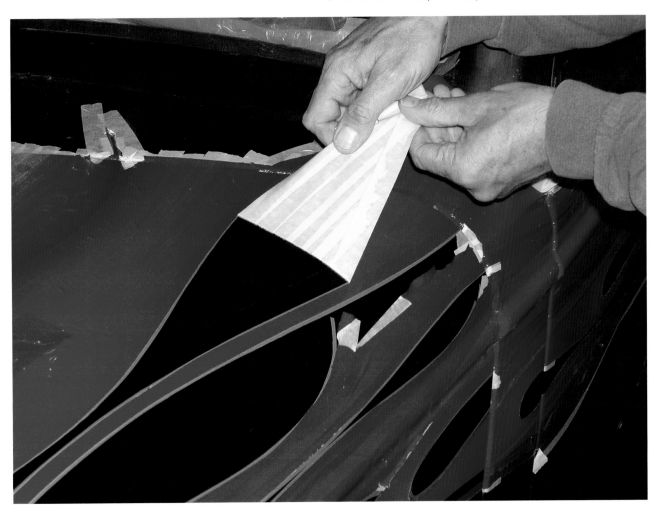

A big advantage to systematically overlapping tape is that the untaping process will be quicker and less apt to harm the still pliable paint. Notice that the tape is being pulled back over itself. The blue outline tape is removed last.

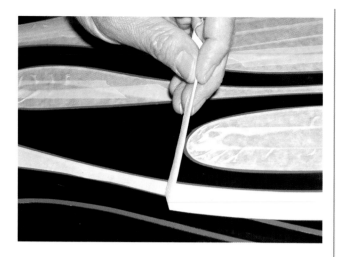

After the cut has been made, the unwanted tape is carefully pulled up and removed. This method is quick, but it requires a steady hand and gentle pressure with the blade.

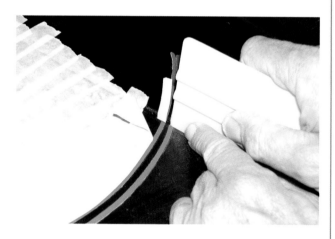

The burnishing tool or plastic squeegee comes in handy for pushing the cut tape ends into place when you're taping around body gaps. The blue Fine Line Tape should be positioned first, before regular masking tape is added.

Complex, overlapping flame designs require careful cutting of the layout tape in the crossover areas. Noted custom painter Travis Moore relies on his trusty stainless snap knife because it always has a sharp blade. The cuts need to be precise to keep the flame edges crisp.

Travis Moore uses the sharp tip of the snap knife to carefully separate and lift the excess tape. Care needs to be taken when painting overlaps to keep track of which lick goes where. A digital photo of the original design sketch can be helpful.

Some painters tape out the flames so they flow through the doorjambs, but most prefer to just let the flames bridge the gap. That means the flames go around the lip of the door, but not into the actual jamb.

Jambs should be taped before the initial flame layout is done. Then the layout proceeds by bridging the gaps. It's during the masking process that the blue vinyl tape should be cut in the center of each gap. Carefully wrap the loose ends around the edge of the door.

Taping is a very time-consuming and often tedious part of a flame job, but the extra effort spent here will be reflected in the quality of the finished product.

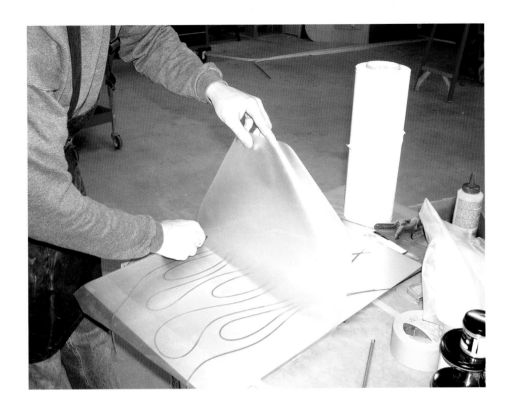

Transfer tape is usually clear or semitransparent so the blue tape outline can be easily seen when removing the excess masking material. Transfer tape is best for complicated graphics, lettering, or small areas of flames. When using transfer tape lay it down slowly to avoid air bubbles.

Sometimes air bubbles or small wrinkles can't be avoided, so use a squeegee to carefully work out the bubbles. The squeegee also helps burnish the transfer tape so it totally adheres to the surface. It's most important to press the transfer tape where it meets the blue outline tape.

CHAPTER 3
SURFACE PREP

Proper surface preparation involves three key elements: cleanliness, cleanliness, and cleanliness. Cleanliness is a must for proper paint adhesion. It also helps to have straight sheet metal underneath the paint. Remember that paint magnifies underlying flaws.

There are many excellent books on bodywork and basic painting that cover surface prep in detail. This chapter will recap some of the key points.

Any paint job will go smoother if you remove all extraneous items from the car. Emblems should be removed for a total repaint, but when painting flames you need to decide if the licks will flow around or under any emblems. Some painters treat emblems and molding trim as if they weren't there, and others are careful to work around them.

Emblems and trim pieces are natural areas for wax and debris to accumulate. That's a good reason to remove them. It can be helpful to make an approximate chalk outline of emblems so you will remember their locations when laying out the flames.

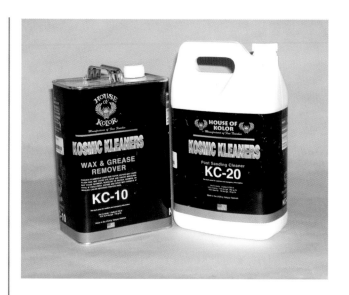

House of Kolor makes two cleaning products, the traditional wax and grease remover (KC-10) and a post sanding cleaner (KC-20). The KC-10 should be used prior to sanding or body work. The KC-20 is designed to remove sanding residue after sanding. Both products require an applicator cloth and a wipe off cloth.

You can't get a car too clean. Painting involves chemical reactions, and the best chemical experiments are done in sterile laboratories. Body shops generate a lot of dust, dirt, and assorted varieties of airborne debris. That's why they have spray booths, but even spray booths require constant cleaning. If you don't have access to a spray booth, the area where you paint needs to be as insulated as possible from the rest of your shop.

Cleanliness for painting involves both the vehicle and the location. Cleaning one and not the other is an invitation to dirt. Don't let poor prep work detract from an otherwise stunning flame job.

Getting and keeping a car clean can involve multiple cleanings. It's best to do a thorough cleaning before any bodywork or base painting is done. By cleaning a car before any sanding is done, you eliminate the chance of grinding contaminants into the surface where they may pop up later.

It's best to use the same brand of products throughout the entire paint and bodywork process if possible. House of Kolor is well known for its vivid colors, but it also has a complete line of primers, primer surfacers, and primer sealers. House of Kolor's KO-Seal II Primer Sealer comes in white, black, and metallic (silver) to better match the top coats.

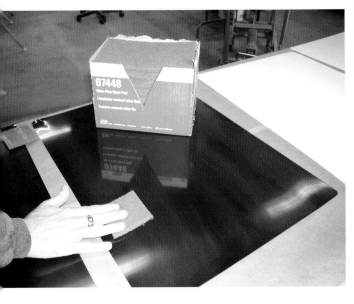

Most flame jobs only need a light scuffing with a gray 3M Scotch-Brite pad. The idea is to dull the glossy finish and provide some "tooth" for the paint to grip. The area should be wiped with a tack rag after scuffing.

Have a good supply of fresh tack rags on hand. They are cheap insurance for eliminating dust and debris from the surface about to be painted. Fluff the tack rag and turn it frequently as you wipe.

Cleaning the vehicle means eliminating all contaminants that could interact with the fresh paint. Silicone is painting enemy number one. That is why professional painters get so upset about cars that have been detailed with silicone-based products.

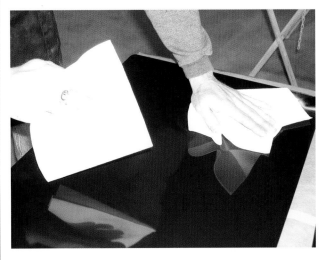

Wax and grease removers require two clean cloths, one to apply it and another to wipe off any residue. Many people make the mistake of only using a single cloth.

It's a good idea to wash the vehicle a couple times. Use soap that will remove wax. Remember to address areas like the inner wheel wells. You don't want caked-on dirt to get loose during the painting process. Even though areas such as the wheel well should be thoroughly masked, it doesn't hurt to start with them being as clean as possible.

A quality wax and grease remover is a must. Follow the instructions carefully. Many people think you can just slop on some wax and grease remover. Most wax and grease removers are a two-cloth process, one to apply the product and a clean one to wipe it off. Wax and grease remover evaporates quickly, but it still needs to be wiped off. Use several clean, lint-free cloths for wiping. Don't use shop rags that have been professionally cleaned, because they can retain chemicals.

An important note about wax and grease removers is that they should only be used before sanding or bodywork. Once a surface has been sanded, it should be cleaned with a water-based cleaner like House of Kolor Post Sanding Cleaner KC-20. Regular wax and grease removers such as KC-10 are solvent-based.

Blowing off the vehicle with compressed air is part of most painters' preparation process. Care needs to be taken that the compressed air is clean. You don't want to blow contaminants all over something you're trying to clean. Body shops use multiple filters to keep their air as clean as possible.

Blowing off a car will stir up dust. That's why tack rags are also an important part of surface prep. Tack rags are

inexpensive, so get several. Turn the tack rag frequently during use so a clean surface is exposed to the area being wiped.

Cleanliness extends to your person. Painters wear protective overalls to protect themselves and the paint job. That same dual purpose applies to wearing latex gloves. You don't want the natural oils in your hands to affect the surface.

If all this talk about cleanliness sounds a little paranoid, it probably is. There are cars that have been painted in dirt floor garages and yet they appeared on national magazine covers. Those cars required extensive wet sanding to eliminate all the debris that got in the paint. The point is that dirt can be dealt with, but why not save a lot of aggravation and start with a clean vehicle?

Product compatibility is a subject that's related to surface prep. Accomplished painters can mix and match almost anything, but using dissimilar brand products increases the chances of problems. The safest plan is to stick with one manufacturer from start to finish. That means using that manufacturer's body filler, primer, reducer, wax and grease remover, paint, and clear. Every time you eliminate a possible problem source, it increases your chances of getting a perfect flame job.

Curing time is another aspect of surface prep. The more time that can elapse between bodywork and paint, the better. You want to follow the manufacturers' recommended curing times and, if possible, exceed those recommendations. Hastily applied products with insufficient curing time can lead to underlying products bleeding through the top coats.

Since flames are usually done on top of other paint, surface prep outside of cleaning can be minimal. A light scuffing with a 3M Scotch-Brite gray scuff pad will provide enough "tooth" for the flame paint. The paint only needs to be scuffed enough that all traces of a shine are gone. You want the areas inside the flame design to be dull.

When using a scuff pad, take care not to damage the edges of the layout tape. You want the border of the flames to be scuffed, but not at the risk of leaving ragged tape edges. Blow off the area and wipe it with a tack rag.

A lot of this surface preparation may seem like overkill, but it isn't. Cleanliness is essential for a beautiful paint job.

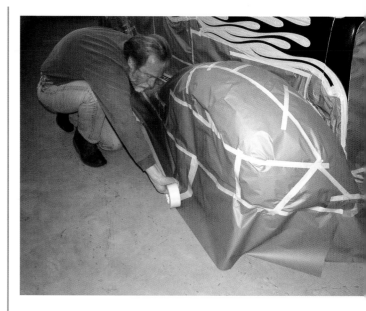

Besides thoroughly cleaning a car before paint, some painters go as far as taping the car to the spray booth floor. That protects the car from overspray and prevents any chassis dirt from escaping.

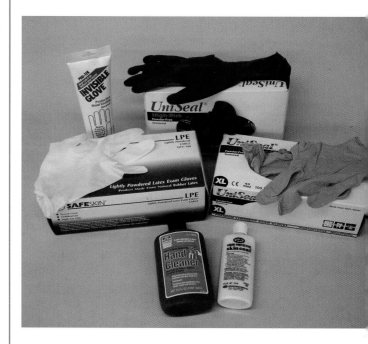

It's a good idea to protect your hands during the paint and body work process. Wearing disposable gloves also keeps the oils in your hands from reaching the painting surface. If you don't wear gloves, consider using a protective hand cream so cleaning your hands will be easier.

CHAPTER 4
TOOLS

Truly talented body men and painters can fix dents with a rock or paint a car with a bug sprayer, but the job is so much easier with the right tools. Most automotive enthusiasts are tool junkies, and it's easy to get carried away financially while buying the latest gadgets. Fortunately, custom flame painting can be done successfully with minimal tools.

Just how many tools you need depends on the level of flame painting you desire. If pinstripe flames are all you want, a couple inexpensive striping brushes will get the job done. You can buy a good striping brush for the price of a couple rolls of masking tape.

If you'd be content with some small accent flames or even the trendy realistic flames, you can get by with an airbrush

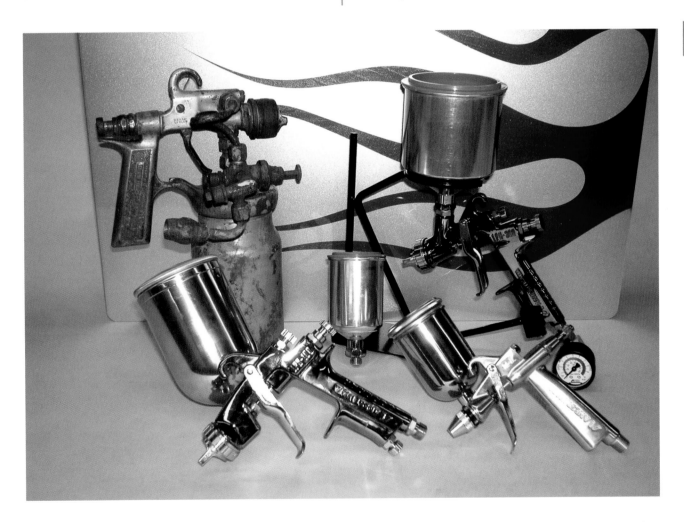

Modern spray guns are a vast improvement over the relic in the upper left corner. The precision HVLP Iwata spray guns are (clockwise from upper right) the gravity feed, center cup LPH-300 with a 400-milliliter paint cup; round pattern RG-3L with a 130-milliliter side feed cup; LPH-100 with a 400-milliliter side feed cup; and a spare 150-milliliter center post cup.

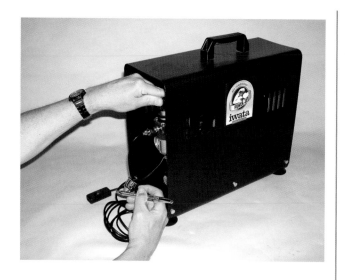

A good compressor is a must for spray painting. If all you do is airbrush work, this Iwata Power Jet IS-900 is an excellent choice. The lightweight, compact (16x13x7 inches) silent compressor has a built-in moisture filter, pressure regulator, and holding tank.

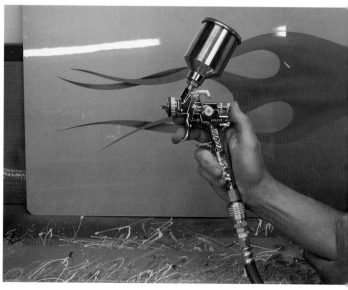

Compact, HVLP touchup-size spray guns are excellent for flame painting. This SATA Mini Jet 3 is one of three SATA HVLP guns in the Eastwood Company mail order catalog. The Mini Jet has a great "feel." The aluminum paint cups holds 150 cc (approximately 5 ounces). The gun requires 3.5 cubic feet per minute (cfm) at 29 psi of air pressure.

and a small compressor. A touchup spray gun and a full size compressor are much better, but you can do a lot of custom painting with an airbrush.

WHAT TO BUY

There is so much neat paint equipment available that choosing can be difficult. If you're new to custom painting, start out conservatively and add tools as you progress. You'll know more about what equipment you want as you practice. Talking to professionals will give you an idea of their gear preferences.

Even though it's recommended that you start out conservatively, don't buy the cheapest possible products. It's hard to go wrong with quality tools. Professional grade tools are high quality, but they're also designed for lots of use. Frequent usage isn't something a beginner needs to worry about.

Most companies market their products in various ranges. A good price/quality compromise is to buy the entry-level professional grade tool. Spray equipment requires precision manufacturing. There are lots of swap meet and bargain tool store products that may look like the name-brand tools, but they're not. We highly recommend buying established, name-brand tools.

The one item you should buy right away is a good quality spray mask. Don't cut corners on safety and your health. A good respirator is very affordable, so don't kid yourself into thinking a simple paper mask will suffice.

To paint flames you need some type of spray gun or airbrush and a reliable source of compressed air. The compressor needs to match the air requirements of the spray equipment. It's a good idea to have more air than the minimum requirement. You don't want a compressor that is always struggling to keep up. You want to complete the task without waiting for the air pressure to build up. Check the spray gun manufacturers' air requirements before you purchase a compressor.

You can buy tools at a variety of outlets. Paint and bodyshop supply stores carry excellent quality, professional grade tools, but they often carry professional grade price tags. General retailers like Sears and the chain home improvement stores have good selections of affordable compressors and some spray equipment. They tend to be better places to buy compressors than specialized spray guns and airbrushes.

There are lots of excellent mail order and Internet sources. A little time spent with a search engine should turn up lots of automotive and bodywork tool outlets. Many of these firms offer better prices than local walk-in stores. The benefit of local stores is that you can check out the tools before you buy and talk to a knowledgeable sales person.

A mail order firm that carries lots of specialized paint and restoration tools and supplies is the Eastwood Company

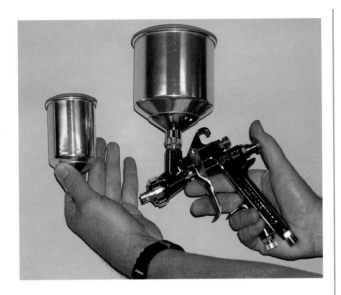

Having more than one size of paint cup increases the versatility of the Iwata LPH-300. The mounted cup holds 400 milliliters of paint. The smaller 150-milliliter cup is perfect for detail or touchup work. Both cups are aluminum, but Iwata also has plastic cups.

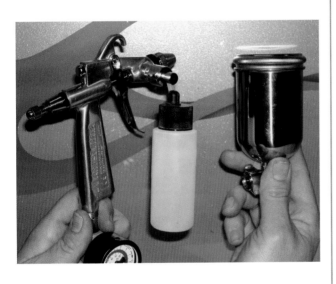

Iwata makes a trick little adapter for side feed HVLP spray guns that allows 2-ounce, slip-fit, airbrush bottles to be used in place of the usual aluminum 130-milliliter cup. The small plastic bottles are excellent for frequent color changes.

(www.eastwood.com). They carry a wide range of spray guns, touchup guns, airbrushes, airbrush compressors, safety equipment, body tools, welding equipment, pinstriping brushes, reference materials, and custom paint by House of Kolor and 1 Shot. Many of the products used in the how-to photos of this book came from Eastwood. Their free catalog is must-read material for any car enthusiast.

COMPRESSORS

If airbrushing is all you want to do, almost any compressor will suffice. If total repaint jobs are in store, you need a serious compressor. An all-purpose shop compressor is a good investment that will provide years of service. A heavy-duty shop compressor can supply air for painting and to power air tools for bodywork and general auto repairs.

Shop compressor prices vary greatly. Construction features of the more expensive ones justify their higher cost, but unless you're constantly running the compressor, the less expensive models should be fine. Ironically, a large stationary or roll-around shop compressor can cost less than a portable airbrush compressor.

There are several airbrush compressor designs. The most basic are known as diaphragm compressors. They're quite loud, they vibrate, and they generate heat. Heat leads to moisture buildup and you don't want moisture in your air lines. Diaphragm compressors don't put out a lot of pressure (usually around 30 psi), so they're best for limited hobby use. The best thing about diaphragm compressors is that they're very inexpensive. The noise can drive you crazy, though.

Another type of small airbrush compressor is known as the oilless compressor. It uses a piston instead of a diaphragm, so it can produce more air pressure than the diaphragm compressor. Oilless compressors are quieter than diaphragm compressors. They often have an air holding tank, which means less stress on the motor.

Silent compressors aren't totally silent, but compared to other small compressors their lack of noise of is pure bliss. Silent compressors are piston-powered, have air holding tanks, and come in a wide range of motor sizes, air output, and holding tank sizes. The biggest ones are designed for commercial artists such as custom T-shirt shops. The smaller models are ideal for advanced hobbyists and commercial airbrush artists.

An Iwata Studio Series Power Jet IS-900 silent compressor was used for several how-to features in this book. The Power Jet IS-900 is the top of a three-compressor line-up. The other two models are the Sprint Jet IS-800 and the Smart Jet IS-850.

The Iwata Power Jet is rated at 1/6 horsepower. That's small compared to full size compressors, but it still produces up to 60 psi. It has a 3.5-liter holding tank, an automatic shutoff, an inline moisture trap (very important), and a built-in pressure regulator. The Power Jet is encased in a protective metal shell with a convenient carrying handle. We were very impressed with the quiet, reliable performance of the Iwata Power Jet compressor.

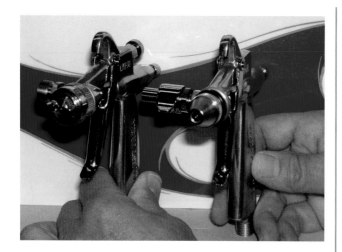

This comparison shot of the Iwata LPH-50 on the left and the RG-3L on the right shows the traditional fan nozzle versus the round pattern nozzle. The bodies of the two guns are very similar, but the unique round nozzle RG-3L makes it more like an oversized airbrush. It's great for shading inside curves of flames.

There are two styles of paint cups for airbrushes. This Iwata Eclipse HP-CS is a gravity feed model. The permanently attached paint cup is above the nozzle. This style of airbrush can be used one-handed with confidence.

The Iwata Eclipse HP-BCS siphon feed airbrush represents the more common style. The plastic or glass bottle uses a slip fit to secure it to the bottom of the airbrush. The connection is secure, but it's a good idea to support the bottle with your other hand.

SPRAY GUNS

Spray guns are a vital component of any flame job. They're a pretty complex subject, so we'll just cover the basics. If you paint for a living, it makes sense to study the subject in greater depth. Most companies offer comprehensive literature that explains the best uses for their different spray guns. For example, the Anest Iwata Company makes a line of spray guns and airbrushes that are favored by many pros. Their catalog and website (www.anestiwata.com) contain charts to help you match to spray gun to the job.

The type of spray gun you choose largely depends on whether you plan on doing total paint jobs or just flames. A production-style spray gun is necessary for total paint jobs. Some pros even use the big spray guns for fine, detail work. The guns can be adjusted to spray small patterns. Other pros favor the smaller detail guns for custom work such as flames.

A drawback of the touchup-size guns is the smaller paint cups. There are different size material cups for some versatility. Some touchup guns can be equipped with an adapter so that small, plastic airbrush paint bottles can be used.

During the production of this book, a couple of different touchup size spray guns were used. These guns are great for flames, because they hold enough paint to do a big section of the car without refilling, and they're small, lightweight, and easy to maneuver. They're easy on your wrist if you're not used to handling a big spray gun day in and day out.

Flame painting depends a lot on details. Touchup or minispray guns allow you to get in close to the work area. Some models, like the Iwata LPH-50, can be adjusted down to a 1/8-inch spray pattern. That's airbrush territory. The Iwata LPH-50 can also spray a 4-inch pattern. There are different nozzle sizes, which affect spray pattern widths. The LPH-50 requires only 1.8 cubic feet per minute (cfm) at 13 psi, so its low air consumption means it can be used with almost any compressor.

One common term that's relevant to spray guns is HVLP, which stands for high volume low pressure. This type of spray gun is mandated in many areas by the Environmental

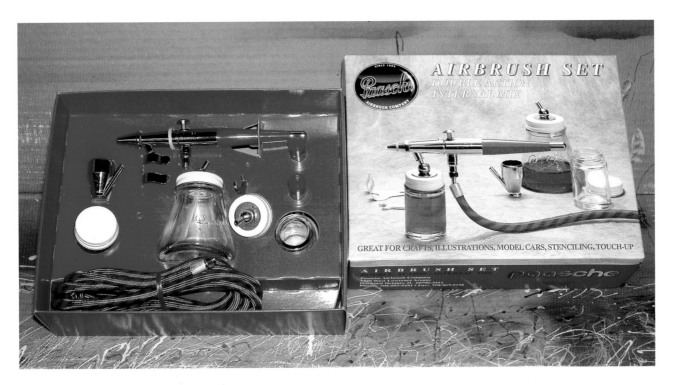

The Eastwood Company carries a wide range of name brand airbrushes and spray guns, including the Paasche VL kit. The kit includes the dual-action airbrush, three different size nozzles, three needles, a 3-ounce paint bottle, two 1-ounce bottles, a 1/4-ounce color cup, and six feet of compressor hose.

Protection Agency, because it produces less overspray than old, traditional spray guns. The Iwata HVLP spray guns carry the LPH designation.

Since HVLP spray guns have less overspray, they consume less paint. Saving the environment is a noble cause, but everyone responds to saving money. Given the high costs of paint in general, and custom paint in particular, any time you can save on materials is a good thing. Iwata claims its LPH spray guns save 20–30 percent over conventional spray guns.

The HVLP guns we used were all gravity feed. That means the paint cup is mounted above the nozzle. A benefit of gravity feed guns is that they will work with small amounts of paint and not spit. Spitting when the paint runs low can be a problem with siphon feed spray guns. Traditional siphon cup guns have the paint reservoir below the nozzle. Of the various Iwata spray guns we used, some had center mount paint cups and some had side mount cups.

A benefit of the side mount paint cups is that they can be rotated. This makes it easier to change from painting horizontally to vertically. A benefit of the center mount paint cups is their superior balance.

Side mount spray guns such as the Iwata LPH-50, LPH-100, and RG-3L can be fitted with a small adapter that allows a slip-fit plastic airbrush bottle to be used. The adapter threads in place of the side mount paint cup connector. This added versatility allows for quick and frequent color changes. You can have several plastic airbrush bottles filled with different colors and one with lacquer thinner. Run a little thinner through the nozzle between color changes. The airbrush bottle adapter is great for detailed graphics.

There are specialized spray guns that help keep heavy metallics, flakes, or pearls in suspension. The Iwata RG-3L that we used has a round pattern nozzle instead of the traditional fan pattern. The round nozzle makes the RG-3L the equivalent of a large airbrush. The RG-3L can produce a round pattern that varies from 1/8 inch to 2 1/2 inches. It's a great gun for shading curves on flame paint jobs.

Spray gun maintenance is vital to a good paint job. Always clean your equipment as soon as the job is completed. Guns are far easier to clean when the paint is still wet. Dried paint can clog the tiny internal passages and lead to disastrous results.

AIRBRUSHES

Airbrushes are miniature spray guns. They're very versatile and great fun. Once you get an airbrush and start playing around, you'll find it hard to put down. Airbrushes are a key tool for any type of custom painting.

Many professional flame painters rely on big production spray guns and touchup guns, because of their ability to lay down large amounts of paint quickly. They use airbrushes for detailed custom graphics. Whenever special effects such as unique textures within a flame lick are required, airbrushes are the tool of choice.

Airbrushes have their limitations, which is why many pros stick to the larger spray guns. Those limitations can actually be a good thing for beginners and hobbyists. Since airbrushes are so small and easy to handle, less experienced painters can have greater control with an airbrush than with a full-size spray gun. A task such as shading the inner curves of flames can be done gradually with an airbrush. A pro wouldn't waste the time, so they'd use a touchup gun. But, as a novice or do-it-yourself painter you don't have to account for your time.

Flames like the realistic flames in Chapter 9 require the use of airbrushes. The intricate detail of realistic flames is much easier to produce with an airbrush.

There is a wide range of airbrushes available for everything from simple model car painting to highly detailed illustrations and fine art. Prices range from a few dollars to many hundreds. The least-expensive models might work for kids or the most basic craft projects. You should expect to spend approximately $100 for an airbrush capable of automotive quality work. Airbrushes in the $100 to $300 range provide ample versatility and precision for custom painting. You can spend more, but those top-of-the-line models can be overkill.

The professionals we photographed during the production of this book favored the Iwata Eclipse airbrush series. They produced beautiful results with various Eclipse models. Iwata offers about two dozen different airbrushes in five series. The Eclipse series is the second least–expensive series, which shows that you don't need to spend a fortune to get professional results.

There are a couple main variations on airbrush design. The biggest difference is between single-action and double-action, referring to the control of the air and paint.

In a single-action airbrush, the control lever or trigger only moves up and down. When the finger pad is depressed, both air and paint are released. Single-action airbrushes are inexpensive and easy to use, but they're not recommended for automotive-quality work.

A double-action airbrush has both an up-and-down movement and a back-and-forth movement. Pressing the finger pad releases air. Pulling the finger pad back releases paint. As the trigger is pulled back, it retracts the internal airbrush needle. That makes the fluid nozzle opening larger,

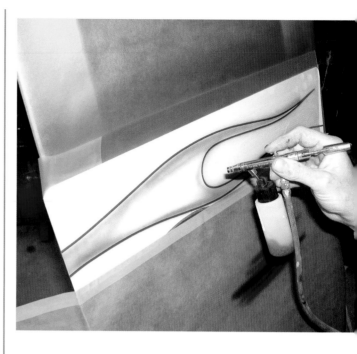

An airbrush like this Iwata Eclipse is fine for detail work, such as shading the edges of a flame lick. The airbrush allows a great deal of control, but it's a slow way to apply a lot of paint.

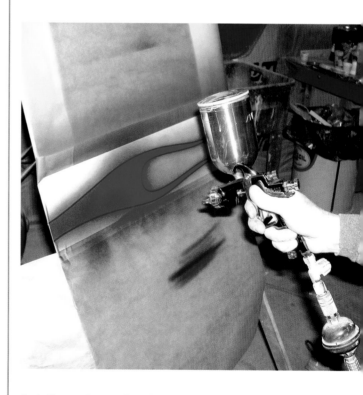

Travis Moore prefers a medium-size spray pattern like that produced by the Iwata LPH-100 for making color blends. This shot is of a test panel, but on a real car there might be several dozen blends. That would take far too much time with an airbrush.

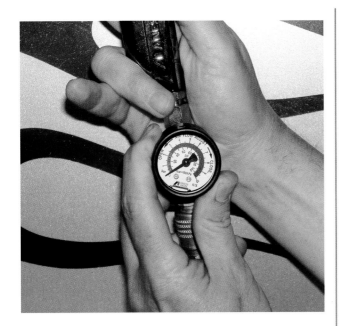

The ability to regulate air pressure at the gun is very helpful feature. Iwata has this clever dual-function regulator/gauge. Turning the dial to the right restricts airflow, while turning to the left increases airflow. The compact gauge fits easily at the base of any spray gun.

which releases a greater volume of paint. Double-action airbrushes give you the ability to carefully regulate the volumes of air and paint for precision control.

There are airbrushes that mix paint and air externally and internally. The most basic, single-action airbrushes are external mix units. The precision airbrushes use internal mixing.

Two other variables are the location of the paint cup (or bottle). There are top- or side-mounted gravity feed models and siphon feed models that place the paint bottle underneath the nozzle. The siphon feed airbrushes are more common for automotive work. The advantage of the bottle beneath the airbrush is that bottles can quickly be changed. Detailed airbrush work frequently involves repeated color changes, so this style airbrush is great for custom graphics. A wide array of plastic and glass paint bottles in sizes from less than an ounce to several ounces increases the versatility of siphon feed airbrushes.

The gravity feed airbrushes are more limited in the amount of paint that can be used at one time. An advantage of the top mounted paint reservoirs is the ability to use the airbrush single-handed. Bottom-mount paint bottles rely on friction to stay in place, so it's possible to dislodge the bottle. Spilled paint would be a disaster, so most painters use one hand to control the trigger and the other hand to support the bottle.

We used an Iwata Eclipse HP-BCS siphon feed airbrush, Iwata Eclipse HP-CS gravity feed model, and a Paasche VL siphon feed airbrush. We preferred the quick-change capabilities of the siphon feed units, but the ability to use the Eclipse HP-CS single-handed was also great. The Paasche VL came with slip-fit 1- and 3-ounce bottles, plus a 1/4-ounce metal "thimble" cup. The tiny color cup made the VL almost like a top cup model, but 1/4 ounce isn't much paint.

OTHER TOOLS

Compressors, spray guns, and airbrushes are the big three of flame painting. Safety gear is extremely important, but not everyone considers respirators, face masks, supplied air systems, eye protection, paint suits, and gloves as tools. It doesn't matter how you classify safety gear, just make sure you use it.

Respirators or spray masks are the most important piece of safety gear. Professional quality respirators can be had for under $50. Full-face masks are more expensive, but they offer the benefit of eye protection along with the respirator. Isocyanates can enter your body through your eyes or any other mucous membrane.

The best choices for respirators are supplied-air systems. These systems provide fresh outside air. Prices for these systems, once the domain of professional painters, have dropped to where they are affordable for hobbyists. The Eastwood Company carries supplied-air systems as well as traditional respirators.

Supplied-air systems come with their own small compressor or use special filters so the shop compressor can be used. When using the stand-alone compressor, be sure it can draw air from a clean source. If the compressor picks up the contaminated shop air, it's just supplying you with bad air.

Respirators are only effective if you consistently wear them. Too many painters own respirators and don't use them. The mask should fit snugly to your face. Good respirators have adjustment straps and over-the-head harnesses to keep the mask in position.

The filter cartridges in respirators are replaceable and should be replaced according to the manufacturer's directions. The effectiveness of the cartridges depends on the quantity of paint fumes they filter. Replacement cartridges are very inexpensive, so don't skimp on using fresh ones.

The more complex the paint is, the more likely it is to be toxic. Products that use catalysts can be very nasty. The chemicals are essentially making a plasticized product. If the paint dries to a rock-hard finish on your car's body, it can do the same thing to your body. When using catalyzed

paints and clears, your hands, face, eyes, and all skin surfaces need to be protected.

You can buy single-use, disposable paint overalls, or you can spend more and get washable ones. Protective gloves are a good idea any time you handle paint products, catalyzed or not, as are head socks that protect your head and hair. Hand creams that dry to a protective coating make cleanup much easier.

Fire safety equipment is another must-have category. Paint is highly flammable, and it doesn't take much of a spark to cause a serious problem. Class A/B fire extinguishers (for common combustibles and flammable liquids) should be mounted within easy reach. The extinguishers should be wall-mounted, not just sitting on the floor. Fire safety includes keeping the shop free of combustible debris, keeping paint cans sealed (preferably in an approved fireproof cabinet), and not smoking in the area.

Painting generates a fair amount of waste paint and solvent products. These hazardous materials need to be safely collected and properly disposed of. Professional shops have services that remove and recycle waste solvents. Your local regulatory agencies can tell you how to properly dispose of old chemical products. Often, solid waste facilities can handle toxic liquids as well. Never put paint products down any drain or into a septic system.

Air regulation and purity are two areas closely related to compressors and spray guns. One or more moisture filters should be located between the compressor and the spray gun or airbrush. Most painters use big air filters (sometimes known as oil separators) downstream of the spray gun and some type of smaller inline filter at the base of the gun.

Air pressure can be regulated at the compressor, but it's also good to measure and regulate it at the spray gun. Depending on your compressor setup, and the diameter and length of the air hose, air pressure can drop considerably by the time it reaches the spray gun. Having a regulator at the gun aids in making accurate adjustments.

Paint should be filtered (or strained) at every stage, from pouring it out of the can, to mixing, to loading the paint cup. Special stands make straining easier. HVLP guns with gravity feed paint cups won't rest on a workbench like old-fashioned siphon feed guns. The Eastwood Company has a slick paint gun stand that also functions as a holder for paint strainers.

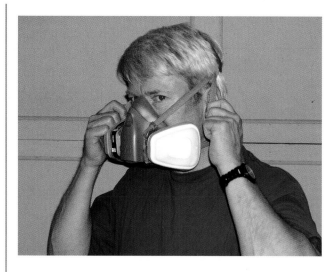

A high-quality respirator is the most important tool investment you can make. Be sure that the mask filters are designed for the type of paint you expect to use. This Pro Respirator came from the Eastwood Company's mail order catalog. Straps on each side make it easy to get a snug fit.

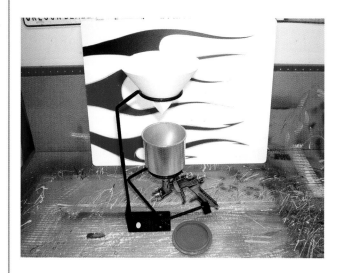

Sometimes it's the simple little tools that make your day. This combination spray gun and strainer holder from the Eastwood Company costs about $15. Guns like the HVLP Iwata LPH-300 need a stand, because they won't stand on their own. The strainer holder swivels and is removable.

CHAPTER 5
TOOL TECHNIQUES

Practice and experimentation are the best ways to learn how to use spray equipment. The practice, practice, practice mantra might be getting old, but it's the truth. We've never met a custom painter who simply picked up a spray gun and shot show-quality paint jobs the first time he pulled the trigger.

A prime benefit of practicing is to get to the point where the spray gun or airbrush becomes an extension of your imagination, eyes, and hands. Instead of being some mechanical device that you have to worry about, you can concentrate on your artistic vision.

That goes back to the basic design concept behind flames—smooth flowing kinetic energy. Forgive us if this sounds like some "Zen and the Art of Flames" treatise, but good custom painters transcend "blow and glow" production

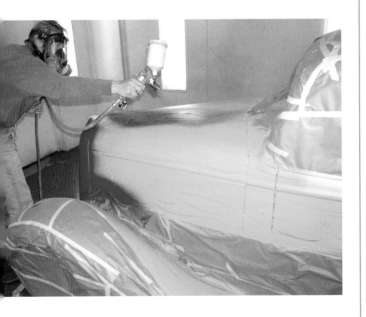

Proper spray gun techniques are important for the best paint application. Consult the paint company's directions for optimum distance between the nozzle and the surface. The nozzle should be parallel to the surface so the entire width of the spray pattern makes consistent contact with the surface. The paint in this photo is being applied to the roll of the hood, so the spray gun might look a little tilted. Always be aware of the air hose, so it doesn't contact the wet paint.

painters. Everything about their work flows. If you're constantly worrying about the functioning of your equipment, it's tough to flow.

Besides practicing on your own, you could take some vocational technical classes related to automotive painting. Many cities have these classes at community colleges or vocational schools or as continuing education classes. These classes will teach you the fundamentals of painting. When the fundamentals are second nature, it's easier to focus on the creative side of custom painting.

SPRAY GUN BASICS

Wrist and arm control are the primary things to master with spray guns. The goal is to maintain a robotlike consistency in the rate of paint application, the pattern size, amount of overlap, and nozzle distance from the surface being painted. Whenever your arm wavers, you risk getting uneven paint application, or worse. If you get too close to the surface, runs are very likely. If you get too far away, the paint dries before it hits the metal, leaving very rough, coarse paint.

If you tip the top of the spray gun in toward the surface, the paint will be wetter at the top of the pattern and drier at the bottom. That can lead to streaking. Keeping the nozzle parallel to the surface is important with any paint, but especially important with candies.

The importance of spray gun control is emphasized in the House of Kolor Tech Manual, which gives specific instructions for shooting candy paints. An uneven candy paint job is a sign of an inexperienced painter, and it's ugly.

Spraying consistent patterns ensures uniform paint coverage. Paint manufacturers specify how much overlap for each type of paint. In general, each pass should overlap the previous one by 50 percent, but with pearls and the first two or three coats of candy paints, a 75 percent overlap is usually recommended.

You don't want to arc or swing the spray gun. That produces uneven coverage. You also need to practice starting and stopping each pass. The idea is to start the airflow before you reach the panel and ease into the paint by continuing to pull back on the trigger. The way you adjust the

fluid control knob determines how much material is released. If you start spraying right at the edge of the panel there is a good chance of extra paint being deposited there. The same goes for stopping at the end of the pass. There needs to be a little lead-in and follow-through.

In addition to maintaining a uniform distance from the surface, you need to move along the car at a consistent rate. The whole front-to-back distance should be covered with one nonstop pass. Don't paint one panel and then proceed to the next one. With flames, spray the entire length that is receiving a particular color.

Obtaining this uniform, nonstop pass often means walking the length of the vehicle. Don't stand in one spot and stretch the spray gun. Walking while spraying involves more coordination than painting a small item that you can cover by moving your arm back and forth.

Your spray gun should come with specific instructions for making adjustments. Generally speaking, there are two adjustment knobs. The knob that is in a straight line with the nozzle is material adjustment. It controls how much paint (volume) flows out of the paint cup. Limiting the amount of paint volume will constrict the pattern width.

The other knob, which is usually the top one, controls the amount of air that reaches the nozzle horns. The horns are the two protruding parts. There are two small holes in each horn where the air exits. When the trigger is pulled back, the fluid needle is retracted. How far the needle is retracted controls how much paint is released. The paint goes past the needle to the hole in the center of the nozzle (or air cap), where it meets the air from the nozzle horns. The result is atomized paint.

The fan pattern should be determined and adjusted before applying any paint to the car. Use a test panel or a section of masking paper taped to a wall to adjust the fan pattern. In general, most paint and spray gun manufacturers suggest being in the 4- to 8-inch range from the surface. The ideal is to get as close as possible without causing runs. Closeness gets more paint on the surface instead of being wasted as overspray.

Use and adjustments for touchup or minispray guns such as the Iwata LPH-50 or the SATA Mini Jet 3 are the same as the full-size spray guns. These guns spray smaller patterns, but they're essentially compact versions of production spray guns.

AIRBRUSH BASICS

Airbrushes are the other main tool used in flame painting. The general concepts of mixing paint and air so it atomizes and is easy to apply are the same for airbrushes as spray guns. The size and locations of the controls are different.

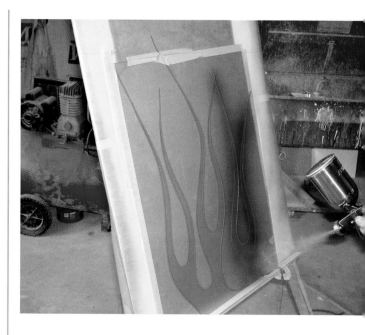

A common tendency is to tip the top of the spray gun a little closer to the surface than what would be perfectly parallel. The position of the movable paint cup on this Iwata LPH-100 makes the gun position appear more tipped than it really is. Painting low areas makes it more difficult to maintain the ideal spray gun position.

Most spray guns have two main adjustment knobs. The knob that is in a straight line with the nozzle of this Iwata LPH-300 is for material or paint adjustment. It controls the flow of paint from the paint cup. When paint flow is reduced, it also reduces the pattern size. The upper knob is the air control. It regulates the amount of air going to the air horns on each side of the nozzle or air cap.

There are many exercises designed to increase your skill with an airbrush. One drill is to make a series of lines, as straight as possible, back and forth on a sketchpad. Water-based paint works fine for practicing. As long as you're confident that the paint bottleneck is securely pushed into the airbrush, you don't need to support the bottle, although supporting it can improve control.

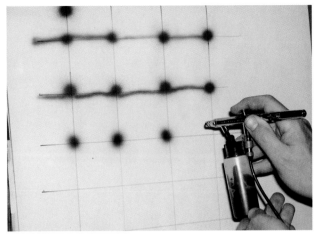

Draw a grid with a pencil and then strive for accuracy as you try to place a dot at the precise intersections of the lines. Once you're satisfied with your accuracy, try speeding things up.

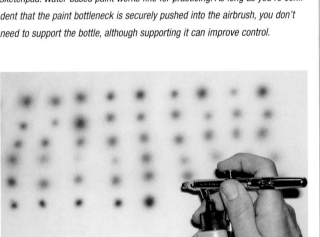

Another airbrush exercise is to make rows of dots. These dots can be the same size, or you can alternate between small and large. You can also do gradual size increases and decreases. These dots appear blurry, because they diffuse some when the paint hits the newsprint.

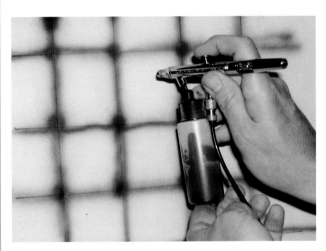

You can use the same grid with the dots to practice connecting lines. Try to get the lines straight and a uniform width. This is tougher than it looks.

Consult the instructions that come with your airbrush for specific recommendations. Both the Iwata Eclipse HP-BCS airbrush kit and the Paasche VL airbrush kit used in the how-to photos came with instruction booklets and basic airbrush lessons.

One problem with airbrushes is that they're much more delicate than spray guns. Too much adjusting (or fiddling) can do more harm than good. These airbrushes tend to be set up just about perfectly as they come out of the box. The fluid needles are particularly delicate. It can also be difficult to reassemble the tiny levers and springs if you loosen something too much.

The most important adjustment with airbrushes is cleanliness. Their tiny passages easily clog with dry paint. A clean airbrush is one that works correctly when you need it.

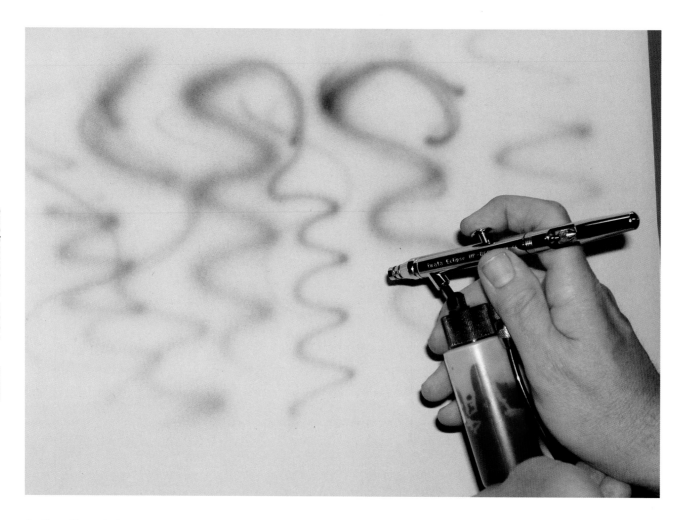

Practice making squiggles, circles, loops, and other random shapes. Using an airbrush is fun, so play around with it. Advanced exercises involve shading objects to make them appear three-dimensional. We used an Iwata Eclipse HP-BCS airbrush for these demonstrations.

Since airbrushes apply very little paint at one time, there is less risk of the paint running. The paint can be built up with a number of relatively thin passes. Control is still a highly desirable trait, but beginners have a little more leeway with an airbrush. The more detailed the airbrush work you desire, the more control you will need.

A good way to gain control with an airbrush is to do practice exercises on a big tablet of sketch paper. It can be almost any paper, but those big 18x24-inch (or bigger) art class sketchpads work well. The least expensive newsprint is fine, since you're just practicing and discarding the paper. Some inexpensive, water-based paint will work fine for practicing. The Iwata Eclipse airbrush kit includes some suitable paint.

Besides practicing on big pads of paper, it's also a good idea to practice on less-porous surfaces. You won't be painting flames on paper cars, so after you get comfortable with the basic techniques, try them on metal. You can get inexpensive, prepainted steel or aluminum sign blanks. By using water-based paint, you can practice airbrushing and then wipe the sign clean to use it again.

Line control and accuracy are two important skills. Distance from the surface affects the thickness and crispness of a line. The farther away the nozzle is, the wider and softer the line will be. Conversely, the closer the nozzle is, the thinner and more refined the lines will be. Practice making different size lines. Use the airbrush in both directions. You need to be as comfortable working from the left as the right. The same goes for up and down movements.

When practicing lines, notice the difference it makes when the trigger is pulled all the way back compared to partially back. The farther back the trigger goes, the greater the volume of paint. You need to be so familiar with the way the airbrush works that you don't have to think about where the trigger is.

Airbrush cleaning is essential for proper functioning. The airbrush needs to be cleaned every time a color change is made. Spraying solvent into a rag placed over the nozzle will force the solvent back through the airbrush and into the paint bottle. The appearance of bubbles indicates back flushing.

Lacquer thinner is a commonly used solvent for cleaning airbrushes that spray automotive paints, or you might use a special airbrush cleaning solution. A small bottle of cleaner fluid came with our Iwata Eclipse HP-BCS airbrush kit. Water-based paints can be cleaned with distilled water.

During the back-and-forth line exercises, pay particular attention to the line ends. You don't want excess paint. The goal is for the lines to be consistent from end to end.

Learning when and how to release the paint is part of getting consistent lines. A dual-action airbrush should be used for all these exercises. Push down on the trigger first. That releases the air. Then slowly pull back on the trigger to release the paint. The opposite is true when ending a line. If you start the paint first and then give it a blast of air, you'll get a big splotch of paint. It's the same as with a spray gun; the air is the first thing on and the last thing off for every pass.

Dots are another exercise. Practice placing random dots on the paper and then try to place them in specific locations. Try to keep the dot size consistent. Then try to go from small to large and back down to small dots, or alternate large and small ones.

Target practice is a way to increase accuracy. Take a pencil and a ruler and make various size grids on the paper. At each intersection, try to make a small dot right on the cross. After you've placed the dots, the same page can be used to connect the dots. Try to make smooth, uniform lines between the dots. This is more difficult than it sounds, but it's the kind of practice you need to master an airbrush.

You can also draw circles, loops, and squiggles to get the feel for airbrush control. Many books on airbrush techniques have exercises on shading balls and boxes. That takes considerable practice, and it's probably more skill than you need for basic flame painting.

Another thing to practice is your body position and the way you hold the airbrush. You may do fine with one hand or you may feel more secure if you use your free hand to support the bottom of the bottle or even the bottom of your airbrush hand. If you practice moving smoothly over relatively long distances, that will make it easier to do things like shading the inner edges of flames. When you're shading with an airbrush, you want the paint to look as if it was applied in one fluid motion. You don't want a bunch of starts and stops.

One aspect of airbrushing is similar to driving quickly on a twisty road or even snow skiing. The idea is to look ahead and plan where you're going. Don't worry so much about where you are right now, but look ahead. Where you look is where you will go. One term for this technique is optical leading. It's another aspect of obtaining the all-important flow to your painting.

Speed is another airbrush technique to master. When you're in the zone and everything is flowing well, it's easier to go quickly than slowly. When you paint slowly, you're more apt to be jerky. That leads to starts and stops, which

Few people have a different airbrush for every color. Some pros and people like T-shirt artists have multiple airbrushes so they can quickly jump between many colors. This airbrush rack was made by using a hole saw to make bottle-sized holes in a length of PVC pipe.

leave obvious marks on whatever you're painting. Confidence is a big component of speed. It all gets back to lots and lots of practice.

TEST PANELS

Test panels are good for practicing airbrush techniques, but they're even better for determining what colors and other elements you want in a flame job. You can look at paint chips and open cans of paint all you want, but you'll never know exactly how a particular color will look until it's sprayed on metal.

Professional painters make good use of test panels so they can get final customer approval before they enter the

spray booth. Some painters cut their own sheets of metal and others use preprimed sign blanks. Others use old hoods or fenders.

Another benefit of spraying a test panel is that it can be taken outside in natural light. Shop lighting or spray booth lighting can give a false sense of the way the paint will look out in the real world. Few cars spend all their time under fluorescent lights.

Flat test panels are easier to deal with, but ones with curves do a far more accurate job of showing how the paint will look on a car. Cars and trucks have lots of curves. How sunlight hits those curves and high spots is very important when spraying custom paints such as candies and pearls.

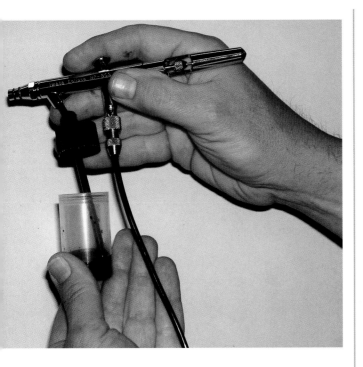

Spare plastic airbrush bottles only cost a couple dollars, but sometimes painters just need a very small amount of a color. A common trick is to put the paint in a tiny paper drinking cup. Another option is to use empty 35-millimeter film canisters. You can even snap the canister lid back on to keep the paint fresh longer. The top and pickup tube from a regular airbrush bottle must be used to siphon the paint from the canister.

Some painters have sheet metal bent with a slight curve and others use old fenders. Old VW Beetle fenders make good test panels because they're reasonably sized and have plenty of curved surfaces.

The type of paint used on test panels depends on whether the panel is for technique practice or for choosing colors. If the purpose is to compare colors, you need to use the actual paint. If it's just practice painting, use the cheapest stuff you can find. The "house brand" or generic paint is fine. Ask your local paint store what their cheapest brand and color of paint is. Sometimes you can get good deals on cans of custom-mixed colors that weren't picked up. This stuff is virtually worthless to the paint store, so ask about it.

CLEANING

Cleanliness is right up there with lots of practice, as far as traits that will go a long way toward making you a successful painter. You can't have the vehicle surface too clean, nor can you have the shop too clean. Likewise, keeping your equipment clean is critical if you hope to obtain optimum performance every time you use a spray gun or airbrush.

First-rate equipment means taking the extra time and effort to clean up every time you put paint in a spray gun or airbrush. That can take discipline because you need to clean up as soon as you're through spraying. Waiting even an hour can lead to dried paint and that will almost assuredly cause problems the next time you use the equipment. Paint is easiest to remove when it's fresh.

Professional bodyshops have special pressurized spray gun cleaning tanks that force solvent through the gun assemblies. They thoroughly clean the spray gun while keeping all the solvents contained.

Do-it-yourself painters have to clean spray guns the old fashioned way. Consult the instructions that come with the gun and the paint. Some paint systems have specific suggestions for cleanup chores. Since paint products are so expensive, you want to use the least expensive solvent that still cleans well.

You will use quite a bit of solvent during the cleanup process. You need a safe waste container in which to dump the dirty solvent. Do not put any solvents or paint products down the drain or onto the ground. Most communities have a waste management department and/or an official transfer station/dump. These facilities are either equipped to handle hazardous waste or they can direct you to an appropriate facility.

The first step is to swish solvent around in the paint cup. Then discard most of that solvent. Take the small amount left in the cup and wipe the insides of the cup with a rag. Add more solvent and spray it through the gun. Some painters like to place a rag over the nozzle to "back flush" the gun. When the trigger is pulled, the rag prevents the air and solvent from escaping and forces it back down the paint tube. This technique works best on siphon paint cups.

The cup should be wiped again and a little more fresh solvent sprayed. You want the solvent to spray clear without any trace of color. Then use clean solvent on a rag to clean the nozzle or air cap. Special spray gun cleaning brushes will clean the nozzles without harming them. Don't try to clear blocked nozzle passages with a sharp object such as a piece of wire. Even a tiny scratch can affect the performance of the spray gun. Those small passages were machined to specific tolerances in order to make the spray gun function properly.

You can soak the nozzle in a small container of solvent. After you're through cleaning the spray gun, dry it with compressed air. You don't want solvent or anything else left in the passages.

Airbrush cleaning is similar to spray gun cleaning, except that everything is smaller and much more likely to clog.

Even a small amount of dry paint can cause nasty splattering and sputtering the next time you spray.

Another difference with an airbrush is the often-frequent color changes. Some painters use a different airbrush for each color, but that's excessive. The airbrush needs to be cleaned every time you change colors. A way to do this is with an extra plastic bottle filled with paint thinner, or one of the specialty airbrush cleaning fluids. Each time there's a color change, slip on the solvent bottle for cleaning before picking up the next color.

Dry paint can build up on the airbrush nozzle while you're painting. A clean cloth dipped in solvent can be kept close by to periodically wipe away the dry paint. Since airbrush nozzles are so small, it doesn't take much paint buildup to interfere with the pattern of the paint being sprayed. Clean equipment will make painting much easier.

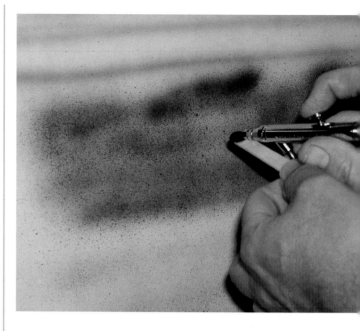

Many custom tricks can be accomplished with an airbrush. A way to make a splattered texture is to place a wooden Popsicle stick or tongue depressor at the edge of the nozzle as you apply paint. You can also deposit some paint on the end of the stick, position it against the nozzle, and then blow air with no more paint (or very little paint). The air against the paint on the end of the stick will make a stonelike texture.

Test panels are an important "tool." Professional painters regularly use pieces of aluminum or steel, or pre-made sign blanks, for customer approval of color and style before the job starts. Old fenders make good test panels, because they have curved surfaces. VW Beetle fenders work very well.

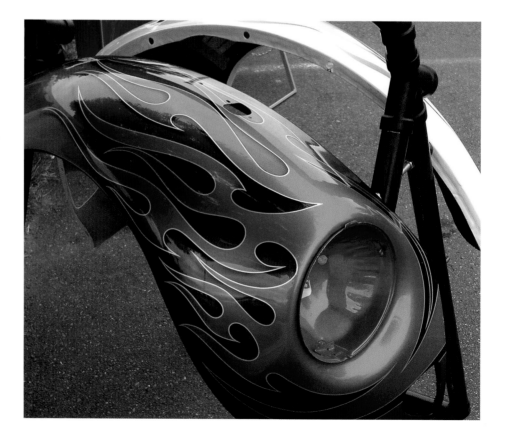

CHAPTER 6
PAINT PRODUCTS

A doctorate in chemistry would come in handy if you wanted to fully understand the intricacies of modern automotive paints. Barring that level of education, the easy answer to how today's complex paints work is: They work. What more do you really need to know?

Huge, highly successful international companies hire very intelligent people who understand everything about paint. These talented individuals do all the serious thinking, so you don't have to.

Probably the most important thing you should know is the value of sticking with one company's system. That's the best advice for avoiding problems. Paint companies design all their products to work well together. It is possible to mix and match brands, but why take unnecessary chances?

The use of a single company's products is called a system. The number of major players in the automotive refinishing

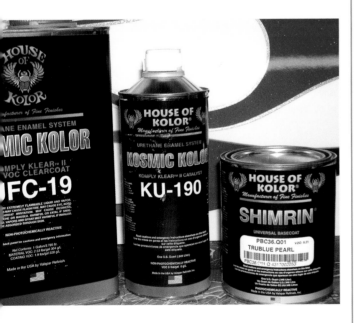

Base-coat/clear-coat paint systems include the base, which is the color, and the clear, which provides the shine. The House of Kolor Shimrin system is an example; there are three products shown here, because the KU-190 catalyst is needed to activate the UFC-19 Komply Klear II clear coat. Shimrin Trublue Pearl (PBC-36) is the base coat color.

field isn't very large, and even fewer companies specialize in custom paints. This makes it pretty simple to determine which system works best for you.

Professional painters and bodyshop owners have their favorites, but if you pay careful attention, you will see that brand loyalties often change. These loyalties can be as much about the sales rep or local distributor and the various deals they offer for switching brands as the merits of the actual paint. Like so much about custom painting, paint selection often is a matter of experimentation and practice.

A second key to avoiding problems is to read and follow directions. That may sound overly simple, but too many people either don't read the company-supplied instructions, or they don't follow them to the letter. All those smart scientists spent huge amounts of time and effort to formulate those directions. Don't try to second-guess the experts. Don't try to save time by not following all the instructions. Any small time savings up front can easily be lost if a problem occurs.

Paint companies publish technical information about their products. These publications tell which of their products can be used with each other. They also specify things like the best reducers to use for varying temperatures, reduction ratios, time between coats, and suggestions for clear coats.

Paint supply stores have tech sheets for the paints they sell. The stores want you to be well informed. Ask the counter people if you have any questions. They want you to succeed, because they don't want to hear from you if something goes wrong. The staff at your paint supply store is a valuable resource, so use it.

Since the subject of this book is flames, and flames are painted over an already existing base coat, we can skip talking about primers and primer/surfacers. Bodywork and preliminary painting should be done before you even think about adding flames. An excellent book about basic paint and bodywork is *How To Paint Your Car* by Dennis W. Parks and David H. Jacobs, Jr. The book is part of the Motorbooks Workshop Series and published by Motorbooks International, St. Paul, Minnesota.

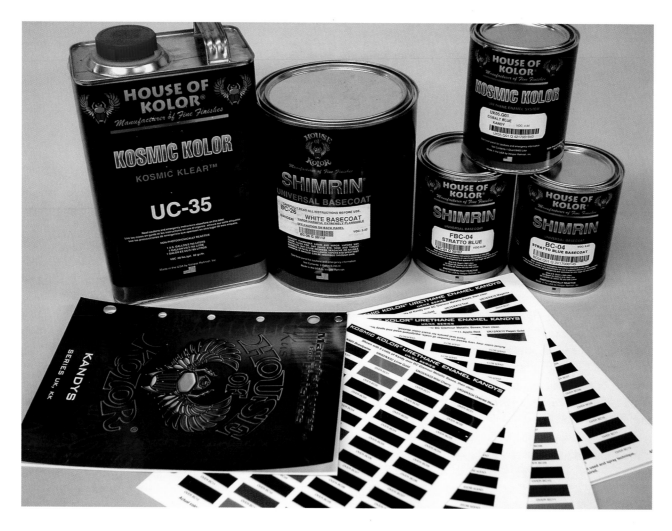

A tricoat or three-stage paint system consists of a base, a candy, and a clear. The base color is very important, because it shows through the candy coats. White is a common base coat, but for Cobalt Blue Kandy (UK-05) a Stratto Blue base coat will give an intense blue. The Stratto Blue is available in two degrees of metallic. The BC series is coarser and the FBC has finer metallics. Color charts give an idea of how various base coats affect the final color, but to be truly appreciated, the colors must be seen in sunlight.

PAINT BASICS

Paint consists of pigments, binders, and solvents. Pigments are the color; binders, also known as resins, hold the pigments together; and solvents are the carriers that allow pigments to be sprayed. Solvents are pretty much dissipated by the time the pigment reaches metal or shortly after.

The role of solvents is to get the pigment and binder from the paint cup to the vehicle surface. When the solvent evaporates, the pigment and binder harden into sheets of color that stick well to properly prepped metal.

Solvents can be thinners or reducers. Thinners are for lacquer products, which aren't as prevalent as they once were. Lacquer paint is rapidly becoming a thing of the past due to its high volatile organic compound (VOC) content.

Reducers are for enamel products and are by far the most common solvents.

Reducers are designed to work best within set temperature ranges. That's why there are fast, slow, and medium temperature reducers. The colder the spraying conditions, the faster the reducer needs to be and vice versa. Some paints need to be sprayed within a specific temperature zone, so that consideration is the most important. The temperature range of the reducer is used to fine tune for conditions.

Acrylic is a word you'll encounter when discussing paint. Acrylic stands for plastic, as in acrylic plastic. The acrylic in paints improves durability. Urethane is another common term. Urethane (or polyurethane as it's also known) paint is very durable.

A neat thing about the House of Kolor Shimrin Metallic Bases, such as this Solar Gold (BC-01), is that they can be cleared for a wild final finish or be used as a base coat for candy colors. All paints should be thoroughly stirred and strained before using. The high metallic content is evident by the sparkle on the mixing stick.

The test panel behind a selection of House of Kolor base coats was sprayed with Solar Gold. The base coat was used underneath the Tangelo Pearl flames and as the surrounding color. That illustrates the great versatility of the HOK base coats.

HOK Shimrin Pearl Bases such as this beautiful Lime Time Pearl (PBC-38) can also be cleared and used as a final color or used as a base for candies. Gold, silver, and white base coats have more latitude as to which top coats can be applied over them, but bases like Lime Time can be used with various green or blue candies to create some truly wild greens.

Urethane paints have many positive characteristics. They are very durable, but easy to use and apply. Urethane paints use a catalyst to provide their famous durability. The downside is that these catalysts use isocyanates, which can be very harmful to your health. That's why safety issues are so important.

VOLATILE ORGANIC COMPOUNDS

Volatile organic compounds, or VOCs, are the byproducts of overspray and solvent evaporation. The Environmental Protection Agency wants to limit the amount of VOCs released into the atmosphere. That's why bodyshops now have enclosed gun-cleaning tanks instead of just shooting the cleaning solvents into the atmosphere.

VOCs are behind modern spray booths and HVLP (high volume low pressure) spray guns. Anything that will reduce overspray helps reduce the amount of VOCs in the air. A motivating factor for developing water-borne paints (instead of solvent-borne) is the reduction of VOCs.

STAGES

Paint systems can be referenced by stages. There are single-, two-, and three-stage systems. The terms "base coat/clear coat" and "tristage" are also used.

A single-stage paint is one, such as a single-stage urethane, that will cover well with two or three coats of a single product. These products are pretty much "blow and glow"—painter's slang for a quick enamel paint job that doesn't

All paint products, regardless of type or color, should be thoroughly strained at every stage of the paint job.

House of Kolor offers the same colors in a variety of products. For example, its wild Burple (a bluish purple) can be had as a Kosmic Urethane Kandy (UK-13), a Kandy Koncentrate Intensifier (KK-13), and a Shimrin Kandy (KBC-13), as shown from left to right.

Kandy Koncentrates are small containers of superconcentrated candy paint. The HOK Kandy Koncentrates can be used to boost or alter the color of regular HOK Kandy paints. They can also be added to Intercoat Clear for use in graphics and airbrush work.

require any postspray work. You blow (spray) on the paint and it glows (shines) immediately. Or "apply, dry, and fly." They don't require extensive postpaint work to get a finished shine.

A big downside to single-stage paints is that since they don't require sanding and buffing, any debris that gets in the paint is pretty much there to stay. That's why state-of-the-art spray booths are the best place to apply single-stage paints.

Base-coat/clear-coat systems are very common. The color is applied in the first step and the shine comes from step two, when the clear is applied. Wet sanding and buffing complete the process.

Candy paints are an example of tristage paint systems. A base coat, usually gold, silver, or white, is applied first. Then the transparent color coats are added. The number of coats determines the intensity of the color. A clear top coat protects everything.

Three-stage systems like candy colors are very common in flame painting. Besides the basic three base coats of gold, silver, and white, lots of other bases can be used. House of Kolor has an extensive line-up of base coat colors. The large number of base colors and candies makes for an almost unlimited array of final colors.

PAINT FOR FLAMES

You could paint flames with latex house paint if you so desired. Some fine flames have been done with a different shade of primer over a primer base. Flames can be painted with everything from simple striping enamel to the wildest $2,000-a-gallon color shifting paint.

Many of the flames in this book were painted with normal base-coat/clear-coat paints. The colors selected were often pure mixing colors instead of a color formulated for a specific year and model vehicle. The mixing colors tend to be very pure versions of a color and therefore very bright. Bold, bright reds, yellows, and oranges are a mainstay of traditional flames.

House of Kolor Marblizer is called an artistic base. It's sprayed over another color and manipulated while it's still wet. Plastic food wrap is the most common item used to give a wrinkled, veined look to the underlying paint. Inexpensive metal utility brushes can be used to draw designs in the wet Marblizer.

Experienced painters are adept at blending base colors for their own special shades. That isn't a good idea for beginners. It's too easy to make mud, and even if you get a great color, you need to be able to match it later for touchups. Sometimes adding a small amount of black or white paint can make a significant change. If you want to experiment with mixing colors, start with affordable striping paints.

One Shot striping enamel makes a black and white just for tinting. Professional pinstripers often tweak colors to get that just-right match. An assortment of 1 Shot colors and some small paper drinking cups is all you need to practice making custom colors.

CUSTOM COLORS

As great as the traditional yellow-orange-red combination is, modern painters love custom colors. Even people who use the basic trio often do customized variants of those colors. Explaining everything there is to know about custom paints could be a book in itself. Suffice to say, the choices are incredible, and the results are even better.

Throughout the production of this book, many House Of Kolor products were used. HOK is a leading manufacturer in the custom paint industry. Custom paint is its main business, while many other custom paints are produced by companies whose main business is OEM paint and repaint

products. Those companies make some beautiful paints, but House Of Kolor is all about custom paints.

The basis of the HOK system is a wide array of base paints that can be covered by an equally wide array of top coats. Add to those top coats a whole line of dry pearls and flakes, and you get an almost endless number of custom colors and effects.

A way to visualize many of the HOK products is the idea of building layers. The base coat is very important, because it sets the tone for the whole paint job. The base coat continues to show through the successive colors, to a greater or lesser extent depending on the number of top coats. When pearls and flakes are added, those layers contribute to the overall effect.

Besides the various layers of colors, custom paint jobs usually involve multiple design elements. The combination of different design elements and assorted colors produces a multidimensional effect. That pretty well defines custom painting.

In addition to all the different HOK colors, the bases are available in various styles of paint. There are solids, metallics, pearls, and candies. The pearls and metallics are available in different intensities of pearl and metallic. By varying the type of base, you can control the amount of sparkle in the final color.

The metallic or pearl effect can be impacted in two ways. The base choice is the first way. The second way is with dry pearls and flakes that can be added to color and clear coats.

Custom colors are only as good as the clear coats that protect them. House of Kolor has a wide selection of high-quality clears. The different clears provide the perfect product for the conditions. The choice of clear depends on things such as local EPA regulations concerning VOCs, drying time, and whether or not multiple layers of artwork are involved. The appropriate catalysts and reducers must be used with the corresponding clears. The type of clear chosen affects the window of opportunity for wet sanding and buffing. Things like this need to be planned to optimize the whole paint system.

CATALYSTS

Catalysts are a critical component of many paint and clear systems. Catalysts are potent chemicals and need to be treated as such. Most paint products have fairly long shelf lives, but not catalysts. Once a can of catalyst is opened it becomes sensitive to the air in the can. If you use pliers to open the can, that can affect the quality of the seal.

Catalysts can go bad quickly, so you should buy just enough for the job at hand. For optimum results, buy it

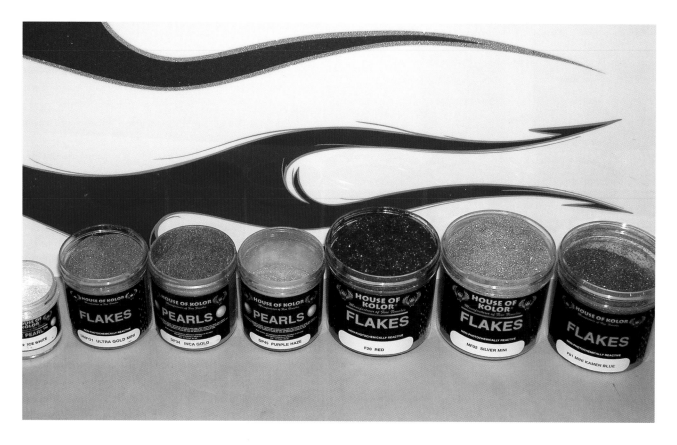

A tremendous variety of dry pearls and flakes can be added to HOK paints and clears, such as Intercoat Clear (SG-100). The pearls and flakes come in many colors and particle sizes.

just before you need to use it. Be especially careful when pouring catalysts. This is when it is the most hazardous to your skin and respiratory system. Wear gloves and a spray mask. You should also wear eye protection (goggles or a full face mask respirator), because the dangerous isocyanates can enter your system through your eyes or any other mucous membrane. Catalysts may look clear and innocuous, but they're highly toxic.

Safety should always be your number one concern when painting.

Catalysts are a necessary evil of urethane paint systems and most clears. Extreme caution needs to be exercised when handling and spraying anything with a catalyst. Besides a respirator, eye and skin protection is also required.

50

CHAPTER 7
TRADITIONAL FLAMES

A flamed '32 Ford is a hot rod icon—a car like this all but shouts, "Hot Rod!" Craig Lang loves hot deuces, as evidenced by the cover photo of this book, which features the hood of his '32 Tudor. The red sedan is but one of several fine deuces in his stable. His cars are definite attention-getters, but a couple years back he thought he might want something subtle for a change. He had the talented duo of Tim and Scott Divers build him a plain vanilla '32 3-window coupe. The car was stunning in quality and execution, like all of the Divers' cars, but it was easily overlooked in a sea of brightly colored street rods.

After a year of being conservative, Craig decided his little deuce coupe needed a personality makeover. He called on flame expert Donn Trethewey (www.treth.com), of Port Townsend, Washington, to heat up the car's appearance. Donn was responsible for the flames on Craig's '32 Tudor and many other top West Coast street rods. By retaining the original vanilla base color and adding school bus yellow, reddish orange, and magenta flames (with hot pink highlights), Craig got a huge visual impact, but still had something different than a typical black and flames highboy. (Not that there's anything wrong with that combination.)

The first thing Craig had to do was convince Donn to do another flame job. Donn, a multitalented artist who is more motivated by the project than the money, keeps threatening to retire from car painting. Donn is one of

Craig Lang builds beautiful street rods. He has a special affinity for '32 Fords. He originally built this vanilla 3-window coupe to be subtle, but after a summer of being overlooked, he decided to flame it. Flames gave this deuce a whole new personality.

Flame artist extraordinaire Donn Trethewey of Port Townsend, Washington, has painted other street rods in Craig's collection, so he was once again asked to apply his magic touch. Donn begins by placing a swoop of masking tape to serve as a starting reference point.

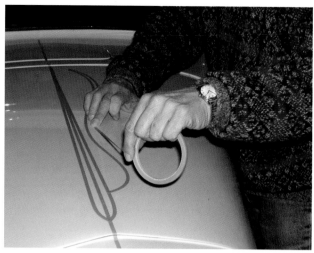

Donn likes to use 1/4-inch regular 3M masking tape for the layout work. It's less expensive than the blue vinyl tape. He uses this tape for pattern making, so the exact shapes aren't critical.

The car was very clean to start with, but Donn always goes over a car with wax and grease remover before starting the flame layout.

Notice how Donn holds the lead piece of tape taut, while he uses his other hand to press down the tape. The key to a good layout is to let the flames flow. You want to avoid jerky lines.

those "if the muse ain't there, the money is moot" artists. He would rather watch sunsets in Baja California than paint a car that doesn't interest him. Donn agreed that the vanilla coupe could use some heat, and Craig was a longtime client, so he agreed to do it.

Two key elements for Donn are design and color; in a previous corporate life he was an art director for big advertising agencies. As for color, Donn will literally spend days experimenting with different colors until he finds the desired combination. Even after "settling" on a color scheme, he will often alter colors midway through a flame job. To speed up the process and to be sure the car's owner is in agreement, Donn often sprays some test panels. Once the paint hits the car, it is very difficult to make significant color changes.

When planning and doing test panels be sure to look at them outside in natural light. What you see in a typical

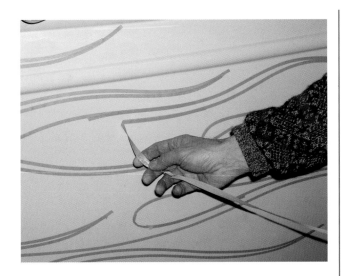

If you're not happy with a particular lick or even a portion of it, simply remove the tape and try again. Tape is the least expensive part of a flame job; so don't compromise the design to save a couple dollars.

fluorescent light–equipped shop and what you see outside are different shades of a color. Make the test panel big enough that you can get enough paint on it to judge what the final product will be.

The photo sequence in this chapter pretty much covers an A to Z flame job, although many aspects are also dealt with in other chapters. The details of paint mixing, types of clear to use and so forth are only mentioned briefly. That's because these factors vary so much, depending on what products are being used and where the car is being painted. Follow the manufacturer's directions, and if you're unsure about a particular product, consult the knowledgeable paint store staff where you purchased the paint. There are also many fine books available on basic painting procedures.

The type of flames shown here are largely symmetrical. Donn acknowledges that fire isn't symmetrical, but this is a stylized representation of fire, not a photograph. For that reason he likes to keep both sides approximately the same.

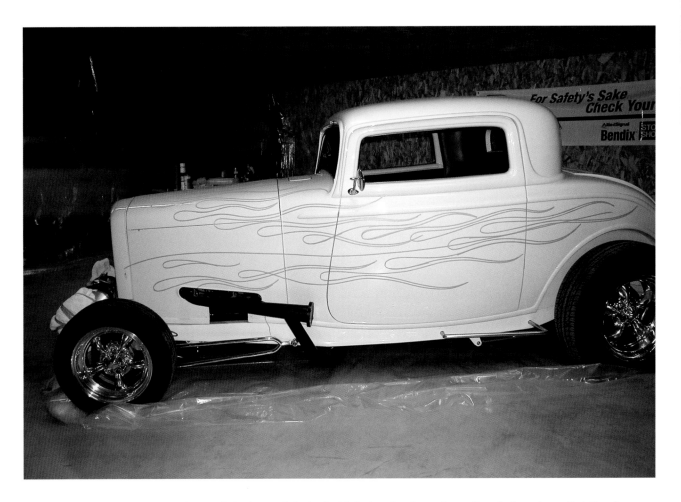

Here is the basic design on the left side of the car. Notice the smooth flowing front-to-back center reference tape and how the flame shape reflects the reference tape. The large piece of plastic underneath the car will be used later to seal off the chassis from overspray.

The flames will be more or less symmetrical, so a pattern must be made for the right side of the car. A couple of pieces of standard masking paper are taped together to cover a particular section, in this case the hood.

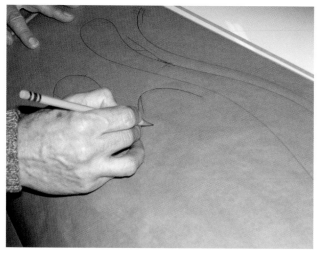

When the masking paper is in place and secured with tape, a common No. 2 pencil is used to trace the underlying masking tape outline.

When making a pattern, reference points need to be established. In the case of the three-piece hood, the seam between the top and side panels was used as one reference point. Several reference points should be used.

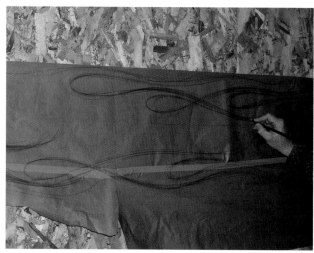

After the basic outline was traced with a pencil, the paper was placed on a flat surface (in this case the shop wall) and gone over with a wider grease pencil.

The key to symmetry is to lay out one side and make a pattern for the other side.

Donn has done so many fine flame jobs that the designs seem to flow smoothly from his mind to his fingers to the tape and on to the vehicle. Still, if he isn't completely satisfied with a particular lick or even a whole side of a car, he's not afraid to rip off all the tape and start over. Remember, masking tape is the least expensive part of a flame job. Use as much as it takes to get the design right before any paint is poured into your spray gun.

Because Donn is making a pattern, he works on only one half of the car. For no particular reason he favors the driver's side. While blue vinyl tape is the standard layout tape for most flame jobs, Donn saves money during the initial planning by using lime-green 3M quarter-inch masking tape. You can go through a lot of tape doing layouts, and standard masking tape costs about a third as much as plastic tape. Donn also likes the green tape because it's easier to see under the pattern paper. After the pattern has been determined, the green tape is removed and replaced with blue Fine Line Tape. On the

Smooth inside curves are a key to great flames. Donn often makes a poster board template to check the consistency of the curves.

Before the layout is finalized and taped, the rest of the car must be sealed. A finished car like this one needs to be protected. Donn likes to err on the side of caution when it comes to masking. Paint supply stores sell rolls of plastic masking material that can speed up the sometimes-tedious task of protecting the car from overspray.

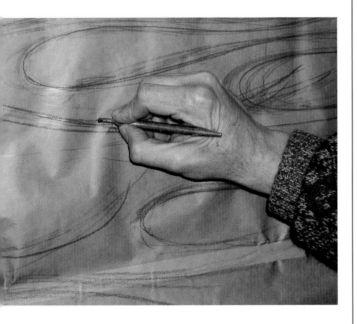

The design is traced with a pounce wheel to perforate the masking paper.

other side of the car, only the blue tape is used. In general, thinner tape is easier for beginners to manipulate on the curves. Also, the blue plastic tape stretches around corners easier than the green tape. Experiment with a couple different sizes and types to determine which one works best for you.

Masking paper is used for the pattern; use wide paper or tape a couple narrow pieces together. Mark several reference points as the paper is positioned over the outline tape. The pattern needs to go back in the exact location after it's been perforated with a pounce wheel.

You can see and feel the masking tape flames underneath the paper. Use a common yellow No. 2 pencil to trace the flames on the pattern paper. When you're satisfied with the design, and sure that no areas were missed, remove the pattern from the car. The green pattern tape can be removed now. Tape the paper to a workshop wall or place it on a piece of plywood or cardboard. Then use a wider marker like a red grease pencil to make the flames more visible.

Next, Donn uses a template, which he makes from construction paper or part of a file folder, to check the uniformity of the all-important inner curves.

When the design is well marked, it's time to use the pounce wheel. This inexpensive little craft tool is available at art supply stores or from the Eastwood Company. Eastwood also offers trick pounce chalk dispensers although Donn just uses a shop rag with carpenter's chalk. The pounce wheel is used to trace the design. It leaves a series of little holes.

Then the pattern is returned to its exact location on the car. That is why the reference marks are so important. The pattern is taped so it won't shift. The chalk is liberally dusted over the pattern. When the pattern paper is lifted up and away (so as not to disturb the chalk) you will see the flame design.

The pattern is carefully flipped over to the other side of the hood or taken around to the other side of the body. Using the same reference points as on the left side, the pattern is secured to the right side. The chalk is once again dusted and

you have the virtually symmetrical flame pattern everywhere you intend to paint.

After the chalking comes the final taping. For this stage, Donn uses 3M blue plastic tape. He likes the quarter-inch tape, because it offers more area for the green tape to adhere to. Painters who do the initial layout with the eighth-inch blue tape often need to come back with a round of the quarter-inch tape. The goal is to eliminate any possible cracks where paint might seep through. The paint will find even the tiniest security breach. Constantly check the integrity of the masking tape. It's helpful to do a check after each new round of tape instead of waiting until the very end. Following the blue tape outline with the three-quarter-inch green tape will fill in a lot of the gaps. The remaining

open areas should be filled with tape in an organized fashion. That is, don't place the tape randomly; layer it from top to bottom or vice versa. Then when it's time to remove the tape, it will come off quicker and in larger sections.

Large areas that need taping can be handled more quickly with 2-inch-wide tape. Masking paper can be used on extra large areas. Be careful to avoid creases when using masking paper. Any creases need to be taped over; otherwise, overspray can settle in the creases and blow out at inopportune times.

Besides taping around the flames, every other possible part of the car must be taped. As a method of protection and a way to save time, the coupe was placed over a big piece of thick clear plastic at the start of the project. The piece was

The pattern is first taped (using the preestablished reference points) to the left side of the hood, where the original design was made. Don't be shy with the chalk. Use lots of it. Donn puts a substantial quantity of carpenter's reference line chalk in a clean shop rag and uses it to go over the holes that were made by the pounce wheel. There are also inexpensive, specially made chalk dispensers for this purpose.

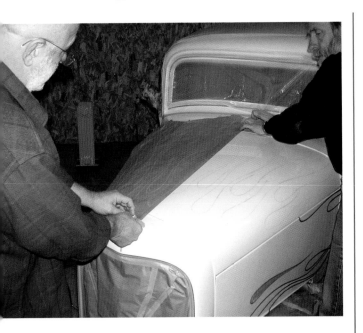

The pattern is then lifted carefully, to avoid disturbing the chalk pattern, and flipped over to the right side of the hood. The same reference points, such as the hood crease, are used when taping down the pattern.

The chalking process is repeated on the right side of the hood. You can see the faint outline that the chalk made on the left side. It might not show up well in a photo, but it is plenty visible in person.

large enough that it could be pulled up around the tires and taped to the body. This plastic comes in handy during the wet sanding process as it continues to protect the chassis, wheels, and tires. Using a big piece of plastic like this means

the expensive wheels and tires can be left on. Otherwise, it's a good idea to put some junk "rollers" on the car.

Areas like the doorjambs require a lot of attention when taping off the vehicle. Chances are excellent that the flames will cross doorjambs. Paint needs to be shot where the flames meet the edges of the doors, but nowhere else. That means the jambs need to be thoroughly taped while it's still possible to open the doors.

Donn likes the flames to cover the door and body edges, but not the innermost part of the jamb. Some painters go to the added work of running the flames all the way through the latch side of the door and doorjambs. This looks impressive when the door is open, but Donn feels flames are meant to flow, so there isn't any need to display them with open doors. Also, his way saves a great deal of work.

After all the taping was completed the car was lightly scuffed with a clean red Scotchbrite pad. Which color Scotchbrite pad you use depends on how much scuffing is required. The idea is to give the old paint some "teeth" to aid the adhesion of the new paint. Wax and grease remover, compressed air, and fresh tack rags are used to complete the prep process. A tack rag should be used right before paint.

The paint used on this project was base coat/clear coat. Donn starts with pure mixing colors and then adjusts them to his specific needs. The primary color was a variation of school bus yellow. It was sprayed over the entire flame area. Before the main flames are painted, the edges of the three-piece hood, grille shell, and cowl get some paint.

The second color is a reddish orange. It was applied from the tips toward the inner curve areas. On this job Donn added some hot pink highlights to the inside curves before applying the third (magenta) color. The end result at the curves is a little pink fogged in with the reddish orange. The tips and some of the crossovers were painted magenta.

Painting the crossovers requires care. The work is done while the other colors are very fresh, although dry to the touch. Surrounding areas need to be masked to protect against overspray, but don't press the tape too hard. The goal is to protect without harming the adjacent areas.

Blending colors or making fades are skills that come with experience. A flame with very distinct color changes is usually the sign of a beginner. Donn lessens the paint coverage where a second color overlaps the underlying color. By applying color in relatively light coats he can make easier blends. This is also known as fogging a color.

Overspray is a factor related to blends or fades. Overspray is usually something to eliminate because you don't want dry paint to get into the wet paint and you don't want one color to contaminate another. Some overspray can be

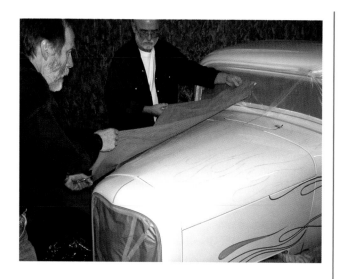

When you're satisfied that all the pounce holes received a good dusting of chalk, the pattern should be lifted up and away. This same left-to-right pattern process is repeated on the sides of the car.

beneficial when blending colors. By having a transition area with some overspray, the overspray will "melt" or blend when the clear top coats are applied.

Talented professional painters can apply paint with an old pump style garden sprayer. Their skill levels exceed the quality of the equipment. Beginners need to rely more on good equipment. For example, blending is much easier with a touchup gun or an airbrush. It takes longer to apply enough paint, but you can do it gradually with the touchup gun or airbrush.

Follow the paint company's instructions for drying time between the color and clear coats, and for when it's OK to remove the masking tape. Generally, the tape is removed while the paint is relatively fresh but not wet. While the paint still has a little flexibility, the edges are less apt to chip.

Removing the masking tape is an important part of flame painting. The tape must be removed carefully and methodically. Don't just start ripping. Only remove the

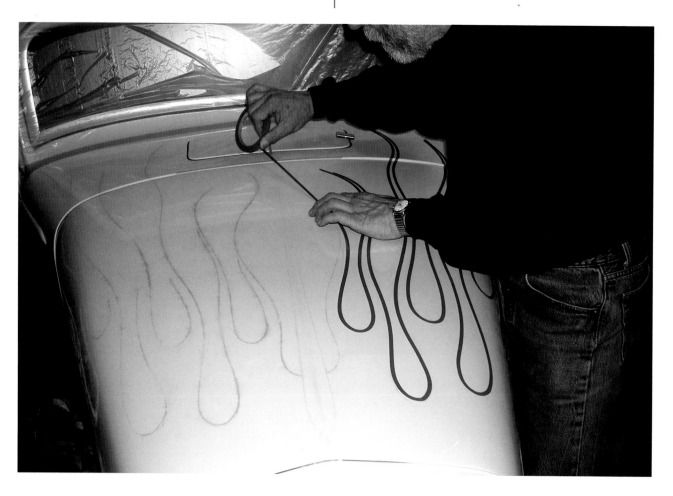

With the chalk pattern as a guide, Donn uses 1/4-inch 3M blue vinyl tape to trace the design. Many painters prefer the thinner 1/8-inch tape, but Donn likes the more secure edge of the wider tape.

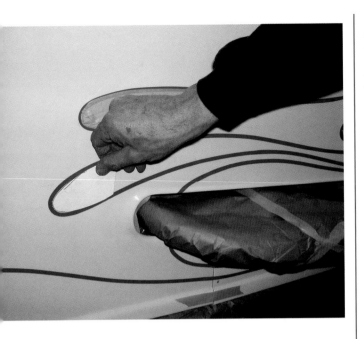

Remember the paper inside curve template from the pattern-making stage? Donn uses it to check the consistency of his taped curves.

masking paper and tape immediately surrounding the flames. The rest of the car needs to remain masked. That's because a lot more mess will be created during the color sanding and buffing stages.

A sharp utility knife or X-acto knife is handy when untaping. If a section of paint appears to be sticking between the flame and the tape, cut it rather than rip it. You want any rough edges to be beyond the flames, so they can be dealt with later. You don't want a chip of paint to come out of the actual flame.

When removing the masking tape, the idea is to pull it back over itself. When you get down to the blue plastic tape that abuts the flame, pull it back and away at an angle. That method allows the tape to slide out from underneath the paint, rather than pulling up into it.

Two or three clear coats are usually applied over the flames. Usually the clear coats are shot only over the flames, although some painters clear the entire vehicle. Some painters clear the flames, color sand them, then clear the whole car and finally color sand the entire vehicle. Ample clear is applied to enhance the gloss and depth of the flames and to leave enough material for wet sanding.

Color sanding or wet sanding is done to smooth out any "orange peel" in the paint. No matter how smoothly paint is applied, it tends to form tiny craters much like the skin of an orange. Since several coats of clear were applied, there is enough material to sand down the orange peel. Sanding is typically done with super fine grit paper, like 1,500 or 2,000. The water helps prevent paint build-up or clogging of the sandpaper. A little bit of dish detergent in the squirt bottle will make the water slippery and aid the sanding process.

The final process is buffing. It's the buffing that puts the shine in the job. After the wet sanding, the car will look quite dull. Buffing out or polishing the paint makes it come alive. A general principle behind color sanding and buffing is to go over the paint with ever-finer grit products, with each successive product removing the tiny scratches made during the previous stage. There are foam polishing pad systems that are color coded to denote the proper progression. By the end of the buffing process, virtually no grit is being used.

Some painters consider the job finished after the buffing stage, but most people like to pinstripe the outline of the flames. Pinstriping helps set the flames apart from the rest of the car. Use of the right color can help the flames "pop" because of the contrasting colors. Pinstriping is also useful for hiding any problems with the flame edges.

Donn uses 1 Shot lettering enamel. He makes custom colors by blending stock colors in little paper drinking cups. An unsharpened pencil serves as a mixing stick and a glossy magazine is his palette. A small quantity of paint is poured on the magazine and the striping sword is worked through the paint to "load" the brush. The idea is to have enough paint up in the bristles to pull the longest possible uninterrupted line. After loading the brush, Donn runs it through his fingers for a final adjustment. This is one of those techniques gained from years of experience.

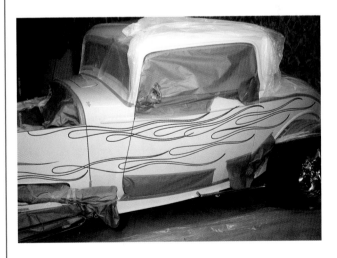

Here is the design on the side of the car. This is a pretty bold design and it dominates the car. One thing to remember during the layout phase is that the tape makes the flames look larger than their final size. The paint will be on the inside of the taped outline.

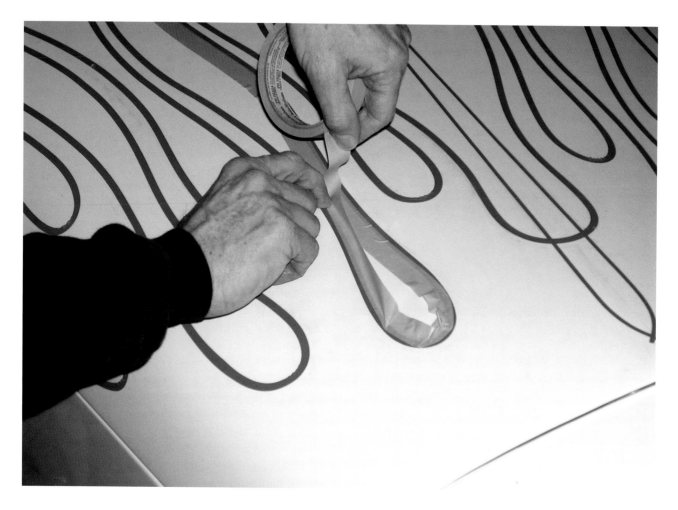

Once he is satisfied with the position of the blue vinyl tape, Donn begins the time-consuming job of taping off all the areas that will remain cream colored. Standard 3/4-inch masking tape is used for most of the chore. It's affordable and easy to manipulate.

Donn often adds a little pinstriping design like on the '32 grille shell or on top of the air cleaner. A signature item for Craig Lang's cars is a little flaming woodpecker somewhere down low on each side of the car. The area is usually the lower part of the cowl. Donn paints the birds with the flaming feathers freehand, but he uses a decal as a reference.

The flames made a huge difference in the appearance and attitude of Craig's little deuce coupe. It went from subtle street rod to a hard-to-overlook hot rod.

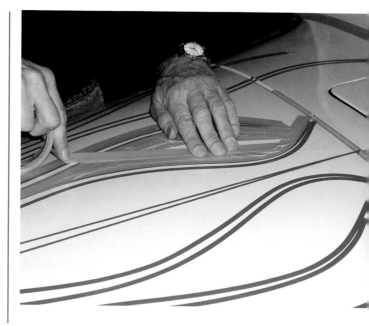

Taping needs to be done with care. It needs to be as flat as possible so it won't trap overspray that could blow into the wet paint. Each piece of tape must overlap its neighbor and be firmly pressed down to avoid leaks.

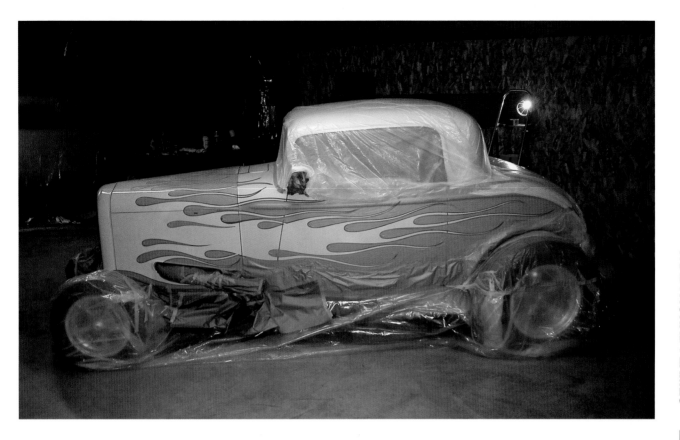

The big piece of plastic that the car was rolled onto at the start of the project has now been wrapped up around the wheels. You can see how well the flame design flows.

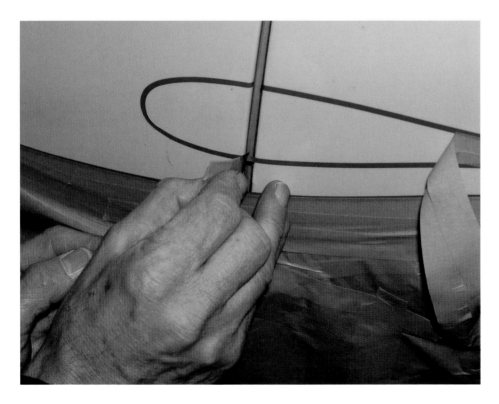

Areas like door gaps and the line where the hood meets the cowl require extra taping. The whole engine compartment was previously taped. Then the blue vinyl tape was used to follow the design. Finally that tape needs to be cut and wrapped around the edges of the hood.

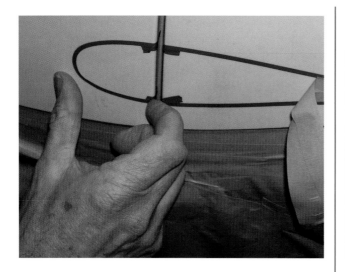

Extra pieces of tape are wrapped around the edges as shown. A single-edge razor blade or your fingers can be used to help secure the cut tape.

Then the green masking tape is used to fill in the area between the pieces of blue vinyl tape. Areas like this require a lot of extra attention, but it pays off in a superior job.

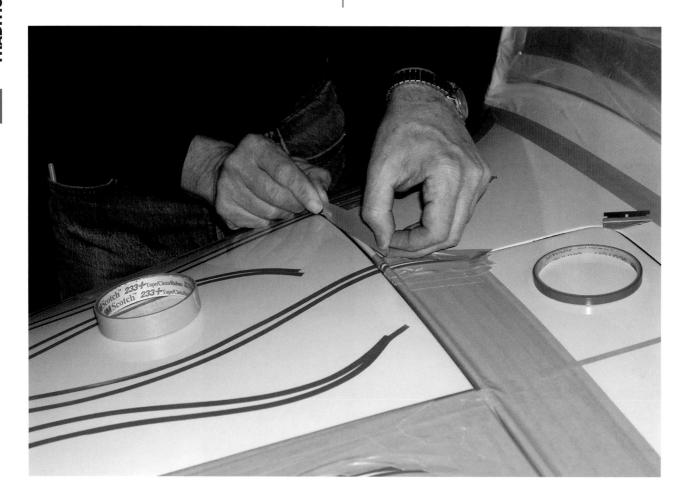

The top of the hood, where it meets the cowl, required much taping. Donn likes the flame tips to cross on to the cowl although the quicker taping solution would be for the tips to end on the hood. This is another one of those little details that separates a great flame job from an average one.

A small piece of red Scotchbrite pad was used to lightly scuff the paint. The base paint was over a year old, but it had had a very pampered existence.

Extra care needs to be exercised along the edges of the tape. It's important to scuff this border for good paint adhesion, but you don't want to lift the tape. It helps to have a logical progression for the paint scuffing so no section gets overlooked.

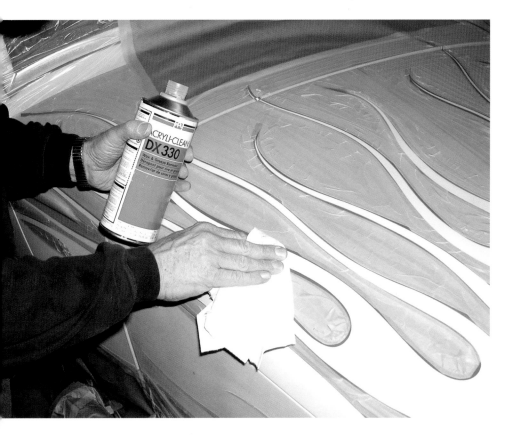

After the car has been scuffed and blown off with compressed air, the wax and grease remover is called back into action. Follow the product directions, which usually call for an application cloth and a clean one to remove residue.

A thorough going over with a fresh tack rag is the last step before paint. Notice that the tack rag is unfolded. Turn the tack rag frequently.

A base-coat/clear-coat paint system was used. The primary color is a variation of school bus yellow. Donn likes to use mixing colors because of their vividness. He often tweaks the color by adding some extra red, yellow, or white. A test panel is a good idea if you're not sure about the colors you want.

The top of the hood was initially removed so all the inside edges and grille shell could be painted. The edges of the cowl and lower hood panels were painted first. A light tack coat is applied to improve the adhesion of the following coats.

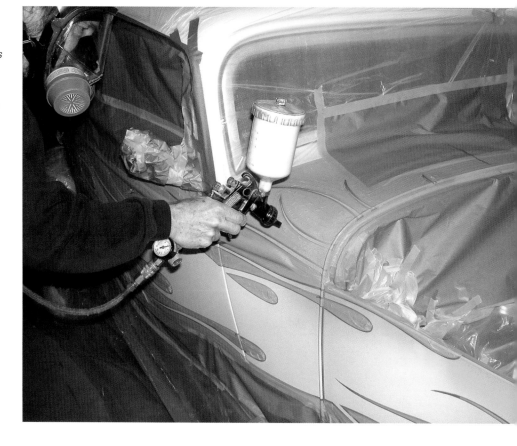

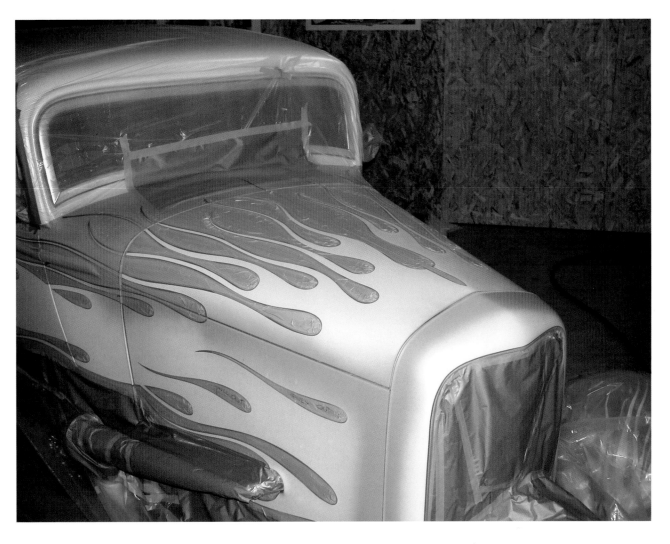

After the yellow paint around the hood perimeter had flashed off, the top hood section was reinstalled. While the hood was off, its edges were painted.

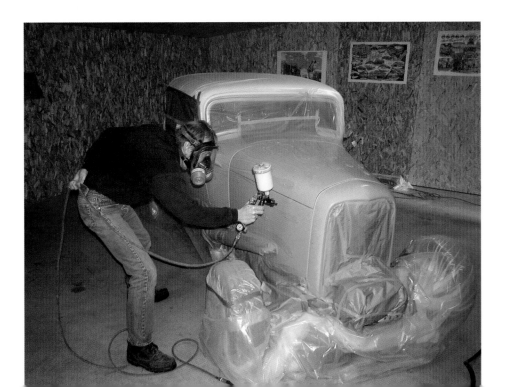

After the tack coat, the heavier coats of yellow were applied. Notice how Donn uses his free hand to control the air hose. Dragging an air hose across fresh paint is a disaster.

A very vibrant orange was custom-mixed for the second color. It was strained into the plastic mixing cup before being poured into the spray gun.

The second color, which covers the back half of the flames, was shot right over the first color. Since all the colors are in the same general spectrum, there isn't any problem about spraying one over the other. The bright yellow base can actually be beneficial from a brightness standpoint. Donn likes to fog or blend the orange into the yellow.

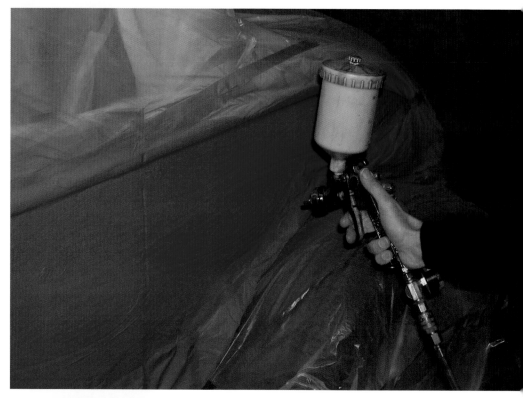

Several different versions of the third color were mixed. It's better to mix up a few small batches and experiment than risk going with the wrong hue. The workbench was covered with masking paper for ease of cleanup.

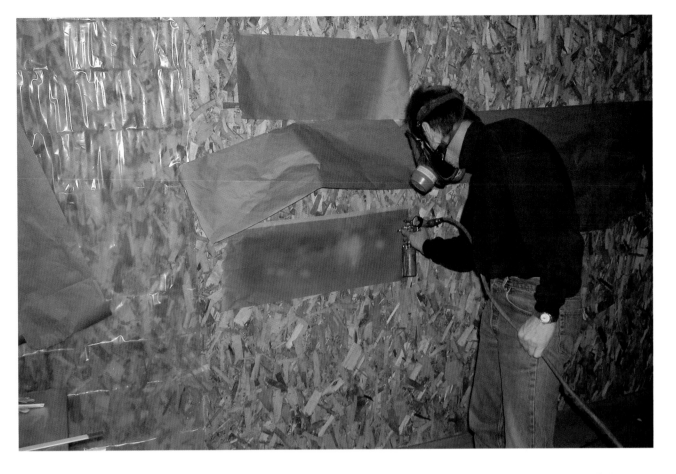

Pieces of masking paper were taped to the wall so Donn could experiment with the third color and the highlight color. Both Donn and the car's owner, Craig, are very fussy about color selection.

In addition to testing paint on masking paper, Donn likes to hold up the paint on a mixing stick right where it's slated to go. Holding the accent color against the larger expanse of school bus yellow gives a better idea of the contrast.

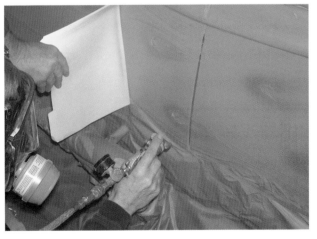

Donn chose to add the hot pink highlight to the inner curves before applying the third color, magenta, to the tips. The primary flame colors are yellow, orange, and magenta. Hot pink is the highlight color, which most painters add last, but Donn chose to use it before he did the magenta tips. The area looks two-toned because he first fogged the inner edges with the second color, orange. A common manila file folder is used to help control overspray.

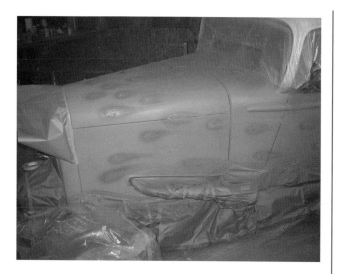

At this stage, the car has the odd look of a yellow and pink leopard. The pink areas look much larger than they will be once the car is unmasked.

Applying the third color, magenta, to the tips often requires sections of masking paper to be strategically placed to control overspray. This is especially true when overlaps are involved.

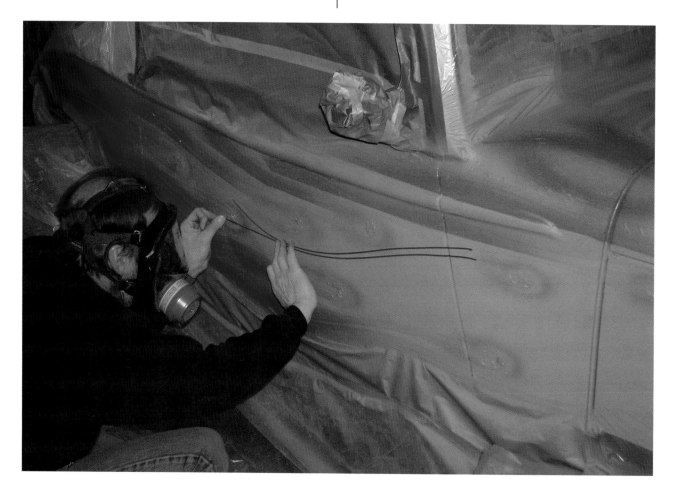

Some overlap areas had to be untaped for the base color to be applied and then retaped for the third color overlap. Referring to the paper pattern helps in positioning the tape.

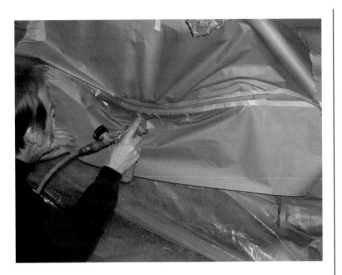

The magenta paint was gradually built up to avoid any runs. Care must be used with the masking tape because the paint is still relatively fresh. The tape needs to protect without lifting underlying paint.

Be careful when removing the temporary masking paper. Notice how it is being pulled back at a right angle to the door.

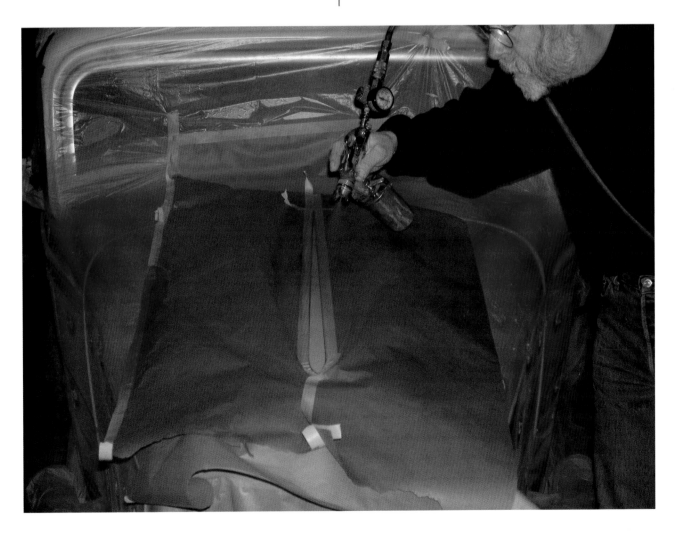

Donn decided to add a little something different to the hood. He made a long teardrop, painted red and fading to a magenta tip, down the center of the hood.

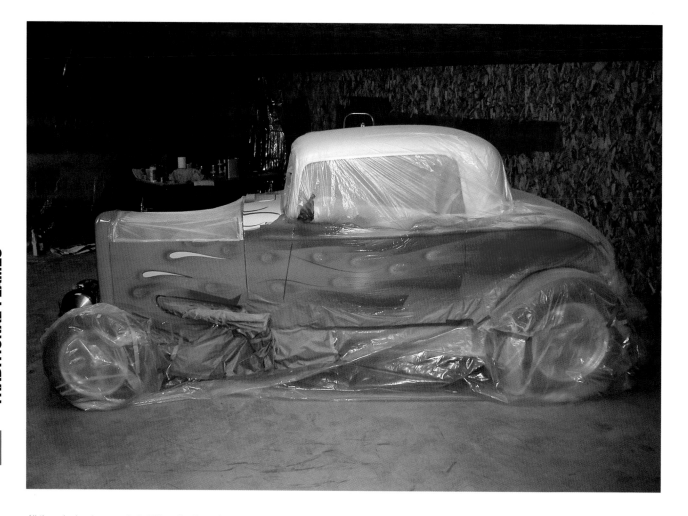

All the color has been applied at this point. Several coats of clear followed the color coats. The urge is to remove the masking paper, but the manufacturer's directions must be followed regarding flash times and when it can be unmasked.

When unmasking time arrives, go slowly and carefully. The paint is still "soft," so you don't want it to lift. The technique of pulling the tape back on itself always applies. Notice how overlapping the tape makes it come off in easy-to-manage sections.

This shot of the hood after it was cleared shows how the red center teardrop adds interest to the design.

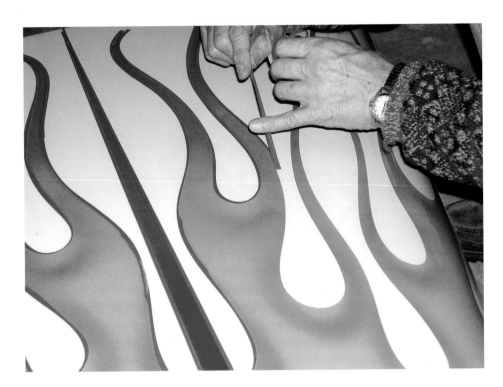

Removing the blue vinyl tape is the most important step, because this is the tape that has contact with the paint. Again, notice how the tape is pulled away from the paint.

The freshly cleared and unmasked paint was allowed to sit for a couple days before the color sanding began. Ultrafine paper is used with lots of water. All the masking with plastic means minimal cleanup time after the sanding is finished.

Donn prefers a squirt bottle to a sponge when he is wet sanding. The surface needs to be wetted frequently.

A sanding pad is used to keep the sandpaper as flat as possible. Using your fingers can put grooves in the paint.

The 3M liquid polishing compound is applied to the buffing pad rather than putting it directly on the car. The polishing compound is lightly smeared on the surface as it is first applied. That helps prevent big globs of polishing compound from flying all over the place. Then it's worked into the paint with the buffer.

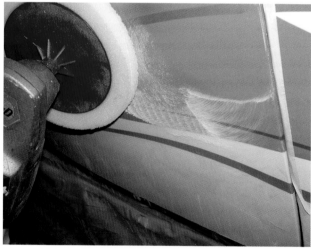

Power buffing is an art in itself. It is also quite messy. Some custom painters have specialists who only do the color sanding and buffing operations.

After the color sanding comes the power buffing. Masking tape is placed over any relatively sharp edges, like the cowl, to avoid cutting through the paint. These areas will be hand buffed later.

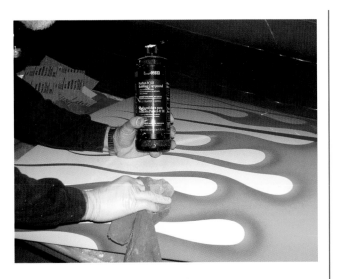

3M Perfect-It III Rubbing Compound is hand applied to areas that couldn't safely be done with the electric buffer.

This close-up of the pinstriping shows how it contrasts with the flames and helps define them. It also shows how careful Donn is to get the stripes into the various body gaps.

A robin's egg blue was selected for pinstriping the flames. Donn uses a glossy magazine page as a palette for loading his striping sword. He mixes the paint in a Dixie cup and uses an unsharpened pencil for a mixing stick.

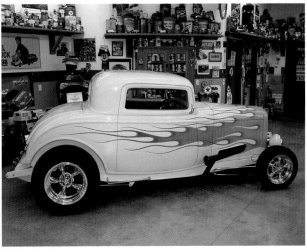

The flames really changed the personality of Craig Lang's chopped '32 Ford coupe. It went from a sedate street rod to a wild hot rod.

Notice how Donn uses any aid he can find when pinstriping. One finger is in the groove between hood panels, and his free hand is being used to steady the one with the brush.

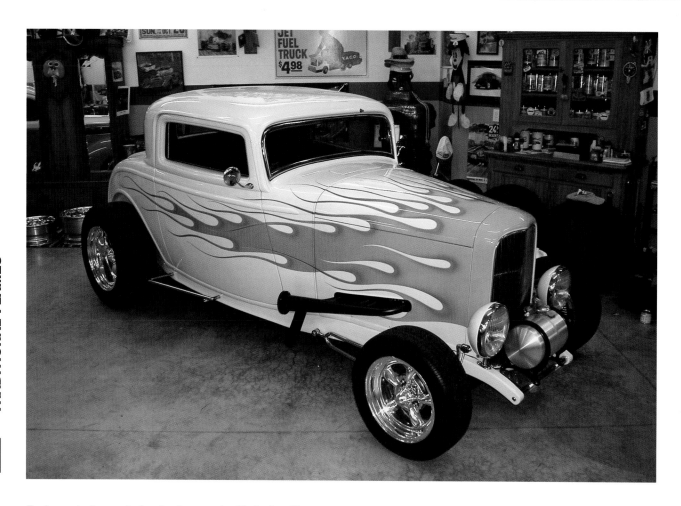

The flames give the car a feeling of motion even when it's standing still.

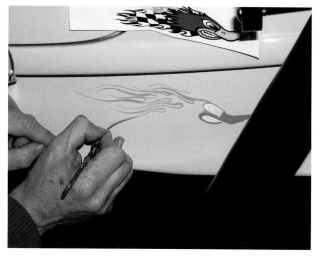

The slotted hood panels and exposed exhaust headers presented a unique design challenge. The easy solution would have been to put the flames above the opening, but Donn went the extra distance and put a lick underneath the headers. That's another one of those little details that separate a great flame job from an average one.

A signature touch on Craig Lang's street rods is a pair of flaming woodpeckers down low on the car. (In this case, they're on the frame rails.) Donn makes the design with a pinstriping brush. He does it freehand, but a decal serves as a general guide.

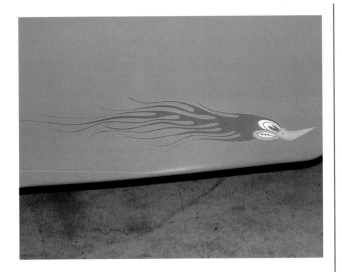

Here is a finished flaming woodpecker on one of Craig's other street rods. It demonstrates that flames can show up just about anywhere.

Donn Trethewey added a little traditional pinstriping design to the top of the filled '32 Ford grille shell.

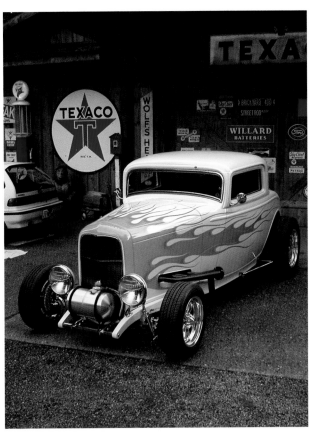

This shot demonstrates how the colors look different outside compared to inside. The car was painted in winter; it was almost dark, about to rain, and a flash was used, so the colors will be brighter on a nice sunny day.

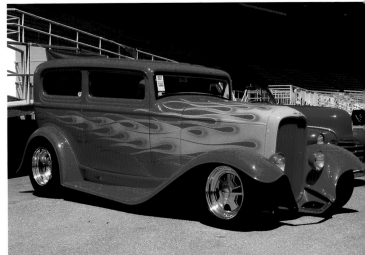

This is another of Craig Lang's beautiful '32 Fords with a Donn Trethewey flame job. The photo was taken on an intensely sunny July day, which was almost too bright to accurately capture the colors.

CHAPTER 8
WALL OF FIRE FLAMES

Mike Lavallee of Killerpaint (www.killerpaint.com), in Snohomish, Washington, is one of the busiest, most successful painters around. His realistic "wall of fire" flames and stunning airbrush artistry have been prominently featured on the popular Discovery Channel TV show *Monster Garage*. His flames are showing up on die-cast model cars and motorcycles as well as T-shirts and limited edition Mac toolboxes.

Mike has painted several trick trucks and cars for *Monster Garage* host Jesse James. Many entertainment and sports superstars have also sought out Mike to apply his airbrush magic to their SUVs and custom choppers. Mike's outrageous flames have even been applied to a helicopter.

Mike is extremely busy, but he did allow us into his spray booth to watch as he applied realistic flames to Mark

One obviously successful businessman was so pleased with the realistic flames Mike Lavallee applied to his Ford Lightning pickup that he had Mike paint his helicopter and offshore powerboat.

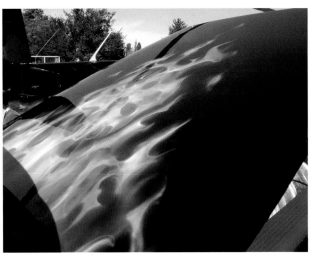

A pickup truck hard tonneau cover is another ideal location for flames, as seen on this Ford Lightning.

The long bow of the powerboat is a great "canvas" for Mike's airbrush artistry. A huge dragon is the source of the flames here.

A good way to understand how real flames look and flow is to photograph them. By studying the photos, you can see where the different colors and shapes tend to be. The photos also give a good idea of how the licks are multilayered.

Harding's lifted 2004 Ford F-350 pickup. The monster truck was so tall that the tires had to be deflated in order to squeeze it into the spray booth.

The unique part of this job was that Mike made the flames blue instead of the usual shades of orange and yellow. The effect looks great on the big black truck. The blue flames are both wild and subtle at the same time. We've seen Mike's realistic flames done in shades of green on a chopper, and they looked great, too. The point is to not be limited to "real" flame colors.

Mike has had years of experience painting realistic flames, so it's almost second nature to him. He instinctively knows where to put colors and what shapes to use. A tip that Mike suggested for people wanting to paint realistic flames is to photograph and study real fires. Mike has used this trick himself. It doesn't need to be a very big fire. It can be in a fireplace or in a barbeque pit. Take a series of photos to capture the flames at the different stages of combustion.

Mike moves so quickly once he gets going that following him is a challenge. Mike uses House of Kolor paints in an Iwata Eclipse HP-CS with the small top paint cup. He sets the initial air pressure at 40 psi. The small paint cup requires more refilling than a bigger jar or a detail gun, but Mike likes the added control of the little airbrush. The Iwata airbrush is so lightweight that it almost becomes an extension of his hand.

To deal with the small paint cup of the Eclipse HP-CS, Mike premixes bottles of the colors he plans to use. These plastic bottles have a handy squirt top so he can easily refill the paint cup. Standard surface prep procedures are employed.

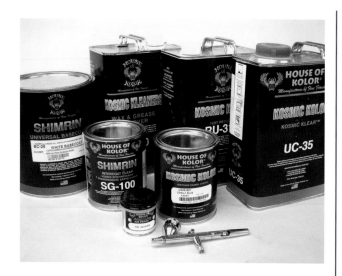

House of Kolor products were used exclusively on this project. Two essential colors are the white and black base coats. The primary action color is Kobalt Kandy Blue. HOK pearl was mixed with Intercoat Clear to provide the pearl highlights. The airbrush is an Iwata Eclipse HP-CS, which offers excellent control for fine details.

The subject for the blue realistic flames was Mark Harding's brand new Ford F-350 pickup. All the areas that wouldn't receive flames were carefully masked. The black paint was lightly scuffed and cleaned.

The first color serves as the base for the subsequent colors. Mike uses House of Kolor Basecoat White (BC-26) reduced at the standard two parts paint to one part reducer. He uses the HOK reducer best suited to current temperature conditions.

Realistic flames are all about layering colors, so Mike has to think several steps ahead. Where the white goes impacts the brightness of following colors, especially on a black truck.

Early in the design process, Mike focuses on getting the underlying shapes. The design flows up and back. The white is added slowly. Some of the white is definite and some of it is wispier. Mike applies the white paint freehand and with a plastic Artool solvent-proof stencil. This type of stencil is far superior to any paper-based stencil. The edges will quickly curl on a paper stencil. The curved edges of the stencil give some definition to the shapes. These shapes serve as starting points for the freehand work.

Overspray is a constant concern, because the paint is applied rather dry. Mike keeps a fresh tack rag handy to wipe off overspray. Overspray isn't as critical on black vehicles as it is on colors like red or yellow. The candy colors that follow the white base coat can hide a lot of minor overspray on a black vehicle. A black vehicle has a distinct advantage over other colors, because mistakes or excessive overspray can be hidden with more black paint. The shade of black doesn't have to be exact. It can even be thinned House of Kolor Basecoat Black (BC-25). On a yellow vehicle, for

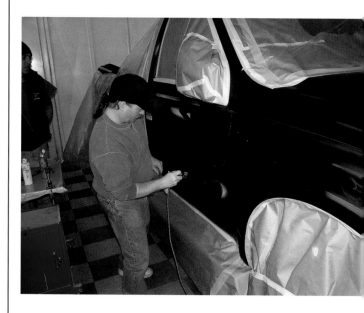

Mike Lavallee (www.killerpaint.com) in Snohomish, Washington, starts the flames by laying down House of Kolor White Basecoat (BC-25). Mike uses an Iwata Eclipse HP-CS airbrush with a small top feed paint cup, because he likes the control it provides.

example, the touchup yellow has to be a precise match or it will stand out.

The main blue used on this truck was HOK Kandy Kobalt (UK-05). It was reduced two parts paint to one part reducer. Mike lays the cobalt blue on pretty heavy, but still

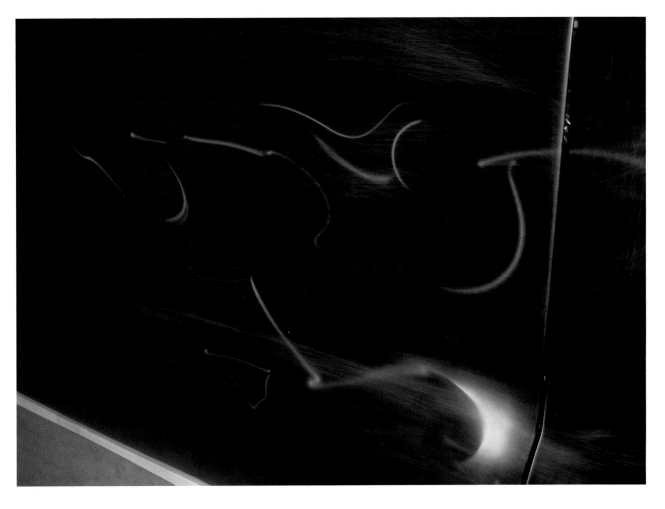

The general design calls for the flames to go up and back. The scratches you see now will disappear when the area is clear coated, wet sanded, and polished.

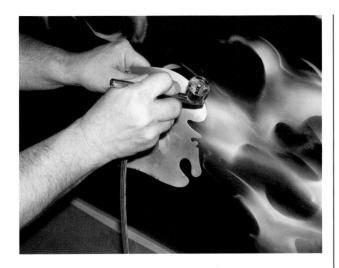

The white paint is applied both freehand and using an Artool solvent proof stencil. The stencil gives defined lines that serve as jumping off points for the freehand stuff.

applies it with the small-capacity Iwata airbrush. Streaks are unwanted when applying the blue, so Mike sort of pulsates the paint delivery in an in-and-out manner. A standard back-and-forth, left-to-right motion is more apt to leave streaks. The in-and-out motion also helps with the layering and appearance of depth.

After the base amount of cobalt blue has been applied, Mike goes over the design with some white pearl mixed in HOK Intercoat Clear (SG-100). The pearl gives highlights to the design. Pearls need to be very well mixed to keep the reflective particles in suspension. Sometimes pearls need a little extra reducer. Mike warned to watch for splatters with pearls as they come out of the airbrush nozzle. You don't want splatters. If too much pearl gets on an area it can be toned down with the black paint.

On this job Mike used dry white pearl. House of Kolor also offers tinted pearls like blue, red, gold, and violet. The blue pearl would be a good choice for blue flames.

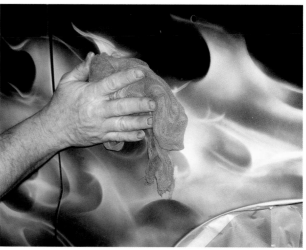

Artool stencils come in a variety of shapes and sizes. There are all kinds of different curves on these. These three stencils are the most useful ones for painting realistic flames.

A fresh tack rag is used frequently to control overspray. The paint is applied rather dry, and that produces overspray.

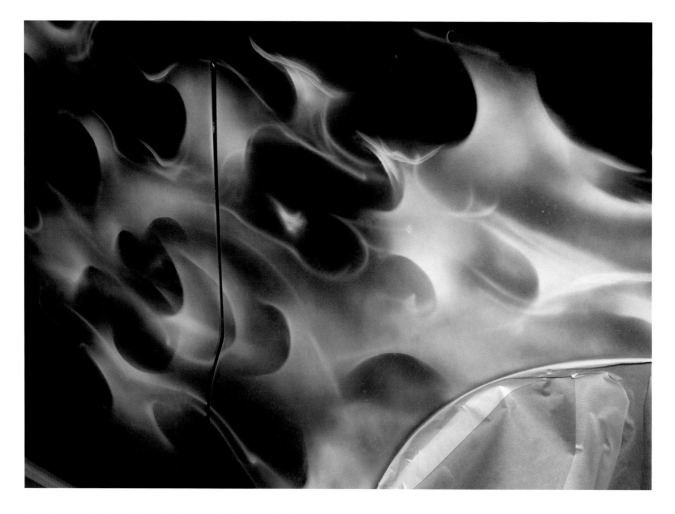

A good amount of white paint is applied, because it will serve as the base for subsequent paint. You can see how the design is taking shape.

Once Mike is satisfied with the amount of pearl high-lights, he goes back over the flames with more cobalt blue candy. The underlying pearl boosts the blue paint's impact.

The flames are allowed to dry for two to three hours. The truck is wiped down with a fresh tack rag in preparation for the clear top coat. Three coats of House of Kolor clear were applied. After the clear was sufficiently dry, it was wet sanded with 1,500-grit sandpaper. Then it was allowed to dry another day and given a final three-stage buffing. The resulting realistic flames are very wild, like something you might see on TV.

If Mike thinks an area has too much white, or if he isn't completely satisfied with the shape, he goes back and fixes things with some thinned black paint in his airbrush. The ability to do this is a big advantage in painting realistic flames on a black vehicle.

Mike premixes the colors he is going to use and keeps them in convenient squirt bottles. If he wants to dilute a color with more reducer or make a blended color, he pours the paint into little paper drinking cups. He doubles the cups for strength.

The House of Kolor Kobalt Blue Kandy is a urethane paint, so Mike wears a respirator when applying it. He moves the airbrush in and out to promote a look of depth and to avoid streaks.

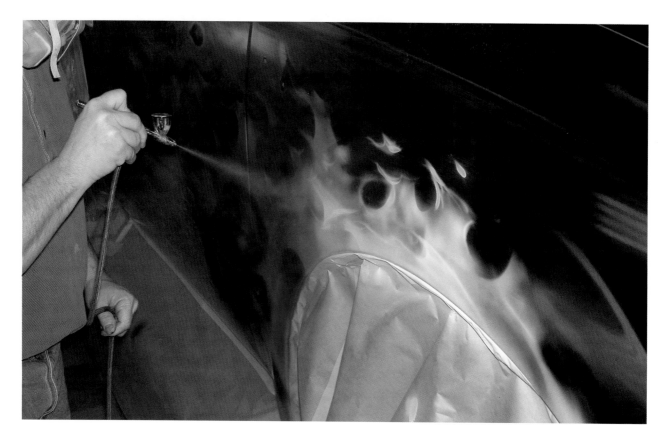

The Kobalt Blue Kandy is applied pretty heavily, because it is the primary color on this truck. This truck has fender flares that will also be flamed, but Mike flamed all the way to the inner fender lip in case anything underneath should show.

The blue paint really pops against the black background. The same techniques can be used with other candy colors.

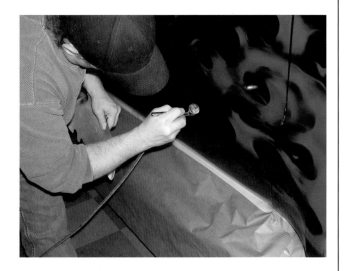

After the main blue paint was applied, Mike went back with the diluted black and touched up any overspray areas. Careful use of the black paints helps add definition to the blue licks.

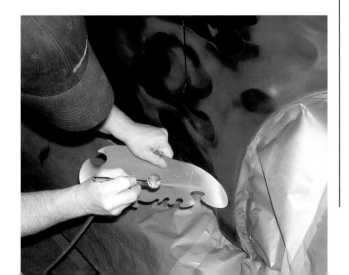

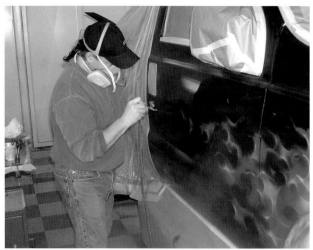

After the pearl highlights have been applied, Mike goes back over the flames with more Kobalt Blue Kandy. The blue that goes over the underlying pearl has an extra kick.

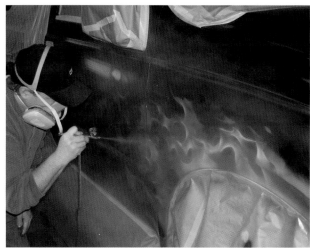

The whole flame job can appear a little hazy during the painting process. Much of that is overspray, which is periodically removed with a tack rag. The clear top coat will make everything sharper.

LEFT: The next step is to add pearl highlights. The Artool stencil was used to put some sharp lines of pearl into the flames. The light will catch these areas and help give the flames a feeling of motion.

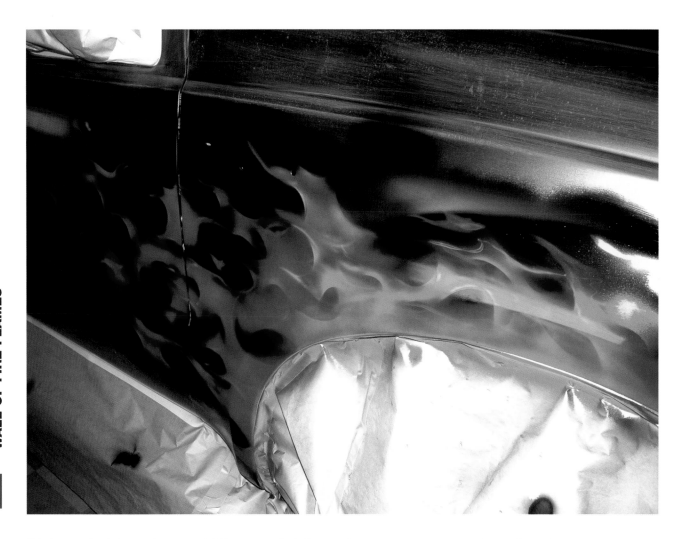

This shot was taken before the clear was applied. The area was wiped with wax and grease remover to give an idea of how it will look after the clear has been applied and the whole area has been color sanded and buffed.

Here is Mark Harding's finished Ford F-350 Power Stroke diesel pickup. The Mike Lavallee blue realistic flames give the truck a one-of-a-kind look.

Here is another view of the awesome pickup.

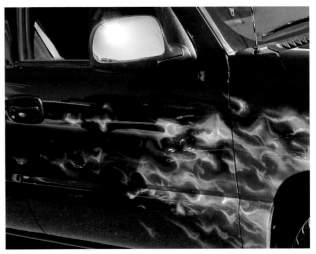

Green realistic flames give the custom Harley tank and fenders a unique look. Mike Lavallee used House of Kolor Organic Green Kandy over a white base coat.

The realistic flames on this late model Chevy pickup are darker with more orange than some of the other examples we've seen. These flames and a set of custom wheels will turn a stock truck into a show truck.

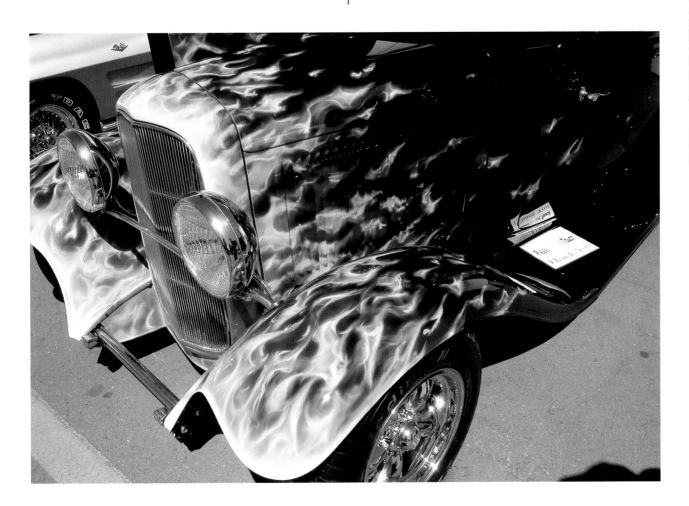

Here are some more of Mike's realistic flames, done this time on a full-fendered '32 Ford with a stock hood. Painting flames over the many louvers is an added challenge, but at least they didn't have to be individually masked.

CHAPTER 9
REALISTIC FLAMES

Realistic flames, as opposed to the traditional stylized flames, have become quite popular recently. Custom painter Roy Dunn, of Dunn Auto Graphics (www.dunnautographics.com), in Des Moines, Washington, pointed out that these realistic flames are a variation of techniques painters used on custom vans in the mid-1970s. Realistic flames are produced with an airbrush, as were murals in the past.

You were as apt to see vivid sunsets and ethereal clouds as fire, but the mostly random, freeform style was the same. If a mural had something like a volcano or a dragon, the fire it spewed would resemble today's realistic flames.

As with all other types of flames, there are several ways to accomplish realistic flames. The general idea is to keep adding layers of different colors until the net result is flames.

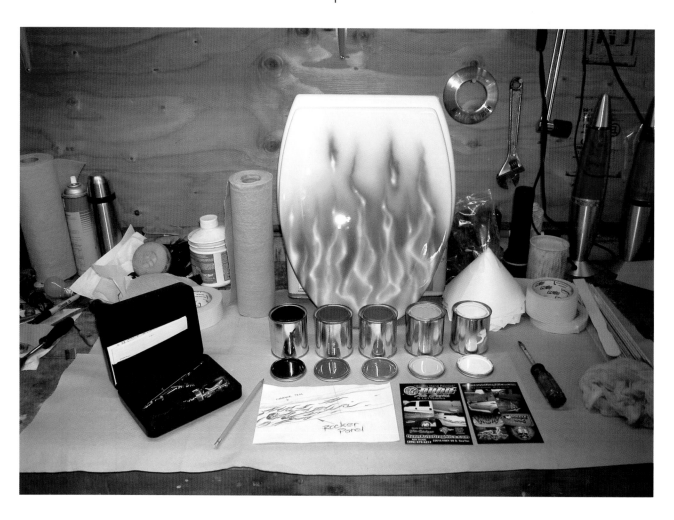

Roy Dunn assembled the items necessary for painting realistic flames. Included are base coat straight mixing colors, an Iwata airbrush with extra paint bottles, paint reducer, wax and grease remover, masking paper and tape, strainers, lint-free paper towels, a tack rag, and a basic sketch of the proposed design. The background artwork shows that realistic flames can be used anywhere.

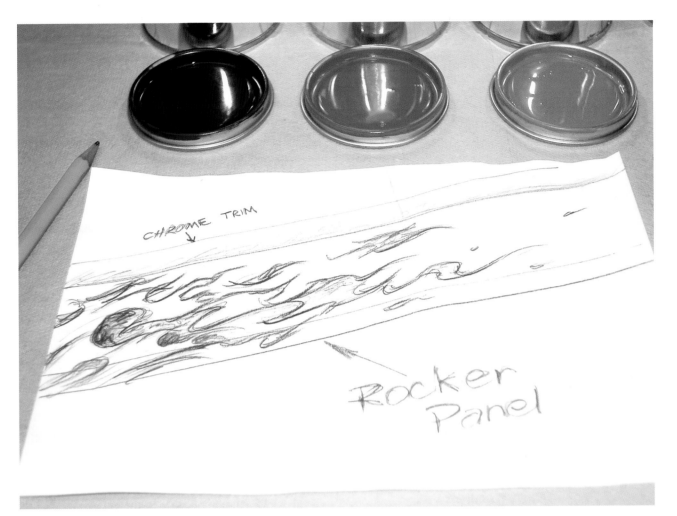

Roy likes to make a sketch of how he wants the flames to flow. For quick reference, he often tapes the sketch to the car just above where he is working.

Roy passed on several excellent pointers, using the term "exaggerate" to describe this technique. Although the goal is realistic flames, they are still an exaggerated interpretation. He cautioned that most people will view the flames from a distance or as the vehicle is driving by. Keep that in mind when painting the flames.

It helps to stand back periodically to see how the overall effect is coming together. What may look a little odd from the distance at which you're working can look more effective when the whole area is viewed at once. Don't worry if a particular lick doesn't end up in the ideal location. Real fire is so random, how can anyone accurately challenge where the licks should be?

Roy feels the distance theory is particularly relevant on big vehicles, such as his 1993 Buick Roadmaster station wagon, which we photographed. The supersized wagon had just received a fresh coat of Plymouth

Prowler metallic orange paint from Roy's friend, Tim Fergurgur. Roy wanted to add a little excitement to the lower rocker panels underneath the faux wood trim. The car sits very low, thanks to its airbag suspension, so the flames are one of those little head-turner features that not everyone notices at first.

Even though the flames are very random, Roy starts the process with a little sketch. It helps him get a feel for the direction he wants the flames to go. He wanted these flames to have an up-and-back flow, so they looked like they were licking the bottom of the wood paneling. The wagon has larger rear tires so it has a raked stance. The upward motion of the flames works well with the rake.

Surface prep is standard stuff, with the exact methods depending on the surface being painted. The Buick paint was only a couple days old and had not been clear coated, so all that was necessary was wax and grease remover, a light

Areas that won't be painted are masked off. The Buick wagon had a fresh coat of Prowler metallic orange paint.

scuffing with a gray Scotchbrite pad, an air nozzle dusting, and a wipe down with a tack rag.

Roy starts with the darkest color. In this case he chose a deep reddish purple. All the colors he used were straight mixing colors in base-coat/clear-coat urethane. He uses a slow drying reducer to lessen the chance of dry paint clogging his Iwata Eclipse HP-BC airbrush.

A good starting point for paint reduction is a 50/50 mix of paint and reducer. Roy starts with this ratio, tests the airbrush, and adjusts the mix to get the desired flow characteristics. It is better to err on the dry side to avoid paint runs. He sets the built-in regulator on his Iwata Power Jet portable air compressor to 30 psi. He always drains the moisture trap before painting.

Roy likes the Iwata Power Jet silent portable air compressor, because it provides lots of quiet, uninterrupted air pressure, and its compact size makes it easy to take to job sites. Roy often uses the Power Jet, even when he has access to a big shop compressor, because the Power Jet is ideal for airbrush work.

The areas immediately above and below the rocker panels were taped and masked. There isn't a great deal of overspray from an airbrush, but the surrounding areas should still be protected.

The first color is applied rather dry. The farther away from the surface that the airbrush is held, the drier the paint application will be. Roy held the airbrush nozzle approximately 3 to 4 inches from the surface. If you want a particular color to be more pronounced you can add more paint as the flames develop. When he gets to the final detailing, Roy holds the airbrush about 1 to 2 inches from the surface.

The dark first color serves as a base for the subsequent colors. Roy covers fairly large areas with broad strokes. Curly, wispy shapes are included as the first color is applied.

After he is satisfied with the base color, he switches to the second color, which in this case is a bright red mixing base. Roy uses separate bottles for each color so he can switch back and forth if necessary. Try not to return to the early colors later on in the painting process—these flames depend on the layering effect of the different colors.

Roy uses the bright red paint to define the main shapes. That makes application of the red the most time consuming. The red paint is applied in relatively long streaks and predominant curls.

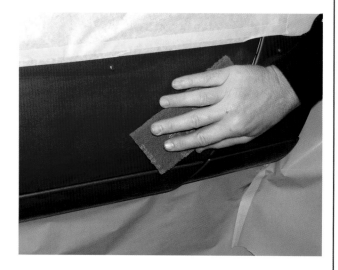

A gray Scotchbrite pad was used to lightly scuff the surface. The scuffing was followed by a wipedown with wax and grease remover.

The final step before applying any paint is to wipe the surface with a fresh tack rag. The tack rag can be used between colors to remove any overspray.

Paint should be strained at every step of the process. A trick that Roy uses to strain paint into tiny airbrush bottles is to tape off the upper part of the mesh. That effectively makes a large strainer into a small one.

The paint and reducer should be thoroughly mixed. A flat-blade screwdriver works well in the small airbrush jar.

A slow drying reducer is mixed with the paint in a 50/50 ratio. The ratio is adjusted after testing the airbrush spray pattern.

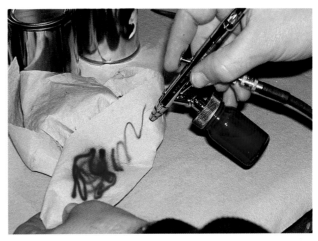

Roy tests the pattern of his Iwata Eclipse HP-BC airbrush to see if any more paint or reducer is needed. Years of experience make it easy for him to gauge the proper dilution.

Orange is the third color. Approximately half as much orange is applied as the previous red. As each new color is added, stand back occasionally to see which areas could use a little more color.

Yellow is the fourth color. More yellow was applied at the front of the design to simulate the hottest, most intense part of the fire. Use of yellow tapers off as the design progresses.

For a fifth color, Roy decided to soften the yellow. He made a toned-down yellow by putting some pure white base coat in the glass airbrush jar. Then he added a small amount of yellow and stirred. He added yellow until the desired shade was achieved.

A sixth color, white, can be added if desired. The white is used sparingly for small highlights. Depending on how soft the toned-down yellow was, the white may or may not be needed. The flames should be allowed to set up for at least an hour before applying the clear top coat. Follow the paint manufacturer's directions as to the window of opportunity for applying the clear.

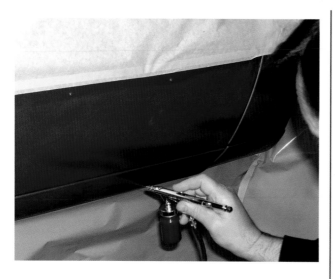

A dark, reddish purple was used for the first color. It serves as a base for the subsequent colors. It is applied rather dry. The airbrush is held 3 to 4 inches from the surface. Quite a lot of paint is applied in big, broad strokes.

Bright red is the second color. This is the primary defining color, so quite a lot is used. Notice that the red is applied in long streaks and big curls.

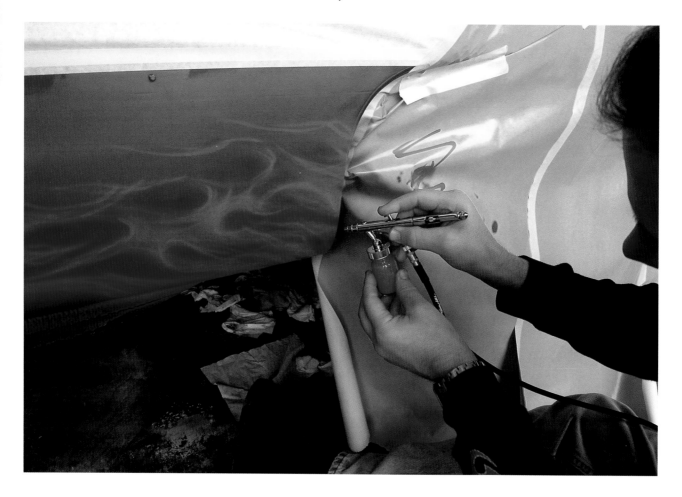

Orange is the third color. Less of it is used than the red. Start out lightly with the orange and add more as needed. Red and orange are the two primary colors of these flames.

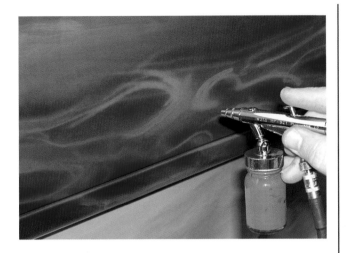

As the application of orange paint progresses, Roy holds the airbrush closer to the surface. That increases the intensity of the color.

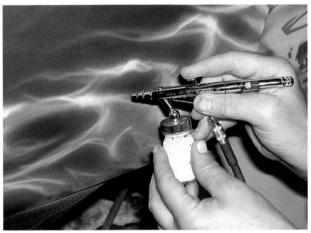

Pale yellow or white paint is used as the final highlight color. Notice that for these little details, the airbrush is held very close to the surface and only a small amount of paint is applied.

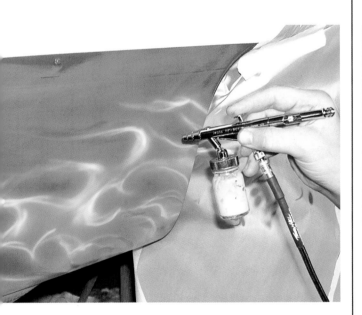

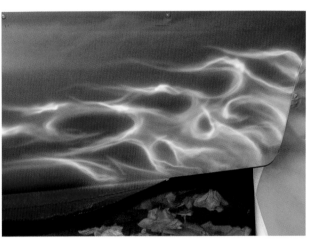

Here are the realistic flames behind the rear wheel well before the clear top coat has been applied.

Yellow is the fourth color. It is applied more toward the front of the flames as a highlight color. These flames start at two places, behind the front wheel well and behind the rear wheel well.

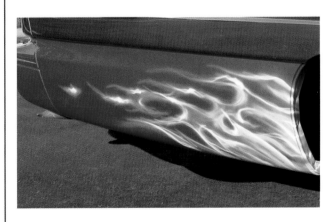

Here is the same area after being clear coated. The clear increases the depth and luster of the flames. This Buick doesn't have inner wheel well trim, so the flames were wrapped around this area.

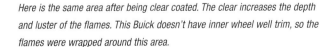

These full views of the big, low Buick wagon shows how the realistic flames add interest without overpowering the car. The flames work well with the bright orange body color and fake wood paneling.

CHAPTER 10
EASY, NO-SPRAY FLAMES

There are many methods of flame application. Without question, a full-on spray booth-applied base-coat/clear-coat flame job with wild custom colors and intricate airbrush detailing will give the best results. If you're not seeking show quality flames, many alternate methods can also provide excellent results.

Probably the neatest trick we uncovered while researching this book is what we call 1 Shot flames. Roy Dunn was generous enough to share this insider technique. We first became aware of this technique when we complimented the slick flames on Roy's brother Allen's primered '49 Plymouth two-door sedan. Photos of the car and flames are included in this chapter. We were surprised to learn the flames were applied with a common household foam paint roller.

This technique is a variation of how sign painters cover large areas quickly. Rather than tediously brush on paint, they use a small foam roller to apply a large amount of paint quickly. Roy uses this technique when he is lettering commercial trucks, for example.

Three key elements of this technique are sign painter's masking material, also known as transfer tape; 1 Shot sign painting enamel; and a foam paint roller. The masking medium goes by various names such as Transfer Rite, R Tape, or Auto Mask. If you can't find transfer tape at a local sign painters supply, a little Internet searching will turn up mail order sources. The job could be done with traditional masking tape, but it would take much longer, and the design stage would be more difficult.

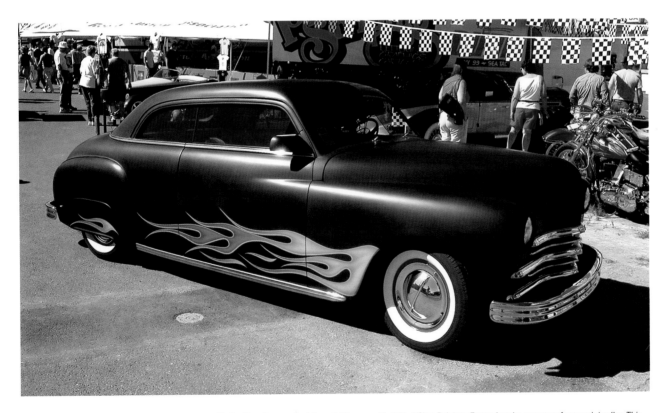

Allen Dunn built this chopped '49 Plymouth coupe. His brother, Roy, applied the wild flames with 1 Shot Sign Painters Enamel and a common foam paint roller. This technique is easy to duplicate.

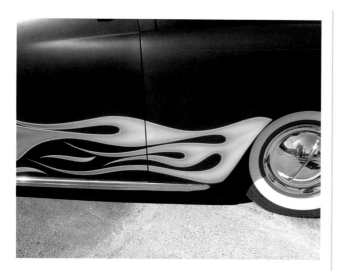

This close-up view of the 1 Shot flames shows how the edges were fogged. The flames were outlined in bright lime green. The green really helps the orange and yellow flames pop off the primered car.

Transfer tape comes in a variety of sizes and is available from commercial vinyl sign making supply firms. The flames can also be done with traditional masking tape, but transfer tape is much quicker.

A key ingredient for 1 Shot flames is obviously 1 Shot Sign Painters Enamel. This bargain-priced paint comes in a huge array of standard colors, plus wild fluorescent and pearl colors.

The masking paper is a light tack adhesive paper. It's best that the paper be solvent-proof, so some general art supply store frisket materials might not work as well as products made specifically for sign painters. The transfer mask is usually clear or slightly opaque, so you can see what's underneath and still be able to do layout work on top.

Sign Painter's 1 Shot Lettering Enamel is the longtime staple of the sign painting industry. It has excellent flow out characteristics and doesn't require a clear top coat. Besides all the factory color choices, you can make virtually any color you desire by combining colors. It can also be sprayed through an airbrush when properly diluted.

Roy Dunn has painted numerous cars and trucks with 1 Shot flames. There are a great number of wild looking Chrysler PT Cruisers in the Pacific Northwest sporting Roy's 1 Shot flames. Unless you're a professional painter you wouldn't know that they weren't done in a spray booth.

This technique is very popular with new car dealerships. Roy can paint the flames at the dealership, if necessary, since a spray booth isn't required. The technique is also very popular with semitrucks. Owners of these big rigs want the flashy looks, but not the upkeep of a true custom paint job. The 1 Shot striping enamel is very durable and easy to touch up if it ever gets scratched or chipped.

One Shot flames are perfect for primered cars. They look great against the matte finish paint and they can be removed without ruining the paint job. Sign painters often use spray-on oven cleaner when they need to remove lettering. If you ever try to use oven cleaner, experiment on something expendable before using it on a car. If not used properly, the oven cleaner can take off more than the paint you wanted to remove.

By painting 1 Shot flames on a primered vehicle you can see how they will look without spending much money. One Shot enamels cost a mere fraction of custom automotive paints. Since the car is in primer, removing flames at this stage is pretty easy. The 1 Shot flames might look so good that you will decide to leave the car in primer. That could

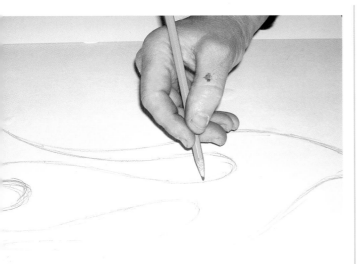

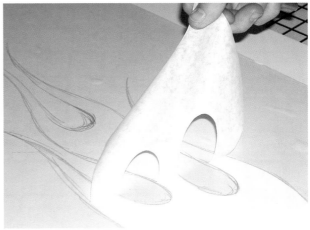

Lift the transfer tape and slowly remove it by pulling it back over itself as shown. If the cuts were smoothly made, the tape will separate easily.

Roy Dunn started the 1 Shot flame demonstration by placing a piece of sign transfer tape over a metal sign blank. Roy uses the Transfer-Rite brand, but any similar product will work. The transfer tape allows him to sketch the flames with a common pencil.

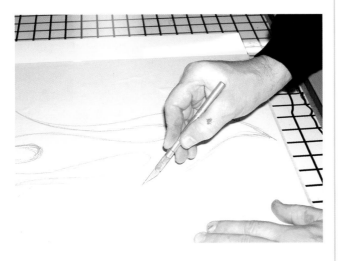

Use an X-acto knife with a fresh blade to gently cut out the design. You want to cut the tape, but not the underlying metal. It is very important that the painted surface does not get cut.

save thousands of dollars that you might spend on a full custom paint job.

To demonstrate how to apply 1 Shot flames Roy used a prefinished blank metal sign. He didn't prep the surface, but if the flames were going on a car it would be prepped first. Standard practices such as washing, wiping down with wax and grease remover, scuffing with a Scotchbrite pad,

wiping down again with wax and grease remover, and using a tack rag apply.

A single piece of Transfer Rite masking paper was placed on the sign blank. Use care with the masking paper to avoid any wrinkles. A plastic squeegee can be used to smooth out any minor wrinkles. When larger areas are being flamed, the masking paper can be slightly overlapped. If you were to try a butt joint there is too great a possibility of paint getting between two pieces.

Once the masking paper is in place, a common lead pencil can be used to sketch the flames. The design doesn't have to be exact at first. It only matters where you finally decide to make the cuts. You could also draw with a grease pencil or a Stabilo pencil. Stabilo pencils are available at art supply outlets. Stabilo pencils are water soluble, which is preferable to grease or china markers.

When you're satisfied with the design, use an X-acto knife or similarly sharp, fine-point knife to cut out the design. Great care must be used on this step, especially if the flames are going on a painted, rather than primered, surface. You must cut only the masking material. Any cuts in the actual paint will show up later.

A sharp knife and a light touch will help you achieve crisp tape edges. It wouldn't hurt to practice making some cuts before trying it on a vehicle. A key technique is to make a continuous cut from one flame tip to another. Don't stop cutting in a curve or in the middle of a line. You won't be able to accurately start up again, and that will leave a ragged template. After the area to be flamed has been removed, go around the edge of the design with your finger to be sure the mask is firmly attached.

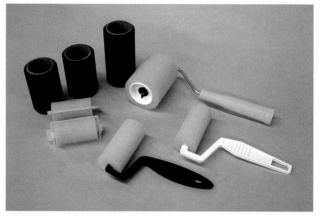

The key to painting flames without spray equipment is an inexpensive foam paint roller. A 3- or 4-inch wide roller is sufficient. The foam must be smooth.

Small foam rollers are available in a variety of widths. There are inexpensive replacement rollers. These rollers only cost a couple dollars. Foam hair rollers can be used to experiment with different colors and techniques on the tips.

Color choice is up to the individual, but the possibilities are endless, since there are so many 1 Shot colors. If you go with a custom made shade, be sure to mix up enough to cover the whole project. The traditional flame hues of red, yellow, and orange are easily obtained right out of the can. If you really want something wild, try 1 Shot's wild fluorescent or pearl enamels. The fluorescent colors really jump off a primered vehicle.

The application tool is a 3- or 4-inch-wide foam paint roller. These little trim rollers are available at home improvement centers for a couple dollars. The foam needs to be clean and free of any debris. A way to be sure the foam is clean is to run a piece of masking tape over it.

The 1 Shot lettering enamel is applied full strength. Pour it on a "palette" such as a glossy magazine page. Run the foam roller through the paint until it is saturated but not dripping with paint. Apply the paint to the vehicle by lightly rolling it on. A light touch spreads the paint without creating any texture. Don't make any more passes than necessary with the roller.

It's best to apply a single color with the roller. If more colors are desired it can be tricky where the different colors meet. The best way to add more colors is with an airbrush. Roy Dunn uses his trusty Iwata Eclipse airbrush, hooked up to an Iwata Power Jet portable compressor. The silent style compressor is about the size of a small suitcase so it's easily transportable, and it supplies all the air he needs.

Adding highlights with an airbrush really makes the flames come alive. The highlights should be added right after the main color has been applied. One Shot lettering enamel needs to be reduced to flow properly through an airbrush.

One Shot offers its own reducer, or you can use mineral spirits. Mix the paint and reducer in a little paper drinking cup. You can start with a 50/50 blend, and experiment to find the ratio that works best with your airbrush. You want the paint to be thin enough to flow well through the airbrush, but you don't want it to be so wet that it runs or sags.

Highlights can be wherever you please, but the traditional places are along the edges, at the tips, and on the inside edges of the curves. On the sample flames, Roy used orange along the edges and magenta at the tips. He also added a little magenta to the inside of the curves. When you look at the photos it might appear that a lot of paint was applied with the airbrush, but there is as much on the masking material as the actual metal surface.

It's best to work quickly when applying the highlights. When all the colors are still wet they blend together better.

As soon as you're through applying color you can remove the masking materials. Start at the tips and pull forward. Lift the mask up high away from the paint. You don't want the mask to touch any of the still-wet paint.

On our sample flames, Roy pinstriped them right away. That's easy for a pro to do because he knows how to keep his hands out of the fresh paint. A beginner might be better off waiting for the paint to dry before doing the pinstriping.

Pinstriping takes much more practice than painting these easy flames, so you might want to skip this step or have a professional do it. A tip that Roy Dunn passed on for making the difficult inner curves is to use a small lettering quill instead of the striping brush. The shorter bristles of the lettering quill are easier to control than the long bristles of the striping dagger or sword. The downside is

The foam roller must be totally free of any lint or debris. Use a piece of masking or duct tape to clean the foam prior to immersing in paint.

Pour the 1 Shot Sign Painter's Enamel on an old glossy magazine. The magazine serves as a palette. Lemon Yellow was used for the base color.

that the quill doesn't hold much paint, so you can't do long, uninterrupted lines with one. The quill width should match the pinstriping brush.

One Shot flames are a great way to learn about flame painting. You can put them on mailboxes, tool chests, trash barrels, or whatever. It's a good way to practice your layout skills without spending much money on paint or equipment. One Shot flames look great and they're easy to do.

Load the foam by rolling it through the paint several times. Make sure it's saturated with paint.

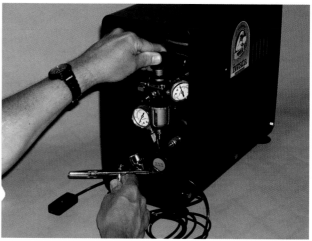

Roy Dunn shared a secret to smooth paint application. Hold the roller handle as lightly as possible. Let the paint flow out of the roller without bearing down. Take advantage of 1 Shot's excellent flow-out characteristics.

One Shot flames can be greatly enhanced by airbrushing highlights. A small portable air compressor like the Iwata Power Jet supplies plenty of air. This is the compressor Roy Dunn carries when he paints these flames away from his shop. The built-in pressure regulator has a large knob for easy adjustments.

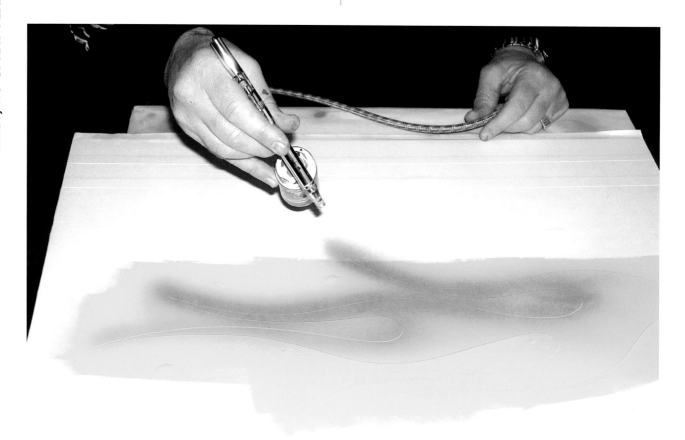

Roy adds highlights to the outer edges and inner curves by reducing some Orange 1 Shot enamel with either 1 Shot brand reducer or mineral spirits. Reduction ratios are a matter of experimentation. He uses his trusty Iwata Eclipse airbrush.

Magenta was used on the flame tips. Roy uses an Iwata Eclipse airbrush. The bright colors are out-of-the-can 1 Shot colors, so they can be easily touched up if necessary.

The precision control of the Iwata airbrush allows Roy to fog in magenta highlights at the inside curves. It might look as if a lot of paint has been applied, but it won't look that way once the mask is removed.

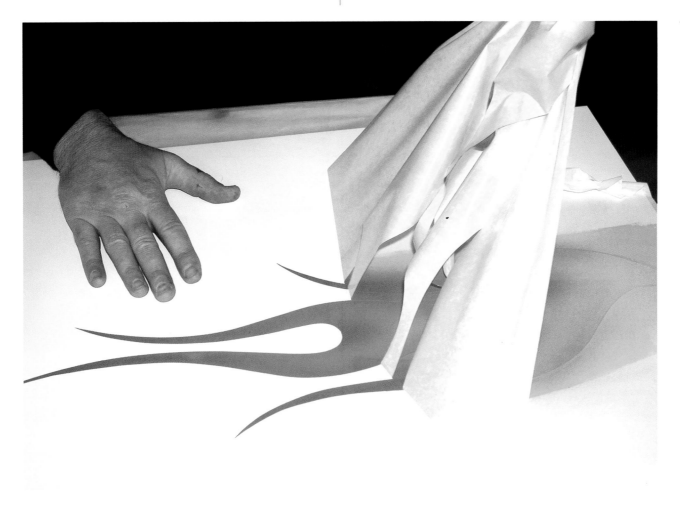

Remove the masking tape by starting at the tips. This makes for smoother edges. Pull the tape up high away from the still wet paint.

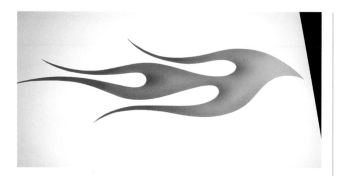

Here are the unmasked flames. They look fine as is, but Roy adds pinstriping to make them really pop.

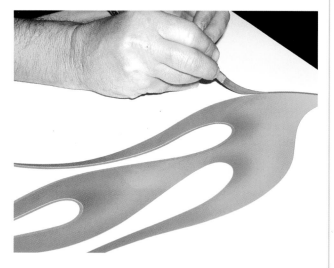

Roy uses 1 Shot Process Blue to outline the flames. This is a very popular color for outlining flames. Roy uses a No. 00 pinstriping brush to make the long, relatively straight lines.

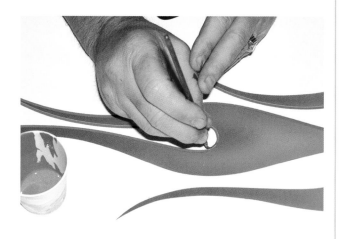

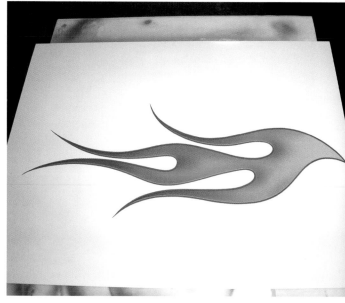

Here are the finished 1 Shot flames. Besides being quick and easy, these flames don't need a clear top coat because 1 Shot is a glossy enamel.

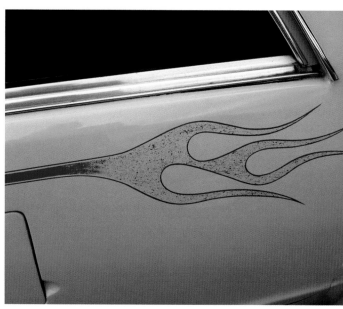

One Shot flames can be enhanced by adding patterns or textures. A small piece of natural sponge dipped in 1 Shot enamel can be blotted inside the flames before removing the masking material for a unique effect.

LEFT: Curves are the trickiest part for novice pinstripers. A trick Roy uses is to switch to a small lettering quill for the inside curves. It's easier to manage the short bristles of the quill. The lettering quill size needs to match the pinstriping brush.

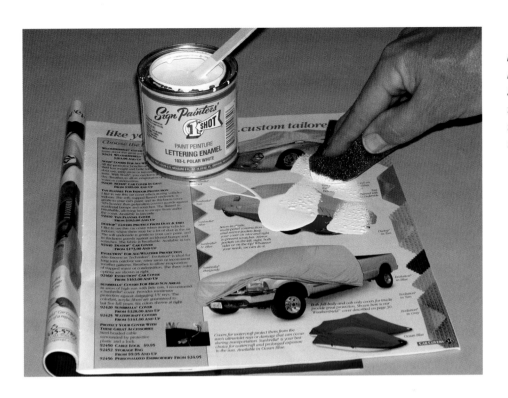

An airbrush is best for highlights, but relatively soft highlights can also be made with a soft sponge and white 1 Shot. Palette the white paint and dab the sponge in it. Then remove most of the paint by pressing it on a dry part of the palette.

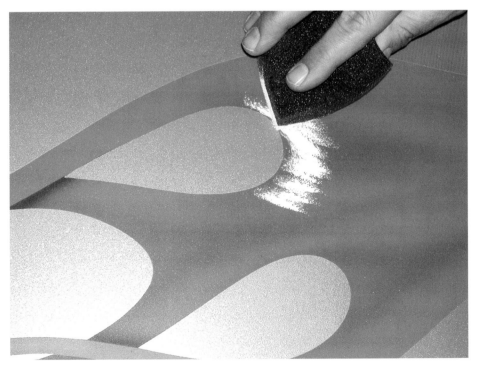

Lightly apply the almost dry white paint to the areas that need highlighting. If you want the highlights to be more prominent, make repeated applications with the sponge. In this example, the sponge needed a little less paint. The good thing about 1 Shot enamel is that mistakes can be wiped off with a clean, soft rag. Ideally, this should be done while the flame is still masked.

CHAPTER 11
GHOST FLAMES

Not everyone likes bold, brash, in-your-face flames. Some people prefer subtle flames. The ideal flames for these people are ghost flames. Ghost flames get their name from their "now you see them, now you don't," ethereal look. Ghost flames often virtually disappear in subdued light only to shine brightly in the sunlight.

The term ghost flames is used rather loosely. Some flames that can be seen in almost any light, but are noticeably more transparent than solid color flames are also called ghost flames. The degree of "ghost" varies, but all ghost flames use less paint than traditional flames.

Ghost flames can be achieved in several ways, but more transparent paints are usually involved. The two types of paint most often used are pearls and candies. Other paints can be used if they are diluted and sprayed on very thin.

Ghost flames can be achieved using multistage paints with the flames themselves masked, instead of the usual practice of masking the surrounding area. In this case, the vehicle is covered with one coat of the base color. Then the flames are designed and the area inside the border is taped. Then one or two additional coats of the base color are applied.

After the desired color is achieved, the tape is removed. The flames are the same basic color, but several shades lighter. This can be an effective way to have ghost flames that are a little lighter than the final color. The degree of hiding will vary, depending on whether the flames are taped over after one coat or two coats. The most buried flames are achieved when the flames are taped after one color coat.

Pearl paints are a mainstay of ghost flames. The iridescent nature of pearl paints makes them perfect for this technique. The tiny reflective particles are great for catching light. House of Kolor offers a tremendous variety of possibilities for ghost flames, including many variations of pearl paints. House of Kolor has dry and paste pearls, which can be added to clear or other colors; Kameleon Pearls, which change colors when viewed from different angles; Ice Pearls, which have more brightness and sparkle than traditional

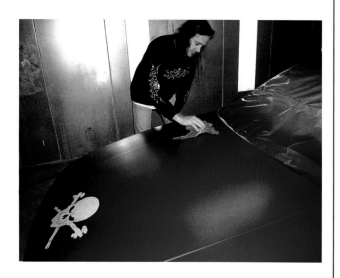

The massive hood on Roy Dunn's Buick Roadmaster station wagon was too much "canvas" to leave blank, so he covered it with ghost flames. The car had just been painted Chrysler Prowler Orange by Tim Fergurgur, so the surface only needed a cursory cleaning and a wipedown with a fresh tack rag.

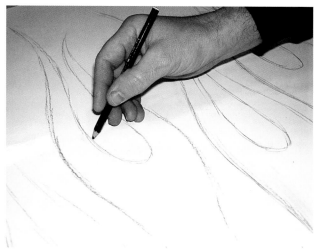

There was a big time crunch on this project, so Roy tried a new type of masking material. A relatively lightweight static-cling-vinyl sign painter's mask was used. It was easy to draw on and cut, but it had a tendency to lift from the force of the atomized paint. The first step was to sketch the flames on the masking material with a blue Stabilo pencil.

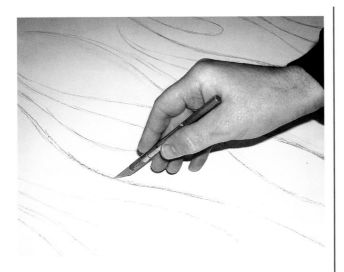

An X-acto knife was used to cut out the mask on a big, flat workbench. Since the mask wasn't cut on the car, there wasn't any concern about cutting too deep.

pearls; Shimrin Universal Pearls; Shimrin Black Pearls; and Shimrin Designer Pearls.

The many House of Kolor Kandy paints are also excellent for ghost flames. The nature of candy colors is that several coats are required for full coverage. Ghost flames can be created by using less paint.

A key technique for successful ghost flames with pearls is to make sure the pearl pigments stay suspended during the entire paint job. If the pearl isn't evenly distributed, the paint will look blotchy or striped. The pearl should be thoroughly stirred and re-stirred if the paint sits for more than a couple minutes.

Ghost flames are seldom pinstriped. If they are, they become a hybrid ghost/pinstripe flame. Since ghost flames usually aren't pinstriped, extra care must be taken during the taping and masking stages. Crisp borders are a must because you don't have the luxury of pinstriping to hide any uneven edges or small paint bleeds. Making sure the tape edges are secure is more important than ever with ghost flames.

One exception to the need for crisp edges is a design that gives the illusion of amplified motion. Then a few blurry edges can pass for added motion. Also, depending on how ghostly the flames are, some less-than-great edges probably won't be noticed by anyone without a magnifying glass.

The style of ghost flames affects how they are achieved. If the ghost flames are pretty traditional in size and shape, standard taping and masking procedures can be used. The main difference is in the type of paint and how much of it is used. If the ghost flames are the busier, multilayered overlapping style, some type of mask or template is usually employed.

The mask can be made from adhesive transfer tape to save masking time, or it can be a cut out template. Templates can be made from common poster board or various plastic films. There are also commercially made solvent-proof masking templates. The templates are moved around as each light dusting of pearl or candy paint is shot. Templates are much faster when lots of licks are involved, but rushing can lead to paint in unwanted areas.

When it comes to mistakes and goofs, ghost flames are pretty forgiving. Since they are so transparent, their appeal is the overall effect rather than a careful inspection of each individual lick. If the multilayered ghost flames involve different colors, it is possible to position subsequent colors so they help hide bleed-throughs or other errors.

A poster board mask obviously works best on relatively flat surfaces. The use of a mask allows the ghost flames to be applied quite quickly. Since only light amounts of paint are being applied, the paint flashes quickly. The mask can then be moved to the adjacent area without fear of smearing the previous area. The same mask and different colors or slightly different masks can be used over the already painted sections.

Poster board masks have a limited life span. If they get too much paint on them, the edges will get fuzzy. However, poster board is very inexpensive, so this shouldn't be a problem.

Depending on the area to be covered, ghost flames can be done with a full-size spray gun, a smaller detail gun, or an airbrush. Since not a great deal of paint is being applied, a small, lightweight gun like the Iwata LPH-50 or RG-2 works very well for this technique. Airbrushes work best on

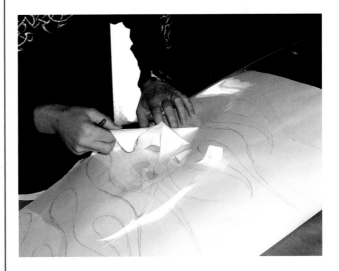

The masking template was separated from its protective backing material. The lightweight material had a tendency to wrinkle, so it took two people to maneuver it.

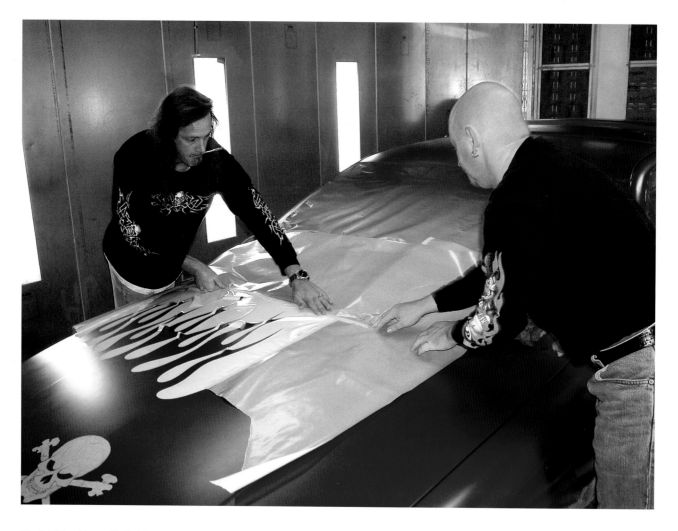

The Buick hood is so wide that the stencil wouldn't cover the full width. It had to be positioned, masked, painted, and moved to the left side of the hood. Tim Fergurgur, who applied the orange base coat, helped Roy position the stencil.

small detail areas like air cleaners, valve covers, dashboards, or motorcycle tanks and fenders.

As with so many other flame techniques, it's a good idea to practice on sign blanks or an old hood before attacking a real vehicle. By painting a test panel, you can get a good idea of how much paint is needed to achieve the desired effect. Always check your sample flames in bright sunlight, because that is where ghost flames really come alive.

The main example photos in this chapter were shot while Roy Dunn was painting his Buick Roadmaster station wagon. Roy was up against a tight deadline, so he needed to minimize layout and masking time. He made a moveable mask out of lightweight static cling sign masking vinyl. It was easy to draw on and cut, but it had a tendency to lift from the pressure of the atomized paint. The same general techniques would apply if a more rigid mask were used.

Travis Moore, another well-known custom painter from Olympia, Washington, helped us shoot some ghost flames on metal sign blanks. These inexpensive blanks come in a variety of sizes and are perfect for practicing. Travis made stencils out of poster board. When cutting out the design, Travis suggests making one smooth, continuous cut on each flame lick. If you stop midpoint you're likely to get a hiccup in the template, which can show up in the final product.

Travis used House of Kolor Shimrin Universal Basecoat in an Iwata Eclipse airbrush. If he had been shooting a real car, he would have used an Iwata LPH-100 or LPH-300 spray gun. On the sample panel he used Hot Pink (PBC-39) and Violet Pearl (PBC-40), since the pink and violet shades complement each other.

Travis also added House of Kolor Gold Ice Pearl to HOK Intercoat Clear to cover some Shimrin Tangelo flames. In

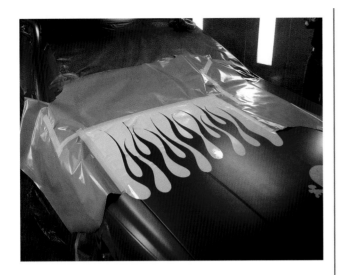

this case, the flames weren't ghost, but adding the pearl gave them more interest. The SG-100 Intercoat Clear is often used as a medium for applying pearls.

Pearl paints should always be well covered with protective clear. The idea is to bury the pearl under the clear, so that color sanding and buffing won't affect the pearl.

The key thing to remember about ghost flames is to go easy with the paint. Adding more paint is simple, but taking away paint isn't. Ghost flames are a great way to be bold yet slightly conservative at the same time.

The high contrast between the white vinyl mask and the orange base coat clearly shows the flame design. Relatively big licks were used because this is such a large hood. Painting started near the windshield and moved forward.

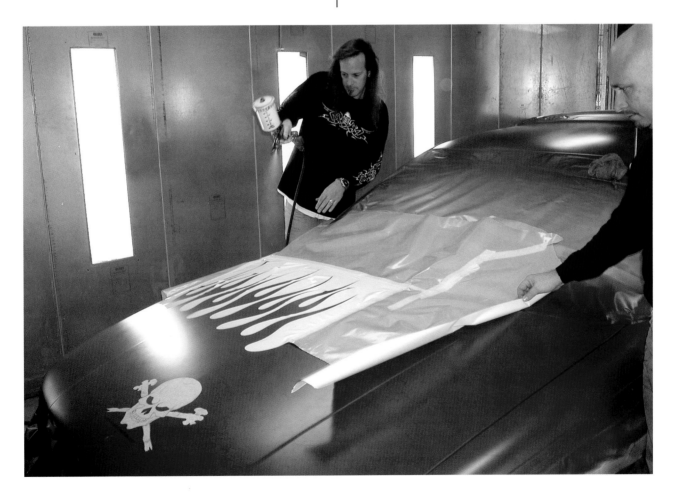

House of Kolor Dry Gold Pearl was used with a slow reducer. It was applied in very light mist coats. Every time the mask was moved, the hood was wiped with a tack rag. Most of the paint was concentrated at the tips of the flames with less paint near the inside curves. Roy shot paint from the rear to help minimize mask movement.

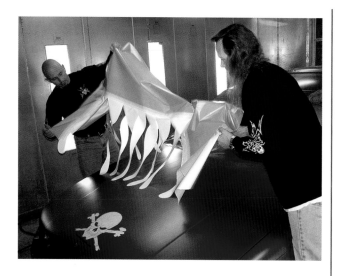

After the first application of pearl flashed, Tim and Roy carefully lifted the mask up and away from the painted section.

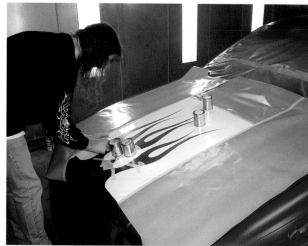

A smaller mask was made for the licks in the center of the hood. Those licks flow from the skull and crossbones that will be airbrushed in the center of the hood, once the flames are done. Positioning the mask is very important for the best looking flames.

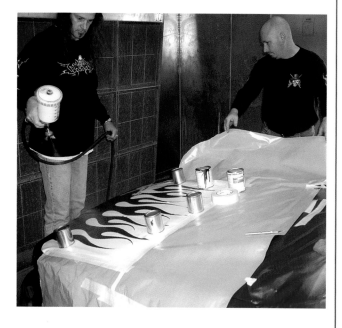

The mask was repositioned several times to get the desired number of ghost flame licks. Clean paint cans were used to help keep the mask in place. A full-size HVLP spray gun was used. Notice that the gun is at least 2 feet away from the hood, and the paint is being lightly misted.

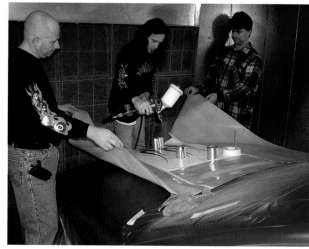

To help minimize overspray, the edges of the surrounding masking paper were held up to serve as a shield.

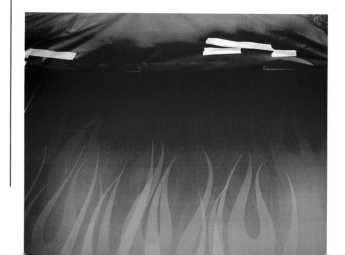

RIGHT: It's not real easy to see in a photograph, but the gold pearl ghost flames do an excellent job of covering the massive hood. Each time the mask was moved, it was shifted slightly to one side. That helps keep the flame tips staggered.

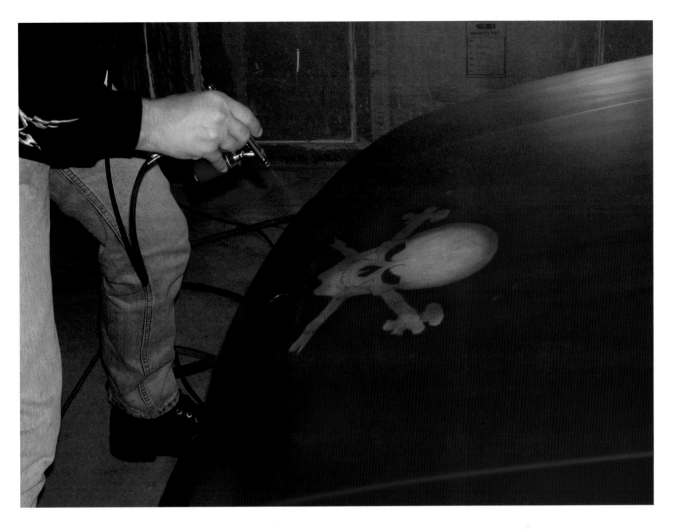

Regular sign painting transfer tape was used to make the large skull and crossbones stencil. The individual toners that made up the orange base coat were used in an Iwata Eclipse airbrush to outline the skull. By using toners, the skull became a variation of the main color.

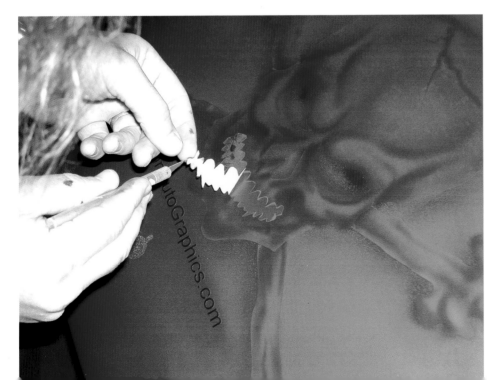

Different sections of the mask were removed as other colors were applied. As each section was outlined and removed, Roy did the details freehand.

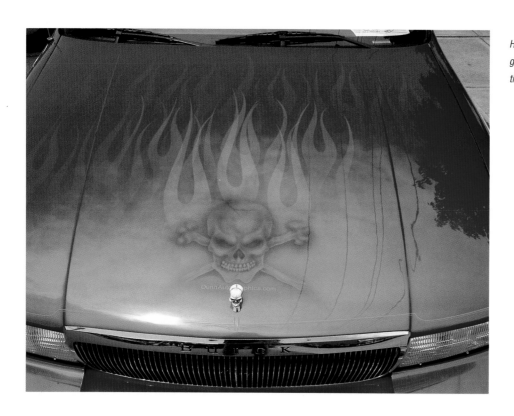

Here is a shot of the finished skull graphics. The hood ornament is also a tiny skull.

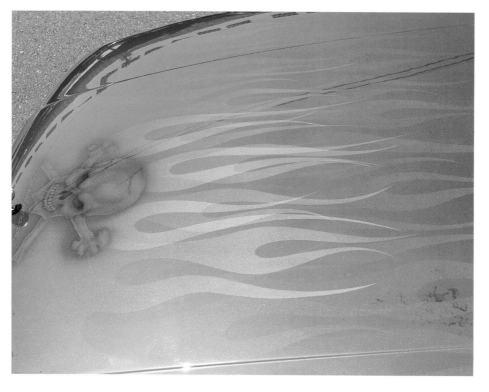

The gold pearl ghost flames work great with the metallic orange paint. The flames really come alive in the sunlight.

House of Kolor has all the bases covered when it comes to pearl paints and pearl powders. By using a combination of base pearls and clear with powdered or paste pearl, you can create a wild array of ghost flame effects. House of Kolor also makes Kameleon Pearls that change colors, depending on how they are viewed.

House of Kolor Intercoat Clear (SG-100) can be used as medium for delivering powered or paste pearls. SG-100 must be applied over Shimrin Universal Bases only. The color of the base determines how much pearl to use. It pays to experiment.

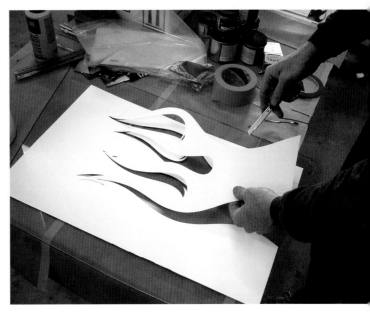

Award-winning custom painter Travis Moore demonstrates how to make a simple ghost flame pattern with common poster board. The design was sketched and carefully cut with his stainless snap-blade utility knife. Poster board patterns have a limited life span, because paint makes the edges fuzzy after a while.

For our example ghost flames, Travis chose complementary colors, House of Kolor Shimrin Base Coat Hot Pink (PBC-39) and Violet Pearl (PBC-40). Small quantities were mixed with RU-311 reducer.

LEFT: Ice Pearl powder from House of Kolor is a great product for painting brilliant ghost flames. The tiny glass flake pigments are brighter in sunlight than traditional pearls. A clean Popsicle stick was used to add Ice Pearl Gold to a small Dixie cup of SG-100 for use in an airbrush. A little Ice Pearl goes a long way, so use it sparingly.

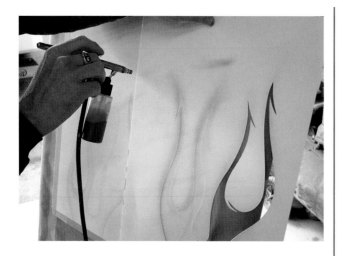

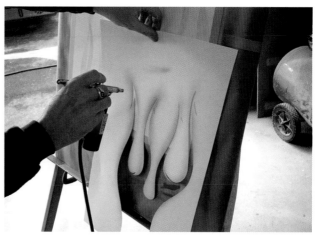

This example piece was being painted on a metal sign blank, so surface curvature wasn't a consideration. The stencil was positioned, and light coats of Hot Pink were applied with an Iwata Eclipse airbrush. When using a stencil, the amount of paint needs to be right the first time, because you can't accurately reposition the stencil.

After enough Hot Pink was applied, Travis switched to a second bottle with Violet Pearl paint. By having separate bottles with different colors, you can add colors at will. These inexpensive plastic, solvent-proof bottles come in various capacities and easily slip onto the Iwata Eclipse airbrush.

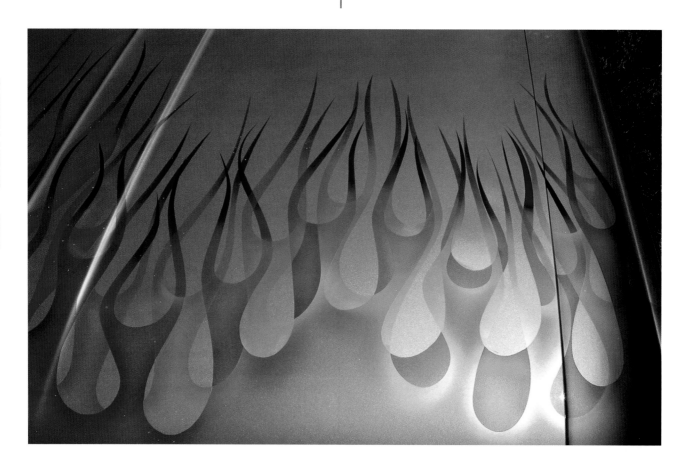

A common technique with ghost flames is to use variations of the base color. This car was painted a metallic greenish blue, so shades of green and blue were used for the overlapping ghost flames. The darker of the two main colors was applied first. Notice that darker blue and purple were used at the tips, so the flames are more prominent as they progress.

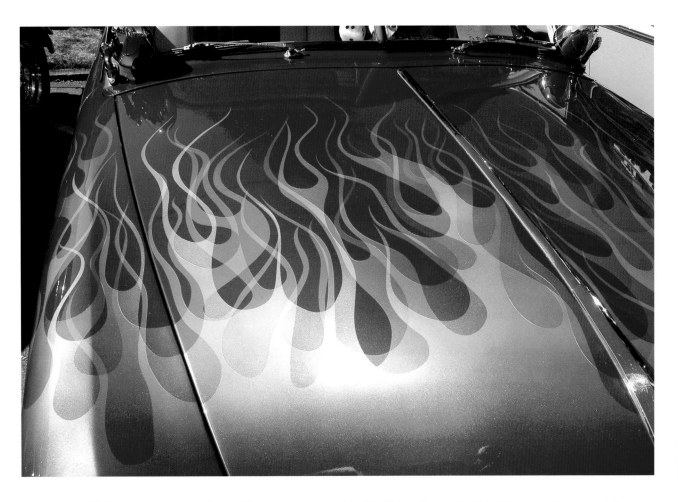

When applying multicolored ghost flames, the order in which the colors are shot makes a big difference to the finished look. This candy red car appears to have a reduced red, followed by gold, violet, and pink (or further reduced violet).

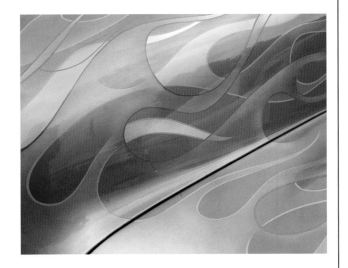

This classic pickup used shades of pink ghost flames over a bronze base, but pinstriping makes them sort of hybrid ghost flames. The pinstriping is relatively subtle in pastel shades of pink and purple. This interesting effect proves there are no hard and fast rules for flame painting.

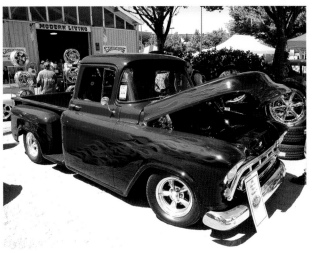

This '57 Chevy pickup has elaborate, but beautiful semighost flames. From a distance, the truck appears candy red with a darker nose, but up close you can see the multilayered flames that cover the hood, front fenders, doors, and rear fenders.

The inner bed panels of the '57 Chevy pickup are smothered in flames like the rest of the truck. This is an outstanding use of flames. They're both subtle and bold at the same time. The bed panels were painted while the bed was apart, which simplified the job.

A ghost flame variation is to paint them inside traditional flames. This Model A street rod used black ghost flames for a smoky effect, but it would also work with shades of orange or yellow.

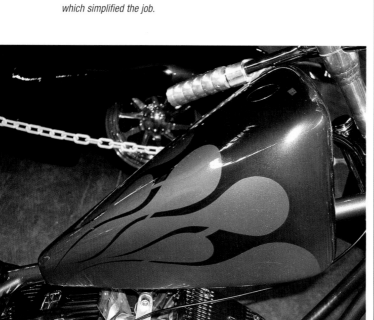

Sometimes ghost flames can be too subtle, as is the case on the motorcycle tank. The pearl white ghost flames are so transparent that from any distance it appears that the main gray flames have a series of gaps. More pearl or something like a blue tinted pearl might have worked better.

GHOST FLAMES

CHAPTER 12
PINSTRIPE FLAMES

Flames don't need to dominate an entire vehicle to be effective. Ghost flames can be very subtle, since they're not always visible. Pinstripe flames are subtle, but they're more evident than ghost flames. Pinstripe flames are an easy, inexpensive way to add flames to a vehicle.

We're talking about two types of pinstriping. There are the stand-alone pinstripe flames where the pinstripe is the flame, and traditional pinstriping that serves to outline and highlight regular, painted flames. There are situations where both styles are used. This can be an effective way to add motion without laying out a complete second or third set of flames.

The easiest way to get pinstriped flames is to pay a professional striper to do them. You can do them yourself, but the results depend on your skill as a pinstriper. In order to do totally freehand stripes you need to practice. A neat thing about 1 Shot lettering enamel (the standard paint for most pinstripers) is that it dries slowly. This means if you don't like the way a line looks, you can wipe it off with a rag and start over.

An old, clean T-shirt makes an excellent rag, because it's soft and easy to wrap around your index finger. Since the T-shirt isn't very thick, it allows good control of where you wipe without affecting the areas you want left alone.

STRIPING TRICKS AND TECHNIQUES

There are some tricks to make pinstriping easier for novices. One trick is to lay out the design with blue 3M Fine Line Tape. You can use any width you wish, since the tape is simply a guide. The 1/8- or 1/4-inch tapes are good choices. When you're satisfied with the design, use the tape to guide the brush.

You can also lay out the design with chalk or a Stabilo pencil. A benefit of a Stabilo pencil is that it's water-soluble. Stabilo pencils tend to get soft when warm, so it helps to store them in the refrigerator, especially during warm weather. After sketching the design, lightly rub the area with a dry cloth. The idea is to remove heavy concentrations of Stabilo pencil. You only need a faint image to follow with the striping paint.

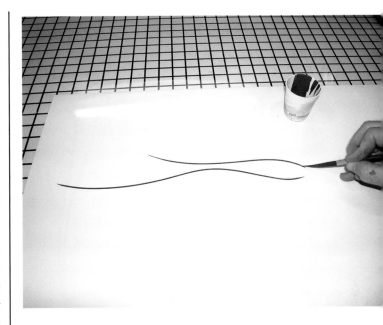

A trick for making pinstripe flames is to pull the two long lines from the tips to the start of the inside curve before painting the curve. In this example, Roy Dunn is using Process Blue 1 Shot Lettering Enamel loaded on a No. 0 pinstriping sword.

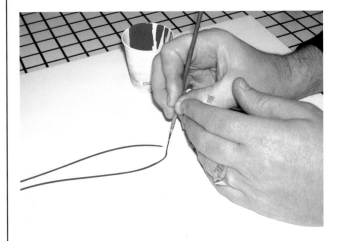

After the two long lines have been pulled, they're connected with a No. 1 lettering quill. The quill holds just enough paint for this short distance, and it's much easier to manipulate.

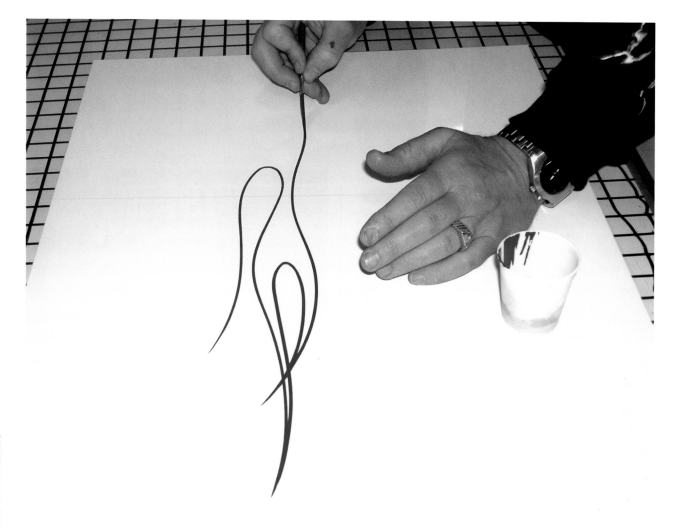

When working on something like a vehicle, it's best to work from the center of the hood to the outside and from the top of the fenders to the bottom. You want to avoid putting your hands in the fresh paint. Notice that one tip overlaps the other for some added interest.

Another technique is to cut out flame templates from white poster board. Use the template as a guide for the brush. Templates can be especially helpful when trying to paint the tricky inside curves. Various premade flame stencils are also available.

Roy Dunn demonstrated a few basic techniques for pinstripe flames. One trick Roy uses is to make the long lines first. He starts from the tip of the lick and pulls the line toward the inner curve area. He stops just after the line starts to curve inward. He paints these long lines with a pinstriping sword. In general, a pinstriping sword is for long lines. A pinstriping dagger (as the name implies) is better for shorter lines. The sword holds more paint than the dagger.

After Roy does a few long lines, he comes back and connects the lines via the inside curve using a lettering quill.

The short bristle quill is much easier to maneuver than the longer bristle brushes. The quill needs to produce the same size line as the sword. In the example photos, Roy used a No. 0 pinstriping sword and a No. 1 lettering quill.

Roy can also do the entire design with a pinstriping brush, but he suggested the lettering quill as an easier alternative for beginners. The design of pinstriping brushes makes it possible to rotate the brush between your thumb and index finger. Rotating the brush is handy when doing curves.

The inside curves need to be connected soon after the long lines have been pulled. This is so the paint doesn't start to dry. When the paint is still very wet, the areas will blend much better. The idea is to make the flame lick look as if it were one nonstop pull from tip to tip. By connecting the

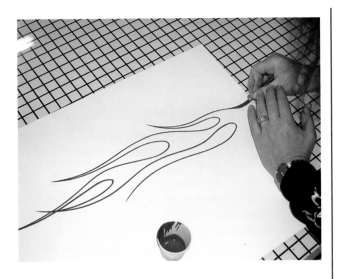

In this photo, Roy is contradicting the suggestion in the last caption, but there is room to work since this is the outside of the test panel. What he is demonstrating here is how he often uses his free hand to guide the hand holding the brush.

Here is the finished pinstripe flame. A metal sign blank, a few cans of 1 Shot, some reducer, and a couple different pinstriping swords, daggers, and lettering quills are all it takes to have hours of fun experimenting with pinstripe flames.

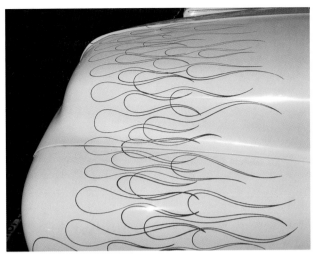

Pinstripe flames are a quick, simple, and very effective way to customize a vehicle without going to all the effort of a traditional flame job.

lines quickly, you lessen the chance of getting your hands in wet paint as you move across the area being painted.

PAINTS AND BRUSHES

Roy likes to reduce his paint about 10 to 20 percent. He wants it to flow as smoothly as possible without being too thin. You should experiment until you find what works for you. Roy mixes the paint and reducer in small, waxless paper drinking cups. He uses the pages of a glossy magazine as a palette for loading the striping sword. The idea is to get the paint up into the bristles so you will have enough paint to pull a continuous line.

There are different schools of thought regarding palettes for paint. Old phone books used to be a staple of the pinstriper's kit, but more stripers favor glossy magazines nowadays. The potential problem with the more absorbent phones books is that they absorb the solvents. The palette is a convenient place to adjust the ratio of paint to reducer and load the bristles.

Loading the brush bristles takes practice. You want a full load of paint, so the longest possible uninterrupted lines can be pulled, but you don't want to overload the brush and get sags, where the paint starts to run and won't stay where you apply it. Some painters like to put paint in a small paper cup and use their fingers to work the paint into the bristles. If you use this method you should wear protective gloves. Pulling the brush through the paint on the palette gives you a feel for the paint. This "feel" helps experienced stripers know if when the paint is the right consistency.

Getting the right consistency is important for smooth-flowing paint. You want the paint to flow without dripping. Like so many things in custom painting, getting the perfect consistency requires practice.

There are two types of pinstriping paint—the old favorite Sign Painters' 1 Shot Lettering Enamel (1 Shot for short) and the new kid, House of Kolor Urethane Striping & Lettering Enamel. The HOK paint can be used underneath clear coats, while 1 Shot is designed to go on top of

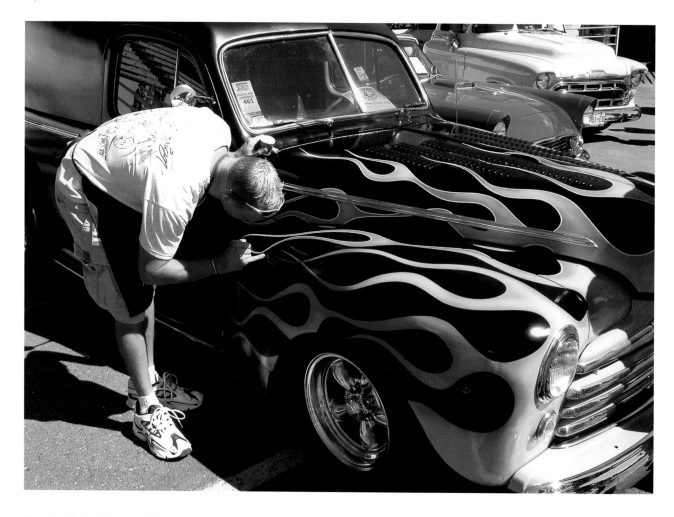

If you don't feel confident enough to do your own pinstriping, let a pro do it. Pinstripers tend to frequent big car shows and street rod events because there is so much potential work there.

the clear coat. It is possible to add catalyst or hardener to 1 Shot and use it under the clear, but most stripers prefer to apply 1 Shot as the final touch.

Both types of striping paint are available by mail order from The Eastwood Company (www.eastwood.com) in Pottstown, Pennsylvania. Eastwood also carries a full line of Mack pinstriping and lettering brushes. The striping brushes are available to paint lines from bold to very fine. Lettering brushes are available in a variety of widths and bristle shapes. Eastwood also carries magnetic striping guides and lots of resource materials.

Pinstriping supplies are very affordable, so you don't have to invest in a lot of expensive equipment to see if you have a knack for striping. Metal sign blanks are a good practice surface, since the metal approximates a car body. Some people like to practice on pieces of common window glass.

SPRAY PINSTRIPING

True fine line pinstriping takes lots of talent and practice. You could use blue 3M Fine Line Tape to back tape the flames and then stripe the outline. This technique involves a great deal of taping, but it prevents a wiggly line from crossing into the flames. Keep in mind that true pinstripes aren't laser perfect. That's part of their appeal, because they don't look machine made or taped. You just don't want them to look too imperfect.

One method of outlining flames without hand pinstriping is known as spray striping. It's also known as back taping. Instead of hand striping, the outline color is sprayed first. The area where the "striping" is desired is then taped over. After the flames have been sprayed, the thin border tape is removed, leaving spray stripes. This method involves extra taping, but it will get the job done if you don't have access to a professional striper and don't have the skills to hand stripe.

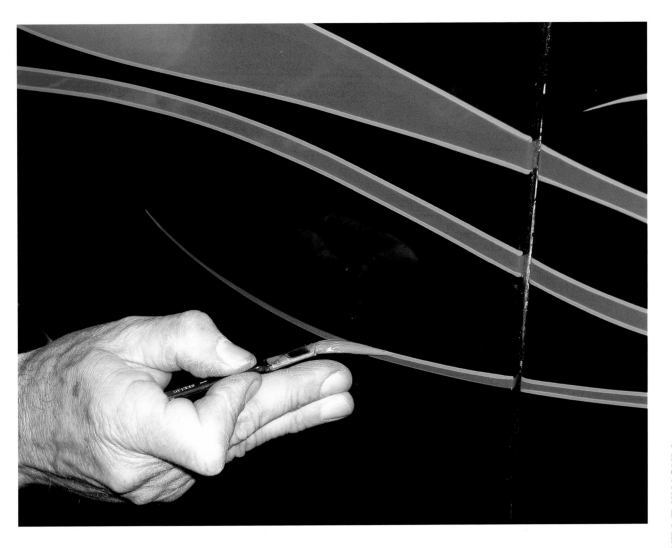

Using pinstriping to outline traditional flames is the most common use. Besides giving added contrast and "pop" to these flames, the striping makes the superthin tips a little more visible. Notice how Donn Trethewey holds the brush at the rounded part of the handle.

This technique works well for flake striping. Since you can't apply flake paint with a brush, the base flake color serves as the outline. Travis Moore demonstrated this technique in the photos and captions within this chapter. The same basic idea applies to nonflake spray striping.

The flames are designed as usual, although you might want to make them 1/8 inch bigger to account for the sprayed striping. The base color is applied. With the flake stripes, it was House of Kolor Silver Mini Flakes (MF-02), which Travis mixed with HOK Shimrin Intercoat Clear (SG-100). This is the base flake color and the pinstripe color.

After the flake dried enough to back tape, the 1/8-inch perimeter of silver is masked off. There are a couple ways to do this. You can simply use 1/8-inch blue Fine Line Tape to follow the inside border of the existing tape outline.

Or, since the silver flake overspray tends to hide the original tape, Travis takes the extra step of tracing the original tape with fresh 1/8-inch Fine Line Tape. Then he comes back with 1/4-inch blue Fine Line Tape and follows the outer edge of the 1/8-inch tape. This effectively covers a 1/8-inch perimeter of the to-be-painted flames. The 1/4-inch tape has better adhesion, and this method lessens the chance of the main color appearing on the wrong side of the silver flake outline.

Then he mixes the candy color(s) for the flames. For this example, House of Kolor Shimrin Hot Pink Pearl (PBC-39) was chosen. Enough paint was applied to achieve a magenta-like hue. When the blue Fine Line Tape was removed, there were some hot pink licks with nicely contrasting silver flake borders.

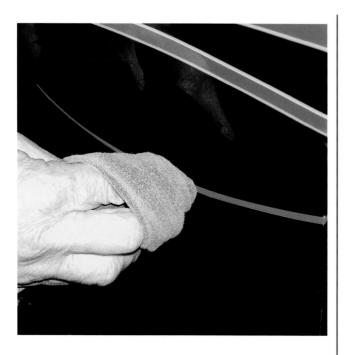

One Shot striping enamel stays wet quite a while, so it's easy to wipe off mistakes or change colors. A soft, clean rag such as an old T-shirt wrapped around your index finger works well for removing wet paint.

A supply of small paper drinking cups and some old, glossy magazines are needed for paint mixing. The magazine serves as a palette on which to load the brush with paint. A separate container holds reducer for achieving the desired paint consistency.

Sign Painters' 1 Shot Lettering Enamel is industry standard for striping paint. One Shot makes a huge variety of standard colors, plus neons and pearls. Painters combine colors for thousands of additional shades. One Shot makes metallic colors, but a trick for improved gold coverage is to mix it with tan. Mixing white or gray with silver makes a superior silver.

SLASH PINSTRIPING

Another pinstriping technique that is somewhat easier for beginners is called slash pinstriping. It's also called ragged edge striping or barbed wire striping. This technique is most often seen on tribal flames. The degree of raggedness varies, depending on the aggressiveness of the flame design.

Travis Moore demonstrated slash striping on some test panels he shot for us. He wanted a bright lime green, so he custom mixed the color by combining House of Kolor Lemon Yellow and Green. Professional pinstripers routinely make custom colors, because it's so easy to do with striping paint.

Instead of trying to pull a continuous line, slash striping relies on a series of short random (or seemingly random) lines. Depending on the striper, the slashes can be nearly parallel to the flame border or more angular. Travis used a traditional striping brush, but a lettering quill will also work.

In Chapter 13 on Rip Flames, Mike Lavallee uses a small lettering quill to apply slash pinstriping to the border of the rips. This style of striping is perfect for rip flames.

Travis did a variation on some mild tribal flames. He did a pretty traditional pinstriping outline and then added random offshoot stripes. Those lines went both with and against the flow of the flame licks. Slash stripes could be done in multiple colors for added interest.

You can't beat traditional, hand-painted pinstriping, but there are creative alternatives.

House of Kolor has a full range of traditional and wild colors in its Urethane Striping & Lettering Enamel line. This striping paint has the advantage of being able to be used underneath clear top coats. That way the lines can be buried smoothly.

The Eastwood Company offers Mack striping and lettering brushes, plus both 1 Shot and House of Kolor striping paints via mail order. These striping swords range from a No. 4 bold line (approximately 1/2-inch wide) to a No. 00 very fine line (approximately 1/8-inch wide).

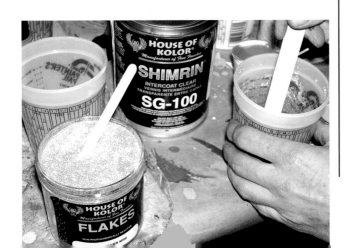

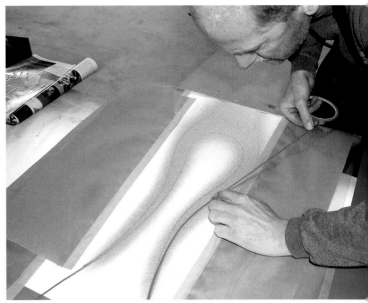

The silver flake made it difficult to see the underlying tape, so Travis retraced it with fresh 1/8-inch 3M blue Fine Line Tape.

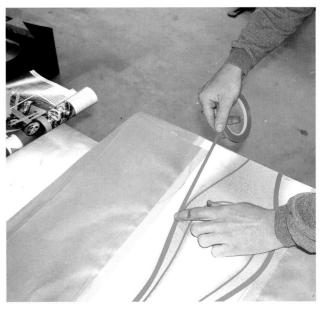

Fine Line 1/4-inch tape was placed over the 1/8-inch tape, following the outer edge of the 1/8-inch tape. That placed the 1/4-inch tape 1/8-inch inside the border of the silver flake licks.

LEFT: Travis Moore demonstrated how to apply spray pinstriping on a test panel using House of Kolor Silver Mini Flake (MF-02) as the base and outline color. The dry flakes are added to HOK Intercoat Clear (SG-100). The mix is sprayed on the flame licks as normal.

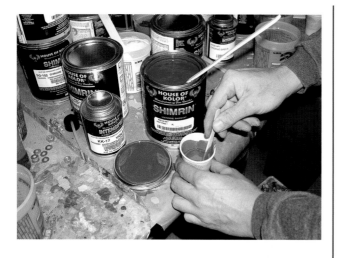

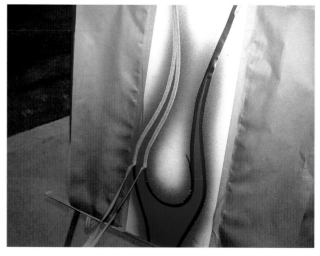

A batch of House of Kolor Shimrin Hot Pink Pearl was mixed up and shot over the silver mini flake base. A single shade was used for this example, but the licks could have been done in multiple colors for a superwild effect.

When the tape is first removed, the stripe looks quite wide. Actually, the outer part of the silver is over the original flame border tape.

When the original blue outline tape is removed (notice that Travis pulls it back over itself) the resulting silver flake spray striping is revealed. It's a neat effect and not difficult to do.

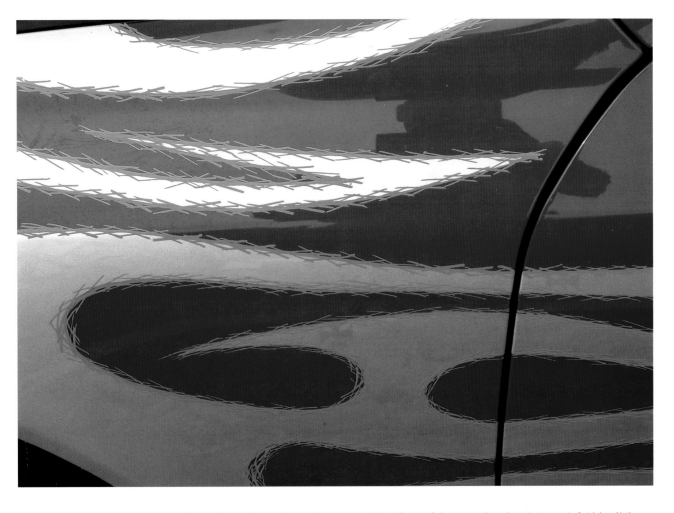

Slash stripes are commonly used on tribal flames. They work well with the wilder designs of tribal flames. Color contrast is an important aspect of striping. Notice how the green striping contrasts with the red car.

The level of raggedness is up to the painter when doing slash striping. The more random the slashes are, the easier it is to claim a mistake was part of the plan. Barry Kluczyk

Travis Moore custom blended a wild lime green color by combining House of Kolor Lemon Yellow and Green Urethane Striping Enamel. He wanted a vivid color to contrast with some darker green flames.

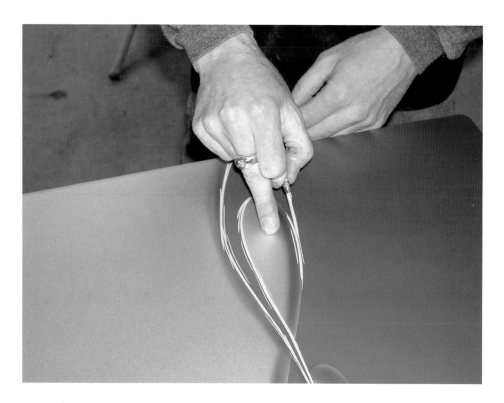

Travis did some modified slash striping by combining relatively traditional stripes with slashes. He did the basic outline first and then came back and added the short slash strokes. Notice how he uses his middle finger as a bridge to support and position the brush.

The aggressive slash striping on Wally Tecca's wild '67 Caddy convertible could be considered barbed wire striping. The slashes cross the whole lick on the thinner parts of the flames.

These mild tribal flames on a Travis Moore test panel show how a limited number of thin slashes can add interest to the licks without overpowering the flames. The lick above the tribal flames shows the long silver flake tip of our spray striping example.

CHAPTER 13
RIP FLAMES

Rip flames are one of the easiest styles to apply. The ragged nature of the "rips" means that the tape edges are very irregular. There are no smooth, flowing lines with rip flames. Care still needs to be exercised during the layout process to ensure a relatively uniform randomness. It's also very important to have secure tape edges. You want rips, not drips.

Uniform randomness sounds like an oxymoron, but what we mean is the rips need to have a common direction and flow. Like traditional flames, rip flames start at the front of the vehicle and flow toward the rear. The general direction of the rips is diagonal, going from the lower part of the design to the upper.

Rip flames are commonly used as a bold way of dividing a two-tone paint scheme. Instead of a smooth line between the colors, the lower color "rips" into the upper color. Using rip flames on a two-tone design means planning it that way from the start.

In order for the lower color to rip into the upper color, the lower color must be applied first. Paint should extend past the area where the top color starts. Even though it looks as if the lower color rips into the upper color, the top color is actually sprayed over exposed parts of the lower color.

The area where the rips will be is covered with 2-inch masking tape. The tape is removed where the top color will be sprayed. All parts of the vehicle not slated for the top color are carefully masked. That leaves a combination of masking paper and tape indicative of where the lower color and flame rips will be when the job is finished.

Chris Odom of Extreme Metal and Paint (www.extrememetalpaint.com) in Anacortes, Washington, was in charge of painting a '47 Chevy Panel/Suburban for RB's Obsolete Automotive. The rip flames shown in the accompanying photos were done on that truck.

Orange was the truck's predominant color, so the House of Kolor Shimrin Tangelo Pearl (PBC-32) was applied first to the fenders and main body. Orange wasn't applied to the roof, roof posts, or the center of the hood, since those areas would be Majik Blue Pearl. The Tangelo was applied high enough that there wouldn't be any thin areas where the two colors meet. Custom paint is expensive, so there's no sense wasting it.

Chris applied four coats of Tangelo Pearl and then let it dry overnight. The paint was wet sanded to make sure everything was smooth and dirt-free before adding four more coats of Tangelo. Wet sanding between the two color applications also helps avoid excessive solvent buildup. After the last coat of Tangelo was applied, a quick coat of House of Kolor Intercoat Clear (SG-100) was shot to seal the color.

Mike Lavallee (www.killerpaint.com), airbrush artist extraordinaire and graphics expert, was called upon to help with the rip flames (or tear graphics, if you prefer). Even though an experienced artist like Mike can do the job quicker, this style of graphics lends itself to the amateur painter.

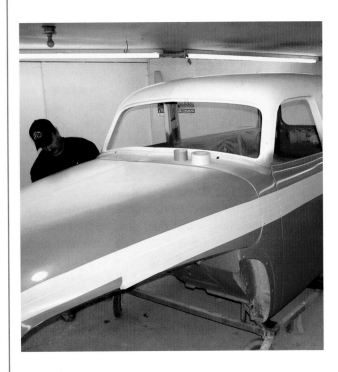

The roof and center of the hood didn't receive any orange paint, because they will later be painted blue. Custom paint products aren't inexpensive, so there is no sense wasting it. The band of masking tape is where the rip flames graphics will go.

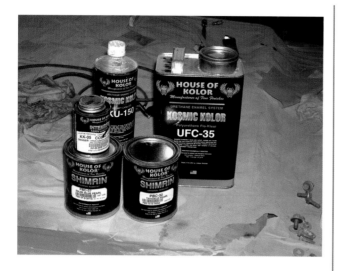

House of Kolor products were used to paint this extensively modified '47 Chevy Panel/Suburban. House of Kolor seems to have the knack for developing super brilliant colors. Its Shimrin Pearl paints were chosen for this project.

Blue Fine Line Tape was used to establish the top edge of the graphics. A few light pencil reference marks can also be used to measure down from a fixed point on each side such as the windowsills.

Since the look is purposely ragged, no two areas have to match. That type of inconsistency is perfect for an inexperienced painter. How can someone criticize the design as being wrong when there aren't any specific parameters? Even the brushed on highlights were done in a shaky style.

Mike and Chris used an illustration by Chris Ito as an approximate guide to the placement of the rip flames. Lots of 2-inch masking tape was used to modify the design until they felt it was ready for paint. An upper boundary line was established all the way around the general beltline area with blue 3M Fine Line Tape. Then three strips of 2-inch masking tape were slightly overlapped as they were applied. The rips will come out of this 5- to 6-inch band of masking tape.

A pen or pencil can be used to approximate where the rips should be. The shapes are truly ripped, not cut. A knife should not be used. Chris and Mike used their fingernails to start an area and then slowly ripped the tape with random, jagged edges. They used additional pieces of ripped tape to alter edges as necessary or to fill in areas where too much tape had been removed. If you seem to be making an area progressively worse, you can remove the tape and try again.

Even though the design was supposed to be ragged, the edges were checked before painting. You want ragged edges, but no bleed-through areas. The areas that are covered with tape will be orange and the open areas will be blue. The entire area below the design band was masked off.

The areas of orange that were to be painted blue were carefully scuffed and cleaned. The orange paint was fresh,

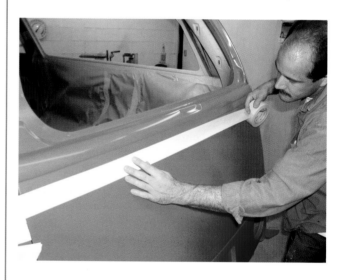

Starting at the blue tape, three strips of 2-inch regular masking tape were applied. The strips were slightly overlapped. The rip flames will be designed within the boundaries of the tape. The size of the rip flames determines how many bands of tape are needed.

so not too much prep work was required. Cleanliness is the main thing.

House of Kolor Shimrin Majik Blue Pearl (PBC-37) was applied in the same manner as the Tangelo Pearl. When the blue paint was dry, Mike Lavallee used an airbrush to apply some darker blue highlights to the rips. House of Kolor Cobalt Blue Candy (KK-05) was used to enhance the glow of the blue where it meets the orange. The Cobalt Blue was

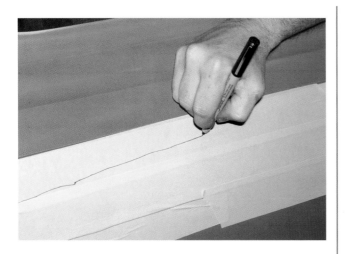

A marking pen can be used to rough out the rip lines if desired. If you want a reasonable similarity between sides, marking will help. Otherwise, the rips can be totally random.

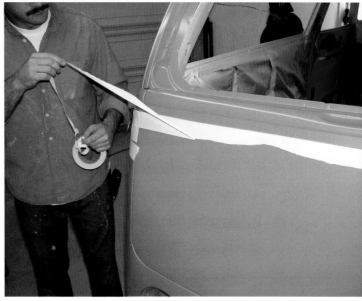

An alternative approach to pulling the tape out of all three strips is to make the top edge first and then rip individual sections and place them underneath the upper border. Don't be afraid to use a lot of tape trying different techniques until you get what you want.

allowed to dry for two hours before Mike applied hand-painted borders to the graphics.

Then the graphics were unmasked. Care should be exercised anytime masking tape is removed to avoid lifting an edge. Since these graphics are ripped, it wasn't imperative that the tape be removed perfectly. Any loose or rough edges were lightly brushed away by hand.

Instead of precision pinstriping like one would find around traditional flames, a lettering quill was used to highlight the borders. Mike used shades of orange ranging from a very light, almost crème, to a dark orange. The paint was applied predominantly to the Tangelo Pearl part of the main paint. In some places, Mike overlapped light and dark shades of orange.

Like so much of custom painting, the brushed-on highlights were placed where the artist thought they best belonged. That is one of those things that can't very well be described, but is a matter of experience and artistic ability. Since the graphics appear on the firewall and inside the doorjambs, highlighting was also done in those areas.

After the highlights dried, the entire truck was cleared inside and out. The clear was House of Kolor UFC-35 with KU-150 hardener. The clear was allowed to dry for two days. Then all the graphic areas were wet sanded until they were smooth. The rest of the truck was wet sanded, too. When Chris was satisfied with the smoothness, he applied another round of clear.

This time the clear was allowed to cure for a week. Then it was wet sanded again, first with 1,000 grit paper and then with 1,500 grit. The final step was to buff the paint to perfection.

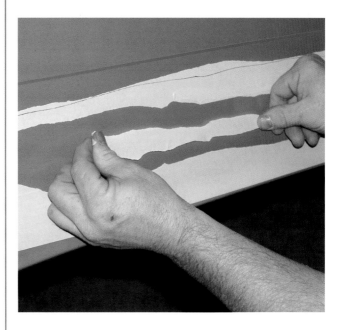

This style of flames involves a lot of moving shapes and altering their size. The rip sections were loosely placed until they were satisfied with their final location. Tape is cheap, so don't be afraid to experiment.

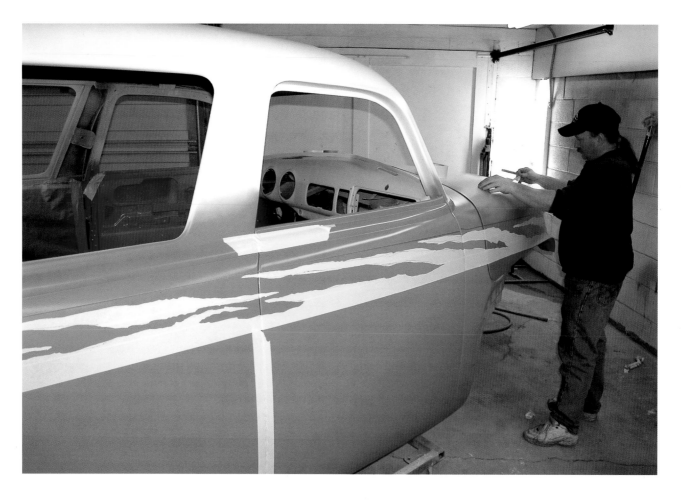

This view shows how the tape sections resemble flames. The tape is over the existing orange paint, so these sections will be the "positive" parts of the rip flames. Notice the blue upper reference tape. The doorjambs must be sealed to prevent overspray.

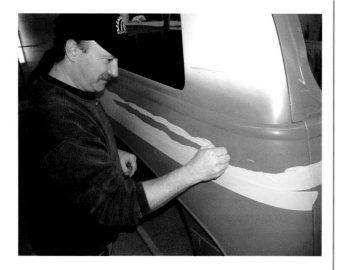

Even though the general design appears random, Mike Lavallee put a lot of thought into the length, slant, and thickness of each rip. There is a common upward flow to the rips.

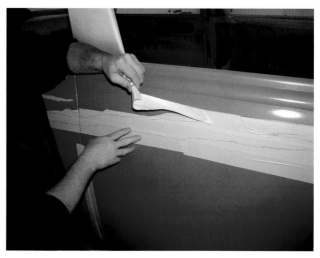

Mike tries to follow the general guidelines as he pulls away sections of tape, but due to the ripping, the guidelines are more of a general reference than a specific rip. Guidelines also help keep the two sides similar.

You can use one hand as a guide while pulling the tape with the other hand. When pulling, experiment with wiggling your hand to help make the tears more uneven.

Once you are satisfied with the overall design, each section of tape should be pressed firmly against the body. If a section of tape gets repositioned too many times, it can lose its adhesiveness. Keep that in mind during the layout phase.

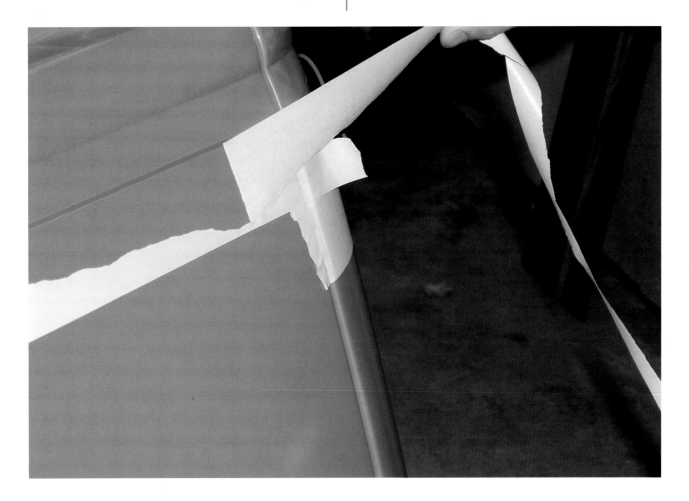

Since these rip flames separate the two colors of the truck, the tailgate needed a boundary. The lower tape section of the last rip on each rear quarter panel was wrapped around the corner and on to the tailgate. This will be a simple ragged line, not an actual rip flame. Once again, notice the blue reference tape.

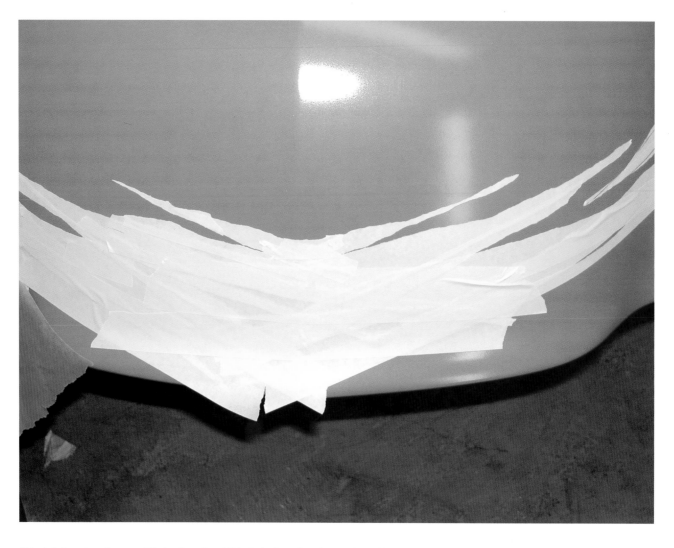

This shot shows how the nose of the hood was taped. This design flows from the very front of the hood, but it could have also been started further back.

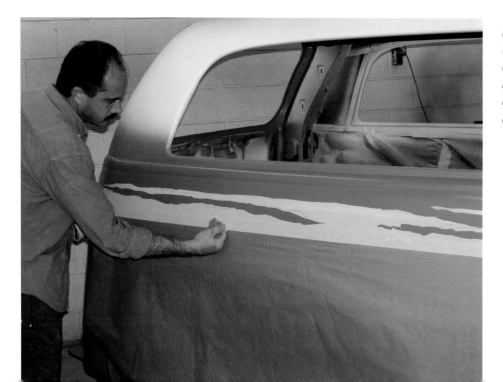

Everything below the rip flames was thoroughly taped off. That included the entire interior. Blue overspray would ruin the whole job. Overspray is insidious. You can't be too careful about overspray.

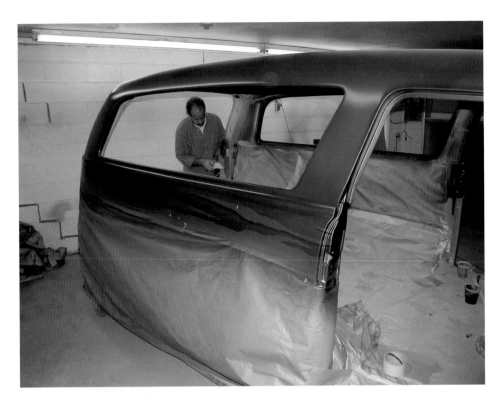

House of Kolor Majik Blue Pearl was applied to the upper part of the truck, using the same number of coats as the lower Tangelo Pearl.

Before the tape was removed, Mike Lavallee applied some House of Kolor Kobalt Blue Kandy highlights to the areas of the Majik Blue around the graphics. He used a small airbrush to create shadows and highlights. This step could be skipped, but it adds some important detail. The quality of detailing often separates an average job from a great one.

After the Kobalt Blue dried, the big sections of masking paper were removed. The paper is peeled backward at a 90-degree (or greater) angle.

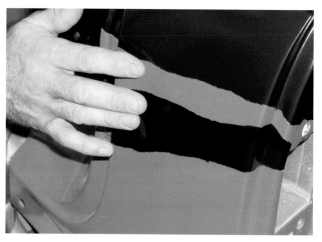

After the paper has been removed, it's time to take off the tape. Reasonable care should be exercised when removing the masking tape from around the graphics. However, with this type of ragged edge graphics, precision isn't as important as with a sharp-edged design.

Chris lightly brushed his fingers along the edges of the rips to remove any paint particles left from removing the masking tape.

Even pros suffer from bleed-throughs. As many times as every piece of tape and paper was checked, a light dusting of blue paint managed to sneak through to the hood. All it takes is a tiny crack for this to happen.

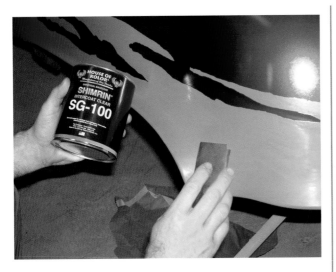

Pros like Chris Odom are adept at fixing the mistakes that can be a nightmare for beginners. This is why it is so important to avoid problems. This overspray was so light that Chris managed to remove it with ultrafine paper and spot in the area with House of Kolor's Intercoat Clear.

The rip flames were also painted on the firewall of the classic Chevy Panel truck.

Mike Lavallee applied several shades of orange paint to the edges of the rips. He used a small lettering quill and didn't try to make the lines uniform. The ragged outlining matches the ripped look of the graphics. The rips extended into the doorjambs and across the firewall.

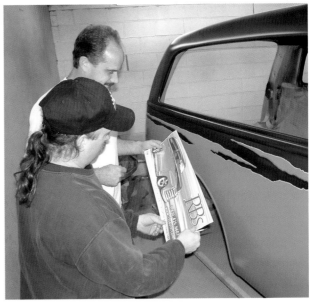

This staged shot shows Chris and Mike comparing the Chris Ito illustration to the finished rip flames. The drawing was consulted more during the layout process. At this point if they made any mistakes, it was too late and too bad.

LEFT: This detail shot shows how the design was carried through the doorjambs. The white residue is polishing compound that hadn't been cleaned up. A great deal of extra masking goes into little details like this.

The finished rip flames are very bold, especially with the wild House of Kolor Tangelo Pearl and Majik Blue Pearl colors. The rip flames give an added sense of motion to the truck.

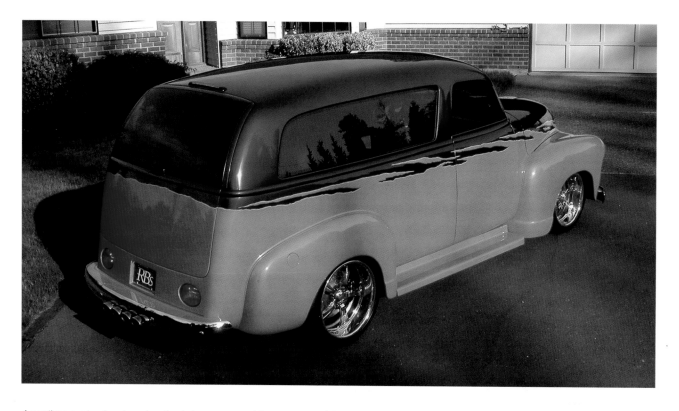

A rear three-quarter view shows how the design wraps around the rear corners of the truck and goes across the tailgate in a single ragged line between the two colors.

CHAPTER 14
TRIBAL FLAMES

Tribal flames are more about style than technique. The term tribal flames has been used very loosely to describe nontraditional flames. Tribal flames are usually characterized by sharp edges and the inclusion of reverse direction licks. Reverse direction licks have their point or tip facing the front of the vehicle, unlike traditional licks, which almost always taper toward the rear of the car.

Tribal flames can be a blend of styles. A traditional flame layout can be made tribal by throwing in a few extra turns and forward facing points. Some people equate tribal flames with the kind of elaborate designs seen in tattoos. Classifying something as tribal is pretty subjective, but like all flames, it's the look that counts, not the name.

Layout and masking techniques are the same as any flames, once the unique design has been established. Custom painter Travis Moore of Olympia, Washington, shared a tribal layout technique that works well for him. He lays out a pretty traditional flame design with blue 3M Fine Line

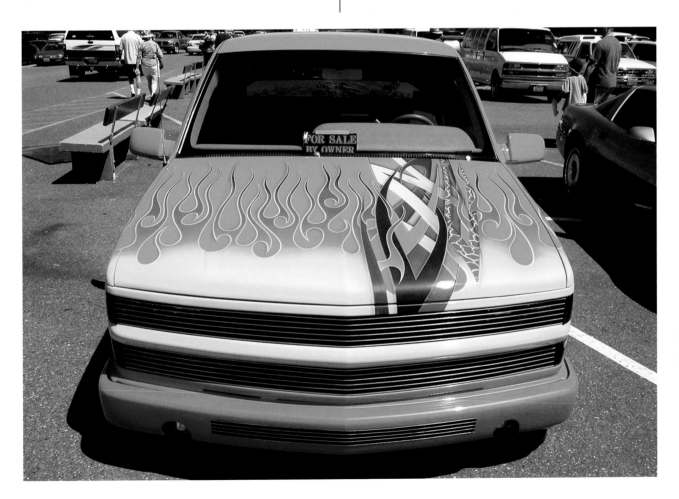

This late-model Chevy pickup is an excellent example of tribal flames. In many respects the flames are traditional in color and general flow, but the forward hooks and interspersed wild graphics give the truck a contemporary look.

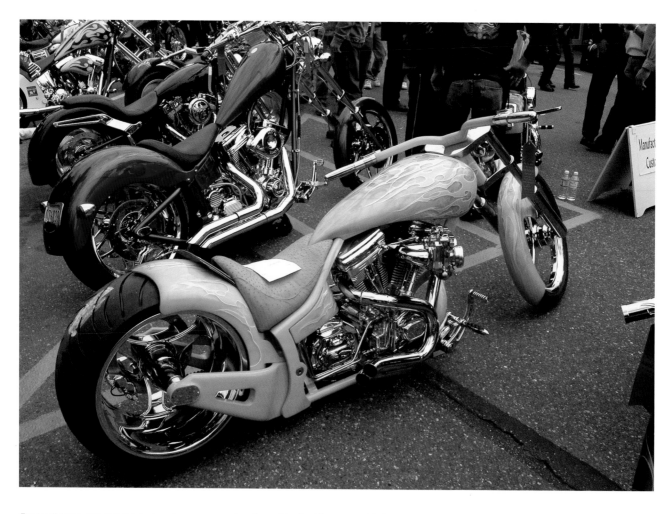

From a distance, this stunning custom chopper appears largely a solid yellowish orange color. There is a sense of subtle flames on the tank.

A close look at the chopper reveals an incredibly detailed paint job with tribal flames, shadowy airbrushed flames, and large skull image. Beautiful pinstriping with extra long tails accentuates the tribal flames. The fenders and oil tank continue the theme.

Tape. Then he comes back and overlays the sharp points, zigs, and zags. This way he maintains a smooth flow to the flames and injects the tribal elements later.

When Travis is satisfied with the additions, he uses his snap-blade utility knife to carefully cut and remove the unneeded sections of tape. By using the knife he can achieve sharper lines more quickly and more easily than if he tried to accomplish it all on the first pass with the tape. This technique might seem like extra work, but Travis claims it actually saves time.

A variation of the cut-and-remove layout technique involves tribal flames that are curvier, but still have forward facing points. The traditional flame licks are designed with Fine Line Tape. Then a curve is taped inside the lick. That curve connects in two places to the original tape outline. That original section of tape is then cut away and you have a smooth tribal lick. The front and rear of the "hole" still have a smooth flow, but there is a gap. From a distance your

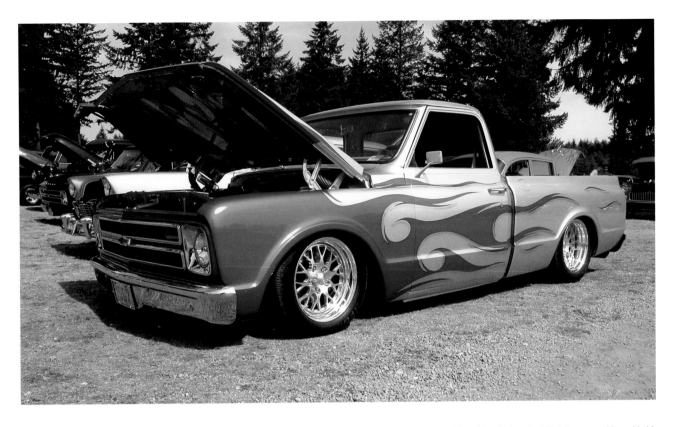

Craig Wick of Wicked Fabrication in Auburn, Washington, is responsible for this extensively modified '67 Chevy pickup. The single-color tribal flames are big and bold. Several free-floating licks were added for a sense of motion. The pinstriping is purple.

eyes will sense the flow even though the licks are interrupted by the tribal elements.

Masking off tribal elements can be difficult with traditional masking tape. The solution is to cover these areas with transfer tape and carefully follow the blue Fine Line Tape with a sharp utility knife. Regular masking tape or masking paper can be added to the areas beyond the flame design.

Tribal flames are most often seen on sport trucks, mini trucks, sport compact cars, and other trendy vehicles. They don't show up too often on traditional street rods. This suggests that tribal flames probably won't have the longevity of traditional flames. A set of hip tribal flames today could brand your car as dated in a few years. Remember the "heartbeat" graphics on Pro Street cars and the pastel color trend? Tribal flames might not have that short of a shelf life, but it is something to consider.

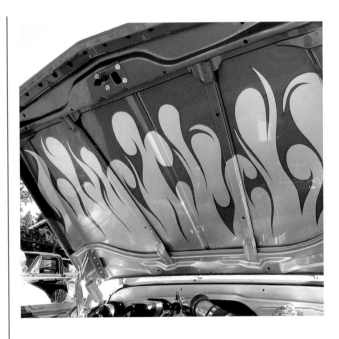

The tribal flames are everywhere on Craig Wick's truck, including underneath the hood, on the inner fenderwells, on the tailgate, and on the dashboard, and the main flames go through the doorjambs. The various underhood braces make painting here more difficult than on the topside.

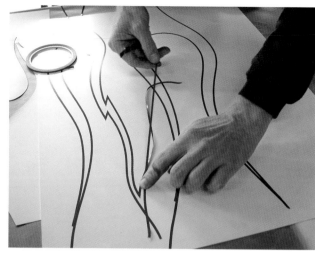

Travis Moore likes to start tribal flames by first doing a pretty traditional layout. Then he comes back and tapes over areas to produce the sharp points and other tribal elements. After all the taping is done, he cuts out the unwanted sections.

Full-size SUVs offer tons of room for tribal flames. These wild flames are full of motion, thanks to multiple overlaps and free-floating licks. A 3-D look was achieved on the inside curves. Airbrushed light reflections bolster the 3-D effect.

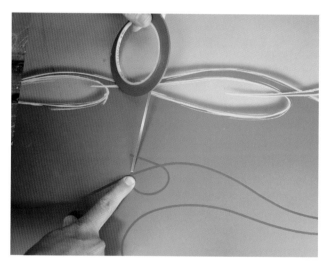

Another tribal flame taping technique involves making forward-pointing tips by inserting small circles inside a traditional flame layout.

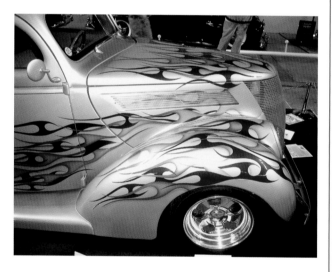

Tribal and traditional-style flames were intertwined on this '37 Ford sedan delivery. The traditional flames were done in a lighter shade than the tribal flames. Numerous crossovers equal a lot of taping and layout work.

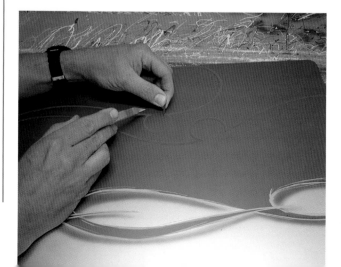

RIGHT: A snap-blade utility knife or an X-acto knife is used to carefully cut and remove the unwanted tape. This is much easier than trying to form these shapes during the initial layout. Transfer tape is used to mask these areas.

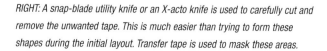

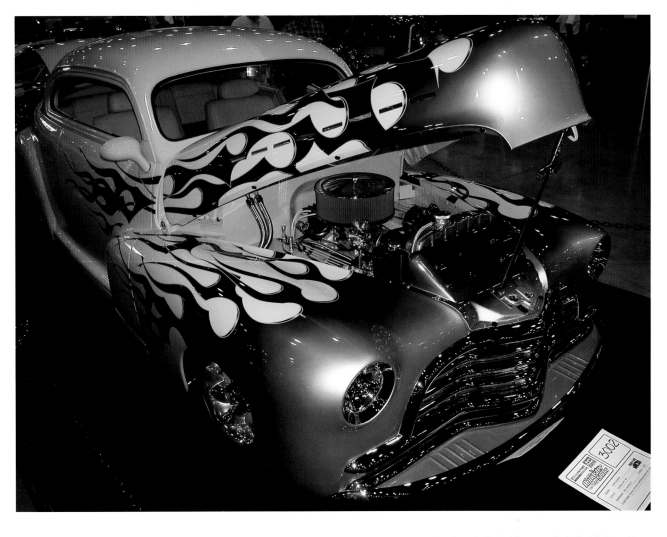

Candy purple flames over a bright yellow '46 Chevy street rod would stand out, no matter what style was used, but these bold tribal flames really do the job. A combination of curves and sharp-edged shapes, plus 3-D inner curves and lime green pinstriping, ensure that these flames are one of a kind.

Stylized flame tips are an easy way to add a tribal flame look without going all out on the main flames. Airbrushed drop shadows were used to make these tribal flames appear to float above the silver base color.

CHAPTER 15
PAINT TRICKS AND SPECIAL EFFECTS

There are more ways to paint flames than we could possibly enumerate. The popularity of flames keeps painters stretching their imaginations to develop new variations. The old traditional three-color fades from yellow-orange-red or white-yellow-orange are still great choices, but it's easy to go a step further by adding little details. It's also possible to go completely wild. The choice is yours.

Many special flame effects revolve around some basic concepts, such as shadowing. Shadows, in their various styles, give a three-dimensional look and extra depth to flat flames.

Textures are a primary way to individualize flames. A great number of textures can be simulated with an airbrush or with the use of special paint products. An airbrush can be used to imitate any surface, from wood to water to diamond plate steel to carbon fiber.

Some special effects are very subtle. They are almost unnoticeable from a distance, but when viewed up close,

they add a great deal of interest. Other effects are very bold and hard to miss.

A good way to learn about special effects is to study cars, trucks, and motorcycles at shows. The more you learn about how custom paints work, the easier it will be for you to figure out how a trick was executed. You can also ask the vehicle owner, as most are happy to talk about their pride and joy. Some custom painters are possessive about their techniques, but truly confident painters take mimicry as a compliment.

Other painters are too talented for any "secret" to remain proprietary very long. Confident painters know that no matter how precisely they explain a special effect, the final product still has a great deal to do with the skill level of the artist.

SHADOWS

Placing shadows on flames makes them look more alive and less two-dimensional. The shadowing, or drop shadow, technique is currently quite popular. The most common place to use shadows is where flames cross. A drop shadow

Drop shadows add a lot of interest and depth to flames. Properly executed drop shadows give a 3-D look. This excellent example shows how versions of the main colors were used instead of black for the shadows. Where the magenta licks overlap the orange, a darkened shade of orange was used for the shadows. Where the orange licks overlap the magenta, a purple hue was used for the shadows. These shadows go all the way to the tips of the licks.

In this example of drop shadows on a black vehicle, the shadows were only placed where the licks crossed over the orange and yellow areas. You can't have a shadow on black paint.

This is an example of a very subtle drop shadow used only where one lick overlaps another. The shadow almost blends into the fogged orange paint around the inner curve of the flame lick.

A very creative use of shadows is seen on this red car. The black shadows start tight to the bottom of a lick and then veer off and get farther away from the lick as the shadow approaches the tip of the flame. This gives an exaggerated sense that the flames are floating above the surface.

at the intersection of the two licks makes the top lick seem to float above the lower one.

Some painters place shadows along almost the entire length of the lick. That gives the whole flame the appearance of floating above the base color.

It's even possible to use shadows and light highlights to make flames appear when both the flames and the base color are the same. The proper use of light and shadows

Shadows aren't mandatory for flame licks that cross over. These bright flames have lots of crossovers, but no shadows. The flames appear flatter to the surface, but they still look great. Notice how the Process Blue pinstriping helps the flames pop off the black base.

makes one area of the single color appear to be separate from the rest of the paint.

The most common method of creating shadows is to spray diluted black paint underneath the flames. The idea is to create a shadow where light would make one if the flames were three-dimensional. A product that works well for black shadows is House of Kolor Basecoat Black (BC-25). To make the black more transparent, it should be overreduced. The amount of overreduction will increase the transparency. Real shadows aren't always perfectly black, so the more transparent black works very well.

Besides black drop shadows, it often looks good to use a variation of the flame's color. When using House of Kolor Kandy or Shimrin Pearl paints, you can use the same color in HOK Kandy Koncentrate. The Kandy Koncentrate is mixed with HOK Intercoat Clear (SG-100). The result is a highly transparent version of the main color. That makes a neat drop shadow.

A good reason to use variations of the flame color for the shadows is that real shadows aren't black. What you're seeing is the underlying color, but without as much light as on the flame that supposedly receives the full light.

People say that something casts a shadow, but the truth is some of the light is blocked. The color you see in the blocked area is the difference between viewing it in direct

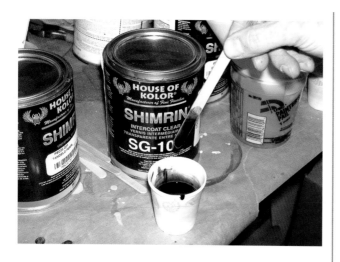

When making black shadows, it's a good idea to dilute the black paint so it's semitransparent. House of Kolor Basecoat Black (BC-25) works well mixed with Intercoat Clear. Notice how thin the paint looks on the mixing stick.

sunlight and at dusk. If you grasp this concept it should make shadowing more understandable. It should also help you choose colors and intensities for the drop shadows.

Since real shadows usually depend on a single light source, that concept needs to be applied to flame shadows. You need to determine where your hypothetical light source is, and treat all the licks as if the light source is the same for all of them. If the "light" is at the top of the vehicle, the shadows should be on the lower side of the flame licks. Shadows need to be consistent to be believable.

The concept of a light source is the trick behind making flames without changing the vehicle's base color. An airbrush is used to draw the outline of flames. The "tops" of the flames are done in white or pearl or some other light color. The undersides of the flames are done in a darkened shade of the main body color. The result is flames that appear to rise above the base paint, but are the same color. We've included some

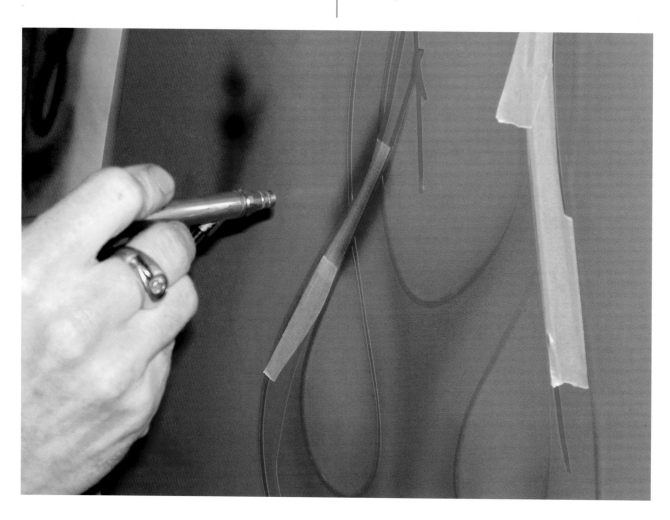

Travis Moore used the diluted HOK black to put shadows on some crossover flame licks. Since the flames were very thin where they cross, he taped the flames to protect them while he airbrushed the shadows. Airbrushes are great for shadows, because you can gradually build up the amount of paint and intensity of the shadow.

House of Kolor Kandy Koncentrate Intensifiers come in the same hues as popular HOK Kandy and Pearl colors. You can make excellent color-coordinated shadows by mixing the appropriate Kandy Koncentrate with Intercoat Clear. Instead of removing the pressed-in protective seal, Travis Moore pokes a small hole with an awl. Since he only uses a small amount of Kandy Koncentrate at a time, he just dribbles some into the mixing cup.

photos on page 144 of a truck done with this technique by Mike Lavallee. The success or failure of this technique depends on getting the light source and corresponding shadows right.

3-D FLAMES

A variation of shadows is making flames appear three-dimensional by simulating depth in the curved areas. Some well-known custom painters use this look as their signature style.

The basic idea is to paint an extra arc in the curved areas of the flames. The arc looks like a crescent shape where the convex and concave edges terminate in points. The thickness of the crescent and the length that the points are drawn out affects the 3-D look.

These arcs or crescents are frequently done in shades of black, gray, and silver. They're supposed to be a shadow or made to look as if the flame is part of a chrome emblem. Airbrushed light streaks or reflection spots are used to reinforce the chrome or metal look.

Three-dimensional arcs are most often pinstriped on both sides of the arc. The striping further defines the depth. Sometimes only the line between the flame color and the arc is pinstriped. Other painters do the arcs without any striping. It's all a matter of taste and choosing the technique you think looks best.

MARBLING TEXTURES

A technique that encompasses a variety of effects is called marbling. It's also known as marblizing, although House of Kolor calls the most common product used to achieve the effect Marblizer. Spelling at House of Kolor is often as unique as its paint. The effects mimic the veins in marble, but the product can be manipulated to achieve many different looks.

HOK Marblizer comes in neutral (clear) and colored versions: silver-white, gold-blue, red-red, blue-pink, lilac-lilac, and green-blue. Any of the four dozen or so HOK dry pearl powders can be added to the neutral Marblizer to create special effects. Various color combinations can be tried for lots of unique finishes.

The way the HOK Marblizer looks also depends on the base that it's sprayed over. Black is a commonly used base, but any of the many Shimrin bases can be used. Black pearl base is a good color for extra sparkle. Marblizer must be applied over a base color. The base color needs to dry for 15–30 minutes before applying the Marblizer.

HOK Marblizer is ready to spray; just stir well and strain. Only apply Marblizer to an area equal in size to what you can work with in a few minutes. Saran Wrap is the most frequently used medium for manipulating the Marblizer. It needs to be applied about 1 to 2 minutes after the Marblizer is sprayed. If the Marblizer dries, it won't work.

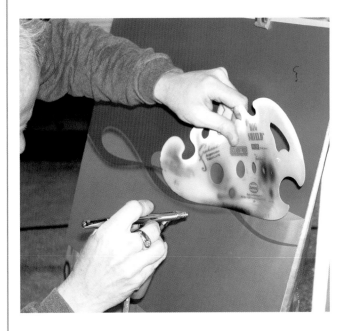

To make Organic Green drop shadows for the green flames, Travis Moore uses an Artool solvent-proof shield as a guide. A shield can save a lot of time when doing shadows.

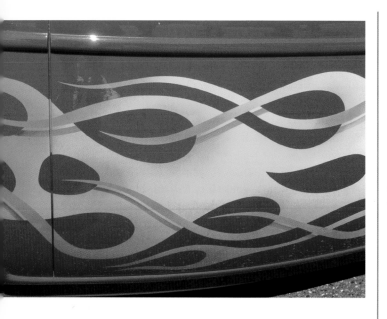

The drop shadows on these wild flames are much wider than most shadows, but they still work very well. The shadows are all done as if the light source were above the flames. Maintaining a consistent light source is key to realistic shadows.

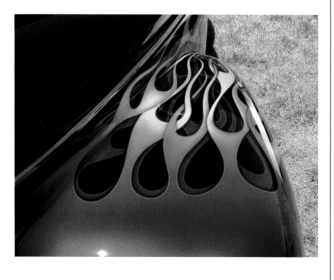

These beautifully elaborate candy flames achieve depth by having a darker set of candy red flames underneath the main flames. The underlying flames are offset and shading is used to accentuate the appearance of depth. Drop shadows are used at the crossovers. These flames took a lot of effort, but the results are spectacular.

The way the Saran Wrap is manipulated determines the finished look. This usually requires some experimentation. The simple way to use the Saran Wrap is to let it wrinkle as it is placed on the wet Marblizer. Other techniques include stretching the Saran Wrap and patting the stretched

section on the Marblizer. The Saran Wrap can be wadded up and touched to the Marblizer. This is similar to some interior house painting pattern techniques.

Other items can be touched to the Marblizer or dragged through it. Cheap, coarse bristle acid brushes work well for "drawing" textures. Bubble wrap, aluminum foil, feathers, and natural sponge have been used successfully to manipulate Marblizer.

Marblizer must be clear-coated, but you can also apply various candy colors over the Marblizer before clear coating. The use of candy colors below and above the Marblizer increases the number of possible effects.

FADES

Fades and blends are a traditional part of flame painting. The idea is to make one color fade or blend gradually into the next color. A mark of a good painter is a seamless fade. Inexperienced painters often leave very distinct lines between colors.

One popular style of fading is to have the nose of the vehicle the same color as the main body. The flames gradually start a foot or two back from the nose. The first color starts off very lightly and gradually gains intensity before fading to any additional colors. A very light and controlled trigger finger is needed to do perfect fades.

If too much paint gets on the leading edge of the fade, the look is pretty much ruined. Any blotches or loading up on body seams also detract from the desired effect.

Fades are easier to do around the inner curves of flames. The idea is to simulate a stylized high-intensity area within the flames. Contrasting colors are frequently used for these fades. Smoothly tapered fades look much better than ones that stop abruptly.

GOLD AND SILVER LEAF

A unique look can be given to entire flame jobs or just the tips by using gold or silver leaf. Gold leaf is most commonly used as a highlight material, rather than for entire flames.

Gold leaf, available at art supply stores, comes in different colors. The color of the "veins" is the main difference. Gold leaf is very thin and fragile. It comes in little booklets with wafer thin sheets of gold leaf. A sizing (a special gold leaf glue) is brushed where the gold leaf is desired. Wherever the sizing goes is where the gold leaf will stick. The gold leaf is gently pressed to the sizing and then lightly burnished. When it dries, the excess material is brushed off. A clear coat is used to protect the gold leaf. Pinstriping is used, because it helps seal the edges and covers any raggedness.

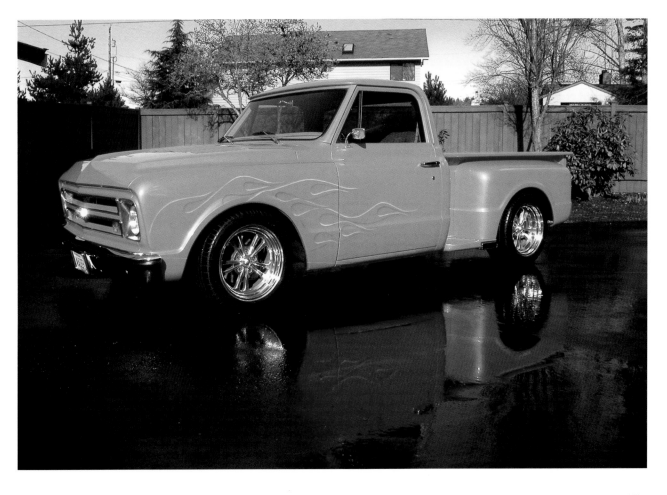

The flames on Mike Hoffman's '68 Chevy are the same House of Kolor Sunset Pearl that Chris Odom of Extreme Metal and Paint applied to the rest of the truck. Mike Lavallee airbrushed light and dark highlights to give the illusion of flames.

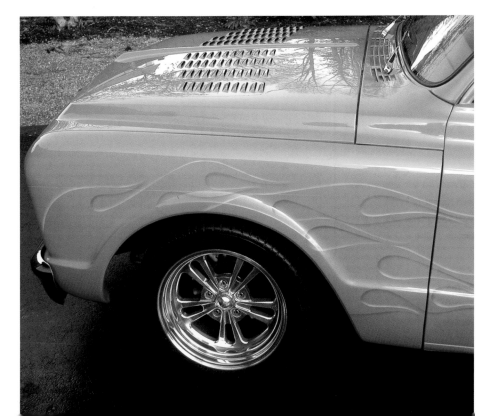

A close look at the Mike Lavallee flames reveals a white airbrushed outline on the top side of the licks and a dark orange outline (or shadow) on the bottom side. Notice that the light outline changes to dark just past the midpoint of each curve.

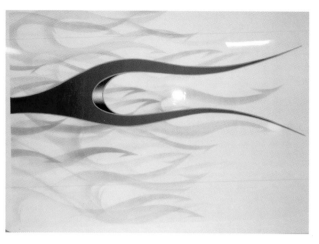

Here is the finished test panel. Travis used white paint with a little pearl added to airbrush the "reflection" in the center of the arc. He pinstriped the arc with lavender striping paint the way he did the rest of the flame. The pinstriping helps accentuate the taper at the top and bottom of the arc.

These flames separate a two-tone paint scheme. The flames are slightly darker than the orange top color. Gray arcs on the inside of the curves give a 3-D look to the flames. These arcs weren't pinstriped, but many painters do stripe them for added definition.

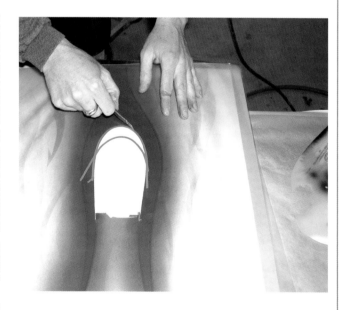

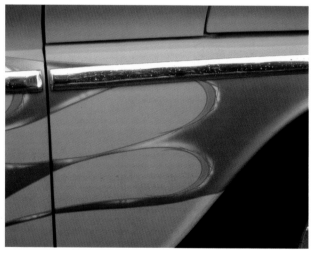

Here is a variation on the 3-D inner arc. The gray flames feature silver arcs, but the red pinstriping was done in a random stroke tribal style (but only on the curves) that diminishes the 3-D look. White airbrushed reflections were added.

Travis Moore demonstrates how to make the 3-D arcs on a test panel. He uses blue Fine Line Tape after the main flame has been painted. He uses silver, gray, or charcoal paint in an airbrush to shade the arc. He sometimes adds small white or silver highlights to simulate a reflection.

RIGHT: Several custom effects were used on the tank and fenders of this wild chopper. The blue base has a subtle marblized pattern. The main yellow and green flames have soft edges and no pinstriping. Pale green pinstripe flames overlap the main flames.

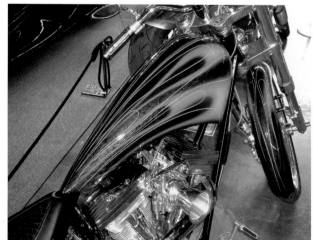

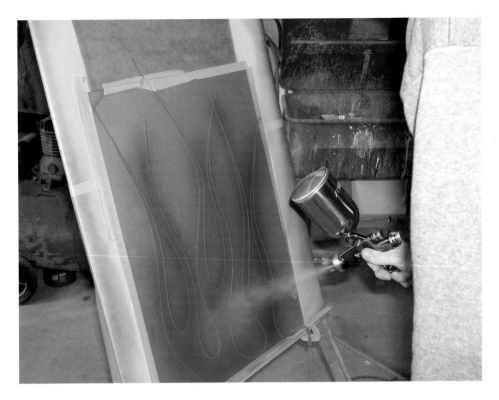

Travis Moore demonstrates how to use House of Kolor Marblizer Artistic Basecoat to apply a unique textured look to some flames on a test panel. The design was done with blue Fine Line Tape, covered with Transfer Rite transfer tape, cut out with a snap-blade utility knife, and base coated with HOK Shimrin Orion Silver (FBC-02). HOK Shimrin Majik Blue Pearl (PBC-37) was applied with an Iwata LPH-100 spray gun.

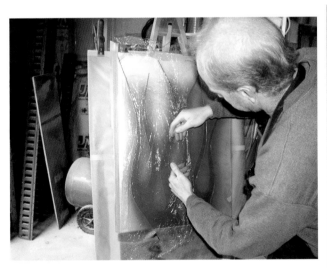

The Majik Blue Pearl dried for 30 minutes before covering with one wet coat of House of Kolor Neutral Marblizer (MB-00) in an Iwata LPH-300 spray gun. Then a wrinkled piece of Saran Wrap was placed over the wet Marblizer. The Saran Wrap was removed, leaving a subtle veined look that is similar to real marble. The Saran Wrap can be manipulated to make different effects.

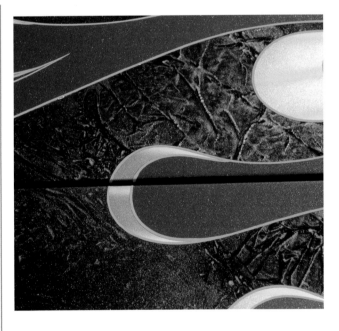

Marblizer can be difficult to see in photos, but it looks trick when viewed in person. A great number of special effects can be done with Marblizer depending on the colors used and the medium used to manipulate the wet Marblizer. Dry pearls and flakes can be mixed with neutral Marblizer. HOK Marblizer also comes in colors.

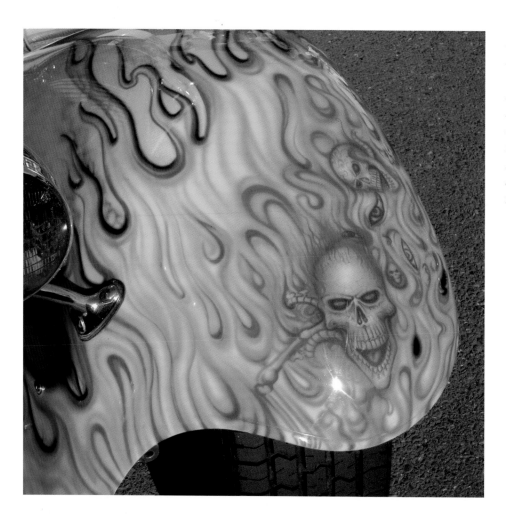

Skulls are a trendy element to incorporate in flames. Skull stencils speed up the process. These wild flames were mostly done freehand with an airbrush. If you look closely, you can see different size skulls and eyeballs in the flames. This level of detail gives the flames two different looks, depending on whether they're viewed up close or from a distance.

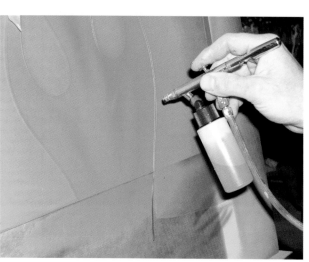

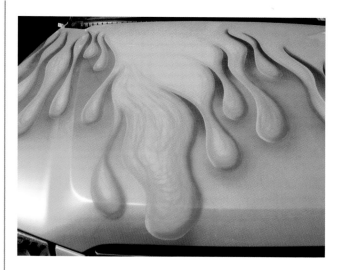

A lot of subtle details can be injected into a flame job with an airbrush. By using candy paints, you can easily alter the intensity of a color. You can also use products like House of Kolor Kandy Koncentrate Intensifiers to add intense highlights of the same basic color. These flames are receiving darker orange streaks that loosely parallel the flame outline.

This is another example of airbrushed details. Copper flames were outlined in red with an airbrush for a soft edge, and then soft orange licks were airbrushed in between the main licks.

This is another wild example of how an airbrush was used to liven up an already bold set of flames. The car has a pearl-white-to-yellow fade at the nose. The airbrushed orange flames start softly in the yellow part of the fade and get progressively darker as they go toward the tips.

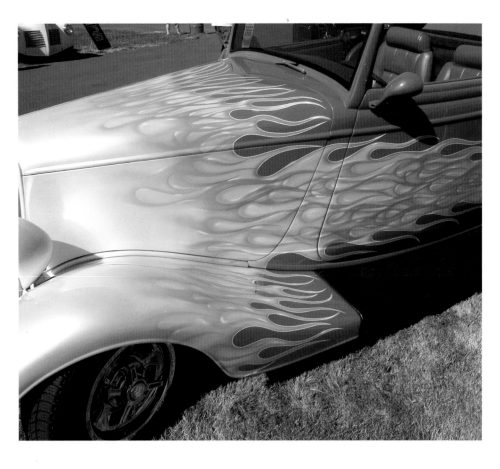

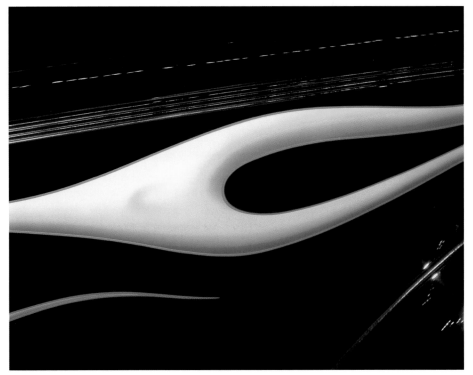

An airbrush or touchup gun is a wonderful tool for adding highlights to flames. This flame lick has great orange and yellow fogging around the edges. The yellow fogging makes an interesting hook that echoes the inside curves of the lick. Lavender pinstriping really sets the flames off against the black base.

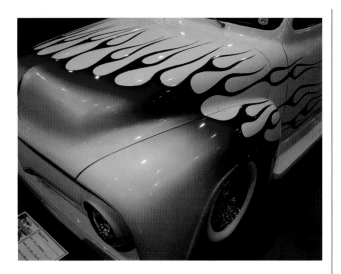

Fogging or fading flames looks great, but it can be difficult to accomplish. The beautiful magenta and purple flames on this classic Ford F-100 gradually intensify as they go back. The nose of the truck is the same color as the rest of it, so the start of the fade is very light. Gun control is essential to avoid splotches, which would ruin the whole flame job. Barry Kluczyk

The ability of airbrushes to produce very fine lines is the key to these ephemeral test panel flames. The flames are very light and wispy. The layering and positioning of the various colors takes careful planning in order for all the licks to work well together.

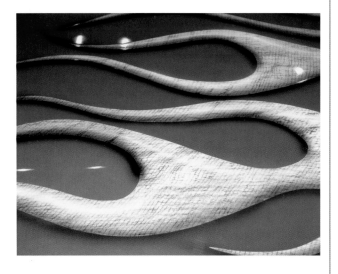

Any texture you can imagine can be used inside flames. These unique flames were made to resemble carbon fiber. Drywall repair or seam tape (the woven kind, not the solid stuff) can be used to simulate carbon fiber. A blue base was applied to these flames. Then they were covered with the drywall tape and white was sprayed. Removing the tape leaves the underlying blue grid. The edges of the flames were shaded with dark blue to give a 3-D look.

These tiny flames within the tailgate letters of a Chevy pickup are another fine example of how an airbrush can be used to add interesting details. On letters like the C and E, the flames were painted as if the gaps weren't there. That gives the licks a consistently long look.

RIGHT: Flames can be used in many places besides the main body of a vehicle. The black valve covers on this Corvette engine were flamed, which makes them much more interesting than plain covers. The flames are traditional, but lots of free-floating pinstriped licks were added.

Beltline flames are a neat way to divide a two-tone paint scheme. This trick can even be added long after the vehicle was first painted. This custom Studebaker pickup added more details by airbrushing serpents into the flames. The licks become the serpent's tongue.

Variegated gold leaf was used on the tips of the flames on this custom Corvette. The many different colors in the variegated gold leaf provide a lot of visual interest. Gold leaf is sold in fragile sheets at art supply stores. It's secured by pressing it onto a brush-on sizing (glue). Any excess is brushed off. A clear top coat protects the gold leaf.

Special effects don't have to be elaborate to be successful. This late model Corvette features a dark red, symmetrical flame that goes right down the center of the hood. It goes underneath the next two yellow licks, but doesn't go any further. The effect is very subtle, but it solves the problem of what to do with the center of the hood.

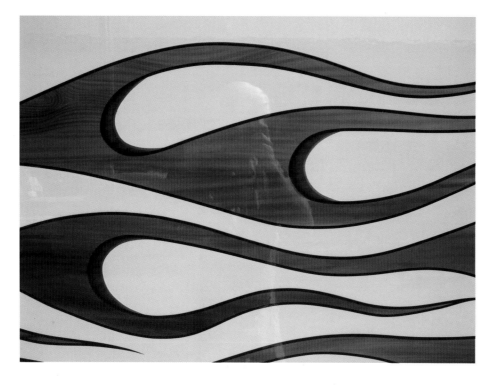

Just because it's illogical doesn't mean you can't do it. The flames on this commercial truck were woodgrained. The main colors are kind of an orange/brown. The dark brown and black airbrushed highlights simulate woodgrain. Even the 3-D inner arcs are woodgrained.

CHAPTER 16
FINISHING TOUCHES

A great flame job is more than designing, masking, and painting the flames. The work that comes after the last coat of color has dried can impact the overall quality. The finishing touches of clearing, color sanding, and buffing are essential ingredients of a perfect paint job.

Unless you've decided to apply 1 Shot roll-on flames, you're going to need a protective clear top coat. The clear does more than protect the underlying paint; it also gives depth and shine. Clear is very important to candy and pearl paints; it's what makes them sparkle. Clear is also an obvious part of a base-coat/clear-coat paint job. Without the clear you might as well be shooting primer.

Pinstriping can be done before or after clearing. Traditional enamel striping paint such as 1 Shot Sign Painter's Enamel must be applied over the clear. House of Kolor's Urethane Striping and Lettering Enamel can be applied underneath the clear. The benefit of using the HOK striping paints is that the surface will be totally smooth after the clear has been sanded and buffed.

Proper safety precautions should be observed in all phases of flame painting, but spraying clears requires extra care. Many clears use an isocyanate-based catalyst for the hardening process. All urethanes are toxic, but the isocyanates are the worst. They can enter your body through your skin

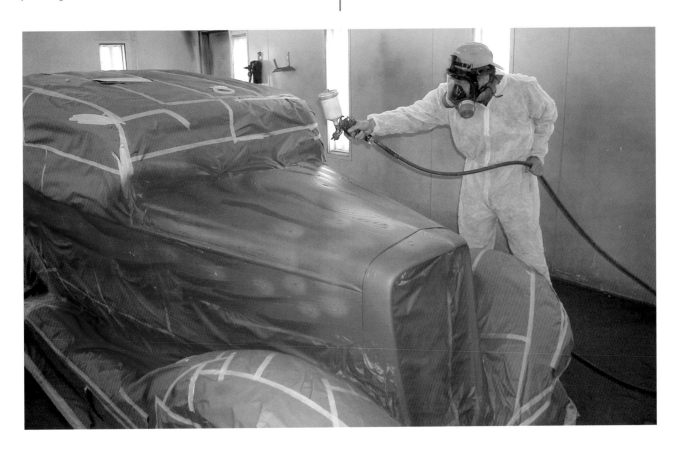

A clear top coat is a key element of most modern paint jobs. Clears are wonderful products, but they can be very toxic. Follow the manufacturer's safety precautions. Donn Trethewey is shown applying clear to the flames on Jim Carr's '35 Chevy. Notice how he holds the air hose to keep it from dragging in the wet paint.

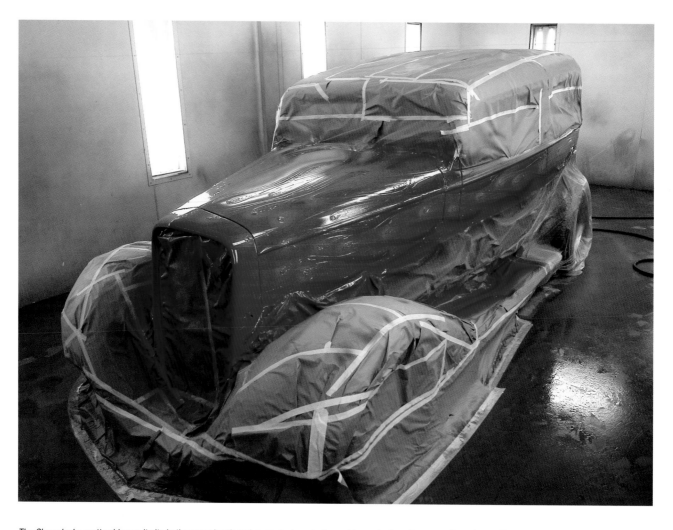

The Chevy looks pretty shiny as it sits in the spray booth and cures. A closer look would reveal a less-than-smooth surface, which is why the clear needs to be wet sanded and buffed.

as well as your lungs. Carefully follow all safety instructions supplied by the manufacturer of the clear you choose.

If you don't have a properly ventilated work area and all the necessary personal safety gear for spraying clear, it would be wise to have a professional bodyshop handle this part of your flame job. Your long-term health is worth far more than any paint job.

There are a variety of clear products. Companies like House of Kolor offer several different clears. Consult company literature or your local paint retailer to determine the best product for your application. As with all paint products, it's best to use products from one company.

Once the clear has been applied and properly cured, the real grunt work begins. No matter how talented the painter is, there is bound to be some orange peel in the clear. Color sanding (even though the residue should be a milky white)

takes down the high spots and leaves a nice, smooth surface. If you see color when you are wet sanding clear, you've sanded through the clear to the color coats. That's not good.

The basic concept of wet sanding and buffing is to gradually reduce the grit size until there is virtually no grit involved. This process uses ever-finer grits to remove the tiny scratches caused by the previous step. The end result is a supersmooth surface.

Wet sanding or color sanding (different names for the same process) isn't applicable to all brands and types of paint. Consult the manufacturer's directions before wet sanding. On total repaints, such as the black '35 Chevy that appears throughout this book, the black paint was wet sanded before the flames were applied.

Jim Carr's chopped '35 Chevy sedan was painted base-coat/clear-coat black by Terry Portch at Kimbridge Enterprises in

After the clear has been applied and the masking tape removed, check around the flames for any paint leaks. Even though Donn goes over the tape multiple times, leaks occur. He used a spray water bottle and some 1,500 grit sandpaper to gently sand off the overspray.

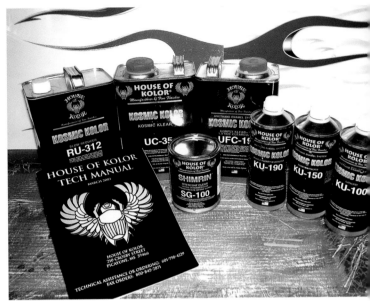

All major paint manufacturers offer their own brands of clear. House of Kolor has a variety of clears that are designed specifically for its custom paints. The HOK tech manual is an invaluable source of information about clears and the entire House of Kolor product line.

Clearview, Washington. The clear coat was wet sanded with 1,500 grit paper. That smoothed the paint, but left it looking very dull. If any shiny areas remain, that means more sanding is necessary. The fresh black paint looks like primer in the photos, as it should.

Donn Trethewey designed and painted the red, orange, and magenta flames with base-coat/clear-coat paint. Since the whole car was going to be clear coated, Donn applied only one coat of clear over the flames. If you're just clearing the flames, follow the manufacturer's instructions. Generally, two to four coats of clear are required. You don't want unnecessary buildup, but you want enough coverage to allow for sanding and polishing.

After the flames were dry and all masking materials were removed, Terry cleared the entire car with three or four coats. The car sat for a couple days before wet sanding. The fenders and running boards were removed so they could be better accessed. The hood and side panels were also removed for sanding. A sanding block is used even though the 2,000 grit paper feels almost like it isn't sandpaper. The block or sanding pad prevents grooves that can be caused by your fingers.

A small amount of common dishwashing detergent in the water bucket will help prevent the sandpaper from clogging. It also helps to soak the sandpaper and sanding block in the water bucket for a few minutes before you start sanding. Be certain that the sandpaper is labeled wet or dry. Terry prefers 3M sandpaper, which is pretty much the industry standard.

Throughout the wet sanding process, it's important to check your progress. A clean, soft cloth and a rubber squeegee are needed. As long as the surface is wet, it will appear shiny. By using the squeegee to wipe off most of the water and the cloth to finish the job, you can spot areas that need more sanding.

There are black and red rubber squeegees. The black ones are typically used for applying spot putty. Use red rubber during the wet sanding process, because the black ones can leave noticeable marks.

It's during the wet sanding process that tiny imperfections and specs of dirt can be sanded out of the clear coat. Sanding and wiping will help you spot those flaws.

Once the whole surface is dull, all traces of sanding residue should be flushed off. Buffing and polishing are next in the process of using ever-finer grits to perfect the paint surface. The terms buffing and polishing are often intermixed. They both refer to using various chemical compounds with a power buffer to increase the smoothness and shine of the paint. Technically speaking, buffing comes first and uses coarser grit products. Polishing is the last step that removes any remaining minute scratches.

Buffing a paint job (sometimes also known as rubbing out the paint) is a specialized skill. A heavy power buffer in the hands of an inexperienced person can do more harm

Jim Carr's '35 Chevy received a total repaint, so the entire car was clear coated after the flames got a single coat of clear. Since the doorjambs were cleared, an extensive amount of masking was necessary. The reflection of the spray booth lights makes the paint appear quite shiny, but it will be sanded dull before it is polished to a high shine again.

than good. This is another one of those tasks you may wish to farm out until you've had time to practice on something less delicate than a custom flame job.

An improperly used buffer can burn through the paint. Burning through a solid color isn't easy to fix, but burning through multicolored flames can be a nightmare repair job. A good buffing job can take a full day of hard work.

Terry Portch likes the 3M Perfect-It III system. It's a stepped system that uses different colored buffing pads to go from heavy to medium cutting compound to light to soft polish and ends with a final finish compound. Buffing and polishing is a very messy job, so anything that isn't being buffed should be protected with plastic or masking paper.

Besides the general messiness of the buffing process, the various compounds shouldn't be allowed to dry. Dried compound can damage fresh paint. Wipe off any excess compound with a clean, soft cloth.

Terry uses a variable-speed electric polisher that he usually runs in the 800- to 1,100-rpm range. He works a relatively small area at a time, always keeping the buffer moving. If you stop in one area or apply too much pressure, you stand an excellent chance of burning through the paint or clear.

Another warning is to be extra careful around panel edges or styling lines. Tops of fenders, door edges, and trunk edges should be taped off to protect them from the buffer.

Theses areas should be hand finished to avoid rubbing through the paint with the power buffer.

Buffing pads are made in both wool and foam. The wool pads were the long-time standard, but modern foam pads seem to be taking over. Ask your local paint retailer to recommend a system and type of pads.

These final detailing steps are very time consuming, but it's time well spent.

Ultra fine sandpaper, 1,500 or 2,000 grit wet/dry, is used to wet sand the clear. Check the manufacturer's directions to determine the proper grit. A little dishwashing detergent in the water bucket helps keep the sandpaper from clogging. The paper should still be replaced frequently.

Terry Portch of Kimbridge Enterprises removed as much of the car as possible to make the wet sanding process easier. He removed the hood and front fenders.

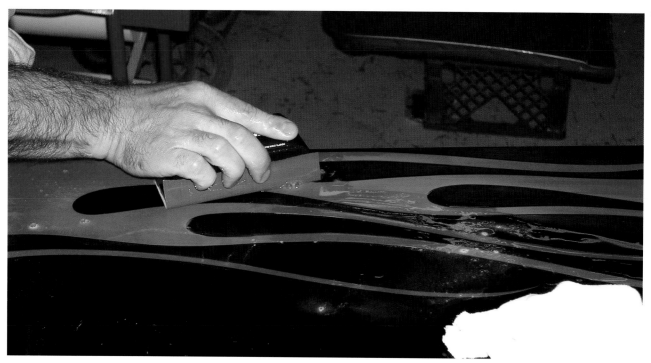

A sanding block should be used to keep the sandpaper flat and to prevent finger gouges. Keep a squeegee and a clean cloth handy to periodically wipe away sanding residue and to check for areas that are still shiny. Notice that the residue has a milky appearance. It shouldn't be colored.

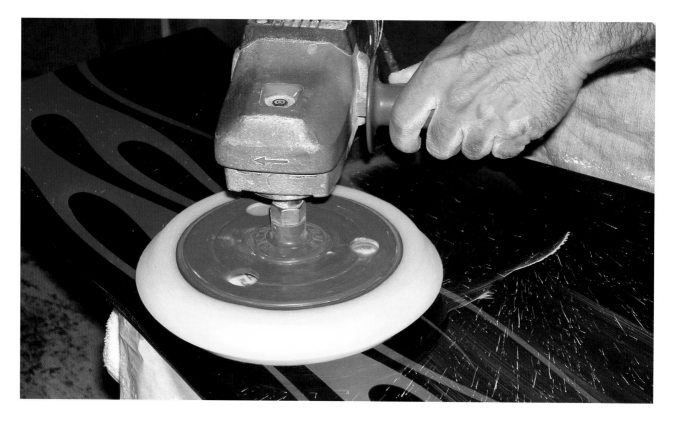

A variable-speed electric buffer is used with a foam pad and various rubbing and polishing compounds to further smooth the surface after the wet sanding. The buffer must be kept moving at all times. The splattered compound gives an idea of how messy this process is.

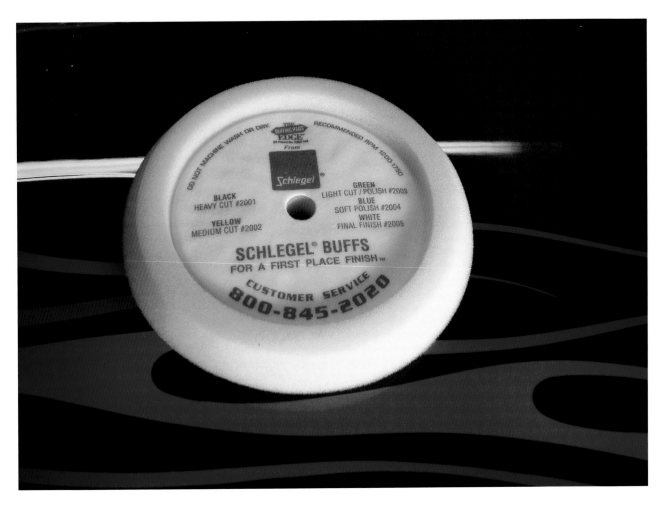

Total buffing and polishing systems consist of graduated compounds and different texture pads. This yellow foam pad is for the medium cut step.

This before and after split shot shows the wet sanded dull finish on the left and the glossy buffed finish on the right.

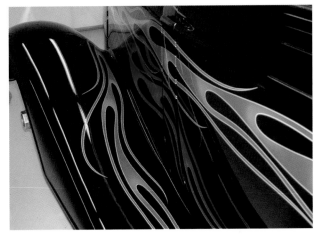

Here is a close-up view of the Donn Trethewey flames on the fender and hood panel of Jim Carr's '35 Chevy after the wet sanding, buffing, polishing, and pinstriping were completed. This is the eagerly anticipated result of lots of hard work.

INDEX